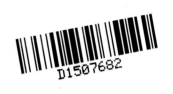

# ISLAND FEVER

*A journey around all the coastal islands of England and Wales*

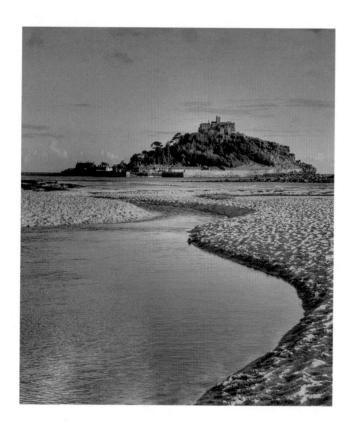

# ISLAND FEVER

*A journey around all the coastal islands of England and Wales*

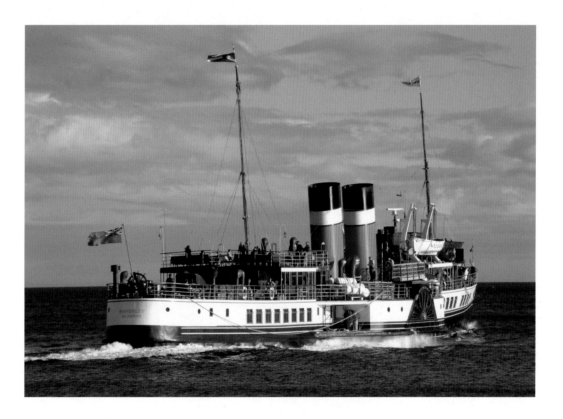

## BY ROBIN JONES

Ian Allan
PUBLISHING

# Contents

First published 2010

ISBN 978 0 7110 3471 6

Additional research: Jenny Jones

© Robin and Jenny Jones, Diamond Head 2010

Published by Ian Allan Publishing

an imprint of Ian Allan Publishing Ltd, Hersham, Surrey KT12 4RG.
Printed in England by Ian Allan Printing Ltd, Hersham, Surrey KT12 4RG.

Visit the Ian Allan Publishing website at www.ianallanpublishing.com

Distributed in the Unites States of America and Canada by BookMasters Distribution Services.

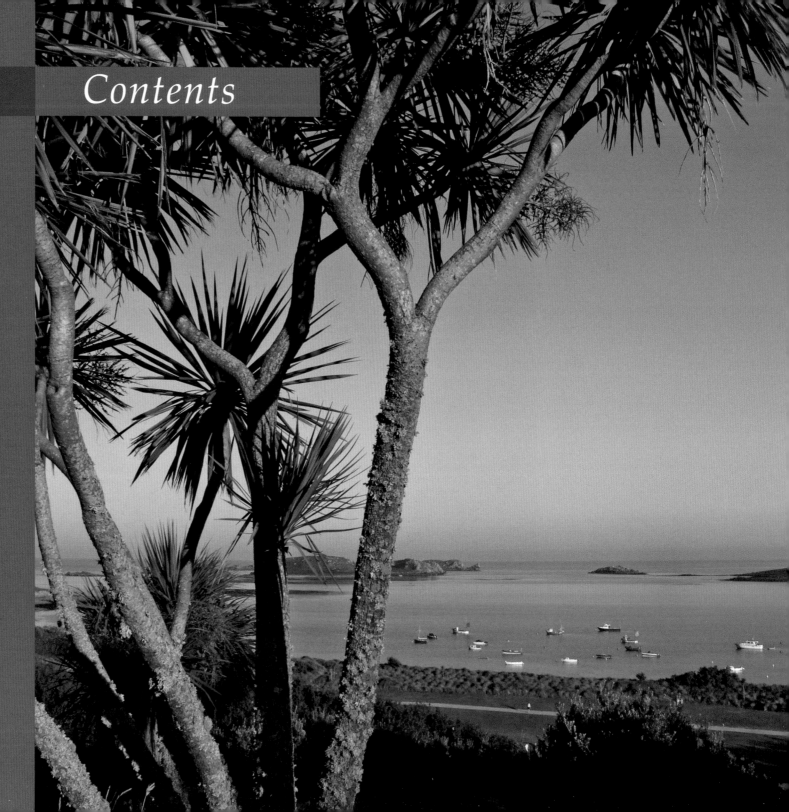

| | | |
|---|---|---|
| Introduction | 7 | |
| 1 Flat Holm | 10 | |
| 2 Steep Holm | 14 | |
| 3 Birnbeck Island and Pier | 18 | |
| 4 Lundy Island | 20 | |
| 5 The Isles of Scilly | 24 | |
| 6 St Michael's Mount | 32 | |
| 7 Looe Island | 34 | |
| 8 Drake's Island | 36 | |
| 9 Burgh Island | 38 | |
| 10 Islets of the West Country | 42 | |
| 11 The Isle of Portland | 46 | |
| 12 The islands of Poole Harbour | 50 | |
| 13 The Isle of Wight | 56 | |
| 14 Portsmouth and its islands | 62 | |
| 15 Hayling Island | 66 | |
| 16 Thorney Island | 68 | |
| 17 The Goodwin Sands | 70 | |
| 18 The Isle of Sheppey | 72 | |
| 19 The Medway and Thames Estuaries | 76 | |
| 20 Canvey Island | 80 | |
| 21 The Foulness archipelago | 84 | |
| 22 The Blackwater estuary | 88 | |
| 23 The Principality of Sealand | 92 | |
| 24 Hamford Water | 94 | |
| 25 Scolt Head Island | 96 | |
| 26 The Humber | 98 | |
| 27 St Mary's Island | 102 | |
| 28 Coquet Island | 104 | |
| 29 The Farne Islands | 108 | |
| 30 Lindisfarne | 110 | |
| 31 The Cumbrian Islands | 116 | |
| 32 The Hilbre Islands | 122 | |
| 33 Anglesey | 126 | |
| 34 Minor islands of Anglesey | 132 | |
| 35 Bardsey Island | 136 | |
| 36 Cardigan Bay | 140 | |
| 37 West Pembrokeshire islands | 142 | |
| 38 Caldey and St Catherine's islands | 150 | |
| 39 Barry and Sully Islands | 154 | |
| 40 Denny Island: The conclusion | 160 | |

# Introduction

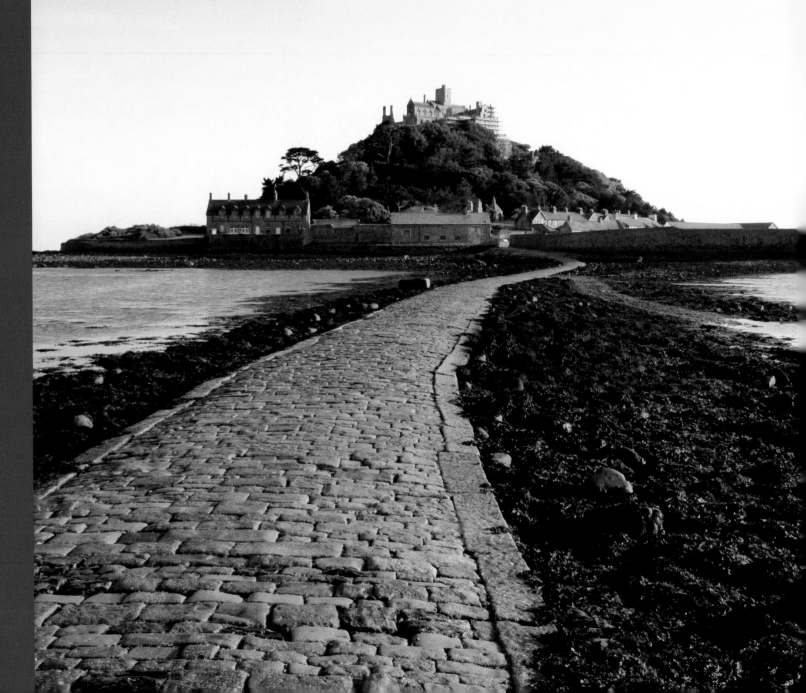

The low-tide causeway from Marazion to St Michael's Mount made from granite setts. Chris Stocker

If there is a niche on earth, no matter how unlikely, it will be occupied by life in some shape or form. The freezing waters of the Antarctic, the vents of undersea volcanoes and the space between grains of sand in the burning heat of a desert all have their inhabitants.

As with life in general so it is with mankind. Although we are generally a social animal, there are those who will readily colonise the most remote place if there is a living to be had, a gain to be made or a purpose to be fulfilled.

By and large society is the product of topography and our own adaptation to terrain and climate. For centuries Britons have revelled in the comparative freedoms that come from being an island nation and have enjoyed the physical security conferred by the English Channel and North Sea. The natural barrier, or lack of it, that surrounds a country will play a major part in the shape that it takes, its civilisation and culture, and all being well, bestow upon it the gift of individuality. That is exactly what this book is all about. Around the coasts of England and Wales, there are literally hundreds of islands and islets, ranging in size from Anglesey, physically the largest, and Portsmouth, the most populated (surprisingly few people realise that the city is built on an island) down to lonely rocks in raging seas where, until they were automated, lighthouse keepers were the sole inhabitants. Each of them is unique and they all have their own tales to tell.

Daniel Defoe got it exactly right in *Robinson Crusoe*: the story of the shipwrecked sailor who survived by studying his new-found island surroundings and, rather than succumbing to despair, harnessed its positive attributes to maximum benefit.

Many of our small islands have been farmed in past centuries, and were abandoned only when they became uneconomic. All except the tiniest isle provided a living, however sparse, for someone at some period.

A number of small islands were sought as places of solitude by early Christian saints and monks. Caldey Island in Pembrokeshire continues this tradition today. Over the centuries several islands became military fortresses bristling with firepower in defence of the realm; Foulness Island in Essex and Thorney Island in Hampshire are still occupied by the military. Even today, the former, from which the general public are largely banned, has a distinctly chilling Cold War air about it, and then there are those strange ghostly towers in the middle of the Thames estuary.

Attempts have been made to turn some of our offshore islands into kingdoms in their own right, complete with monarch, like Prospero in Shakespeare's *The Tempest*. Some have gone as far as issuing their own stamps or coinage. Lundy produced the puffins

and half puffin coins while Anglesey had its druid tokens, and little Birnbeck Island even issued one farthing notes.

Several islands were notorious as the haunts of pirates. Off the coast of Essex the Principality of Sealand is a 'micronation' with its roots in the swinging sixties and the days of pirate radio, its claim to independence still largely unchallenged 40 years on.

Most of the islands covered in this book are small, but several have played a huge, sometimes pivotal, part in world history.

Major 'firsts' claimed by our islands are the first history of Britain to be written, the world's first radio transmission across water, the first radio transmitting station, the first aeroplane flight by a British aviator, the first hovercraft, the first boy scout camp, and in the field of sports and leisure, the first windsurfer. We also have, on one tidal island, the world's only sea tractor bespoke to the particular location and, unbeknown to millions of visitors, another island has a secret railway running right through its centre.

The unique nature of these islands is by no means limited to the activities of man. Some of the world's greatest nature reserves are to be found not in Africa or South America, but around our own shores. There are rare bird colonies that draw visitors from around the world, precious havens for our endangered native red squirrel and marine reserves where coral thrives in British waters.

Charles Darwin went halfway round the world to 'discover' evolution in the Galapagos, but could have found it in the unique species and breeds that have evolved exclusively on our small islands. The Walney geranium, the Bardsey apple, the Skomer vole: Lundy Island not only has its own cabbage, but an attendant Lundy cabbage beetle that thrives on it. Britain's only colony of poisonous scorpions can be found on an island not that far from London. Such species evolved because they were protected from the common mammalian predators of the mainland, had a restricted gene pool and specific habitat. Had Darwin studied them, he might have reached the same conclusion as his study of birds on separate islands in the Galapagos which developed different beaks for different purposes depending on the local food source. Ironically, Darwin's ship HMS *Beagle* ended its days sailing around one of the islands in this book, before being scrapped nearby.

The title of this book, *Island Fever*, was inspired by a Beach Boys song from the *Summer in Paradise* album, but it is wrong to think that exotic diseases were confined to the tropics. Some islands were seen as the perfect place to isolate those carrying contagious diseases. Flat Holm, the first island to be visited in our anti-clockwise journey around the coast of England and Wales, once had a cholera isolation hospital: other islands have been used to

**Burgh Island, as viewed from Sedgewell Sands at the mouth of the River Avon.**
Burgh Island Hotel

Above: **Ryde carnival on the Isle of Wight.**
Isle of Wight Council

Right: **The harbour at Cowes packed during Regatta Week.** Gillian Moy

quarantine infected sailors returning from abroad. Until recent times malaria thrived on the salt marshes of southern England, the last victim in England dying on the Isle of Sheppey in 1952.

In the course of our journey we will visit fairytale castles, grim fortresses and dungeons, trendy yacht havens, a stunningly beautiful art deco hotel, Britain's only island pier, places that have inspired artists, novelists and poets, a world-famous railway scrapyard, an island, long since disappeared beneath the waves, which continues to cause much grief, the site of the world's biggest copper mine, holiday camps and funfairs, the place where Britain's space technology was pioneered, and much more. In short, our islands provide a hidden history of Britain and we will discover much that is very different from daily life on the mainland.

I have focused on the individual character of each island and what has made it unique, has enriched its 'islandness'. The general criteria for inclusion are that they must have been inhabited at some point in history, and must be coastal islands today. There are exceptions, such as the great prehistoric island that is now the Goodwin Sands, the most dangerous sandbank off the British coast.

If I'm asked for my favourite island, I would have to pick the Isles of Scilly for their dreamlike landscapes. But I have long held a soft spot for Steep Holm for rarely have I come across a location anywhere in the world where there is so much to discover per square foot, in terms of flora, fauna and human history.

Each island is different and is possessed of its own rules, appeal and charm. I hope this book will set readers off on the search for their own favourite.

*Robin Jones*

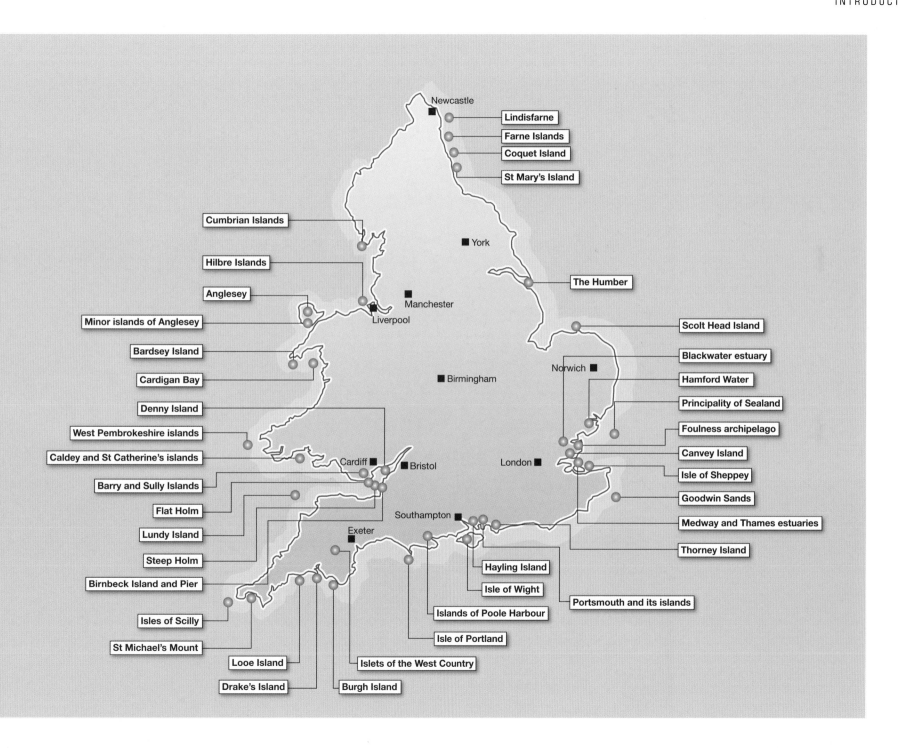

Newcastle

Lindisfarne

Farne Islands

Coquet Island

St Mary's Island

Cumbrian Islands

York

Hilbre Islands

The Humber

Anglesey

Manchester

Minor islands of Anglesey

Liverpool

Scolt Head Island

Bardsey Island

Blackwater estuary

Norwich

Cardigan Bay

Hamford Water

Birmingham

Denny Island

Principality of Sealand

West Pembrokeshire islands

Foulness archipelago

Caldey and St Catherine's islands

Canvey Island

Cardiff

Barry and Sully Islands

Bristol

London

Isle of Sheppey

Flat Holm

Goodwin Sands

Lundy Island

Medway and Thames estuaries

Southampton

Steep Holm

Thorney Island

Birnbeck Island and Pier

Hayling Island

Isle of Wight

Exeter

Isles of Scilly

Portsmouth and its islands

Islands of Poole Harbour

St Michael's Mount

Isle of Portland

Looe Island

Islets of the West Country

Drake's Island

Burgh Island

# 1 Flat Holm

The landing beach and jetty after arrival of the trip boat from Barry Island, with Castle Rock in the background.
Robin Jones

On 13 May 1897, one of the world's greatest technological revolutions began on an island in the Bristol Channel, an experiment which marked the beginning of today's global communications industry. It was on Flat Holm, with a diameter of about 2,000ft and 70ft at its highest point, that 22-year-old Italian inventor Guglielmo Marconi, assisted by Cardiff post-office engineer, George Kemp, transmitted the world's first wireless signals over open sea to Lavernock Point near Penarth.

Having failed to generate interest in his native country, Marconi gained the ear of Welshman William Preece, the chief engineer of the General Post Office, and the pair built a 98ft receiving mast at Lavernock Point. When initial trials on 11/12 May failed, they raised the mast a further 62ft and the signals were received loud and clear. The Morse code message they sent read, 'Are you ready?' The original Morse paper slip, signed by the pair, is now in the National Museum of Wales, while a Marconi monument stands at the centre of the island. History repeated itself on 8 October 2002, when Flat Holm became one of the first areas of South Wales to link to the internet through a wireless connection.

The island has marked the southernmost part of Wales since Henry 1's son Robert Fitzhamon established Glamorganshire in the wake of the Norman Conquest, although it is actually the westernmost of a line of outliers including Brent Knoll, Sand Point, Worlebury Hill, and Steep Holm and geographically belongs to the carboniferous limestone Mendip range of Somerset,.

In prehistoric times Flat Holm was surrounded by woodland, but since the end of the Ice Age rising sea levels flooded the valley through which the River Severn ran and created the unique environment that is the Bristol Channel. The 'Severn Sea' has a tidal range of about 49ft – the second greatest in the world and only beaten by the Bay of Fundy in Newfoundland. Its shape funnels the mighty Atlantic surge into an ever-narrowing passage and strong tidal streams push back the freshwater from Britain's longest river leaving mud particles suspended, which gives the sea its unfortunate brown hue.

The Vikings thought that the plateau-like Flat Holm and its hilly sister Steep Holm were in the river rather than the sea. 'Holm' comes from their word for 'river island', and modified the earlier Saxon 'Bradanreolice' for Flat Holm and 'Steopanreolice' for Steep Holm. A Viking fleet took refuge on the island following a defeat by Saxons at Watchet, in present-day North Somerset.

The island has been inhabited since the Bronze Age and possibly earlier; the date is verified by an axe head found in 1988. The Anglo-Saxon Chronicle records that Gytha Thorkelsdóttir, mother of Harold, the last Anglo-Saxon king of England, stayed on Flat Holm mourning her son before travelling to France after the Norman Conquest, while a folk story claims that graves found near the farmhouse are those of two of the knights who murdered Thomas à Becket in Canterbury cathedral in 1170.

Barbary corsairs or pirates are said to have sailed up the Bristol Channel in the early 18th century, seizing local inhabitants to be sold as slaves in Algiers, Tunis, and Morocco – a sort of reversal of the black African slave trade for which Bristol was infamous – and some say they used Flat Holm and Lundy Island as havens.

Two man-made caves can be found below the island cliffs, and those who assume they were created for contraband are correct. However, it was not brandy or rum that was being concealed here in the 18th century, but soap from Ireland, because of the very high levels of tax on what was deemed luxury goods. Wealthy people in Bristol, Bath, Gloucester and Cheltenham who liked a good scrub provided a ready market.

In 1835, following the example of Cadoc, a late sixth-century Welsh saint and missionary who made frequent visits to the island (then called Echni) for periods of tranquil meditation, clergyman John Ashley saw the windows in Flat Holm's farmhouse glinting in the sun as he looked out from Clevedon, and felt called to minister to those who lived on the island. This initiative led him to set up the Bristol Channel Mission to serve the spiritual needs of the crews of the 400 sailing vessels which used the Channel. The organisation became the Mission to Seafarers, which today ministers to seamen in more than 300 ports. A service is still held annually to bless Flat Holm.

The island, a designated Local Nature Reserve, is managed by Cardiff Council as the Flat Holm Project, which runs the *Lewis Alexander*, a boat purpose-built for the crossing from Barry Island which carries up to 45 passengers. Because of the immense tidal range, landing on the island is only possible two hours either side of high water, limiting day visits to about three hours. The visitors' most likely port of call is the whitewashed farmhouse, providing the warden's permanent home and office, dormitory accommodation for overnight visitors, a snack bar and shop selling souvenirs.

In 1897, the farmhouse became known as the Flat Holm Hotel, after being taken over by publican Fred Harris. Fred previously ran the inn on Steep Holm, doing a roaring trade with sailors whose boats were moored in the Channel but, after clashing with Somerset magistrates over his unorthodox licensing hours in 1885, he moved across to Flat Holm. The island proved a highly-popular destination for thirsty day-trippers on Sundays, when Cardiff was

Accessible rocky beaches, like West Beach and Coal Beach, allow rewarding natural-history expeditions and even sunbathing for those who find time to spare on longer visits. Robin Jones

still 'dry' and no alcohol could be served on the Sabbath, as was typical in much of Wales at the time. However, shortly after appearing before Cardiff magistrates for breaking Sunday licensing laws in 1922 Fred's son Frank closed the hotel for good .

Both islands contain a fascinating wealth of military fortifications which are still in a remarkable state of preservation. The rise of Napoleon III, French Emperor from 1852–70, set alarm bells ringing in an England fearful that history might well repeat itself. Prince Albert expressed concern at the growth of the French

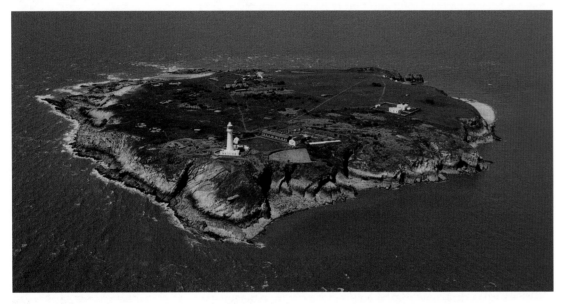

**Aerial view of Flat Holm Island, one of the real gems of the Bristol Channel.**
Flat Holm Project

navy and Viscount Palmerston presided over a Royal Commission established in 1859 to improve coastal fortifications. The result was the building of a chain of 'Palmerston Forts' around the coast of southern England. Many examples will appear in later chapters.

Completed in 1869, Flat and Steep Holm became the centrepiece of a Palmerston defensive barrier across the Bristol Channel from Brean Down to Lavernock Point. The tiny island bristled with armaments, seven-inch rifled muzzle-loading cannon being installed in circular gun pits in four separate batteries on Flat Holm. In years to come, when the threat of invasion had evaporated, the sheer weight of the cannon made them unattractive to scrap metal merchants, and most of those on Flat Holm remain intact. Stone barracks, dating from the same period, have been partially restored and converted into accommodation for project staff. The forts never fired a shot in anger, and became dubbed 'Palmerston Follies'. Napoleon III turned out to be a pale shadow of his uncle

and lost the Franco-Prussian war of 1870. Unlike Napoleon I, he was quite partial to England, and went into exile in Kent until his death in 1873.

The island's lighthouse, now fully automated and powered by solar panels, dates from 1737. For years Bristol merchants demanded the provision of a light to protect their shipping, but it was not until 60 soldiers drowned in a shipwreck in 1736 that anything was done. Shipmasters complained that the light on the 70ft tower was not sufficiently visible, but it took the best part of 100 years before Trinity House agreed to raise the stone tower to 90ft in 1819. That happened after the *William & Mary*, a Bristol to Waterford sailing packet, suddenly struck the Wolves, a nearby submerged island which appears only at neap tides, on 28 October 1817. It sunk within minutes, 54 passengers being lost, including 22 women and children. Only one person survived, and 50 bodies were recovered and buried on Flat Holm. A fog signal station was added in 1908.

The lighthouse, which has a 16-mile range and an intensity of 139,000 candle power, is controlled from Nash Point near Llantwit Major. The keepers' cottages now stand empty.

One of the biggest surprises awaiting visitors on their guided tour is the ruin of a Victorian cholera hospital. Amid fears about sailors returning from overseas with the disease, health authorities in Cardiff ordered all infected seamen to be isolated on either Sully Island, near Barry, or Flat Holm. In 1886, as the number of cases soared, Cardiff Corporation leased the island for this purpose and when a converted farm outbuilding became too small to serve as the isolation hospital, a new pavilion-style building was designed and built.

Fred Harris doubled up as caretaker until the Ministry of Health closed the hospital in 1935, although the last patient to die there, from bubonic plague, perished at the end of the previous century. Despite being Grade II listed, the hospital is now a ruin. The hospital's history, however, provided inspiration for the scriptwriters of the *Dr Who* sci-fi spin-off *Torchwood*, produced by BBC Wales in Cardiff. An episode entitled *Adrift*, broadcast in March 2008, featured Flat Holm as the base of a secret medical facility. Such inspiration is part of the timeless fascination of islands everywhere.

Flat Holm made international headlines in late April 2010 after the island was taken over by a party of more than 40 nudists from British Naturism for a weekend, after four years of planning. The nudists wore clothes and hardhats for the journey, but stripped off as soon as they landed on dry ground, away from prying eyes. Other visitors were invited to take their clothes off, too.

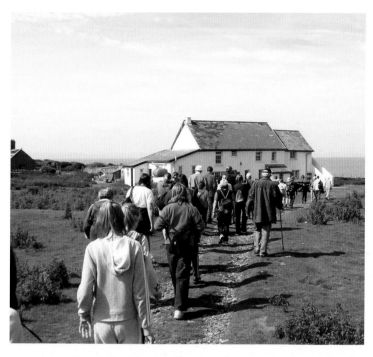

Above: **A party of visitors approach the farmhouse. Visitors are always accompanied around the island by guides for safety reasons.** Flat Holm Project

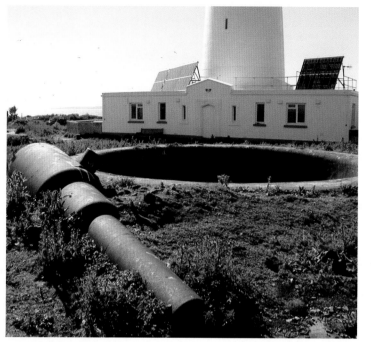

Above: **One of the Victorian cannon and circular gun pits.** Flat Holm Project

Below: **The rabbit is the only mammal on Flat Holm, but the island is also home to slow worms with larger than usual blue markings – in Darwinian terms, a new species evolving in isolation, perhaps?** Flat Holm Project

Below: **The ruins of the cholera hospital, the only Victorian isolation hospital sited on a British offshore island.** Flat Holm Project

Below: **Post Office engineers inspect Marconi's equipment in May 1897.** Flat Holm Project

Below: **Guglielmo Marconi.** Flat Holm Project

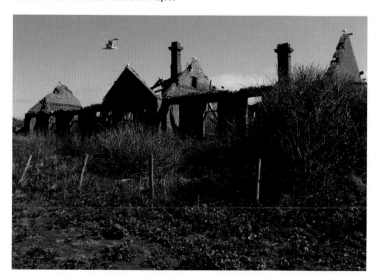

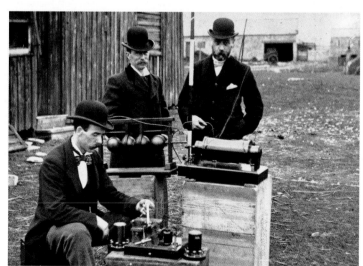

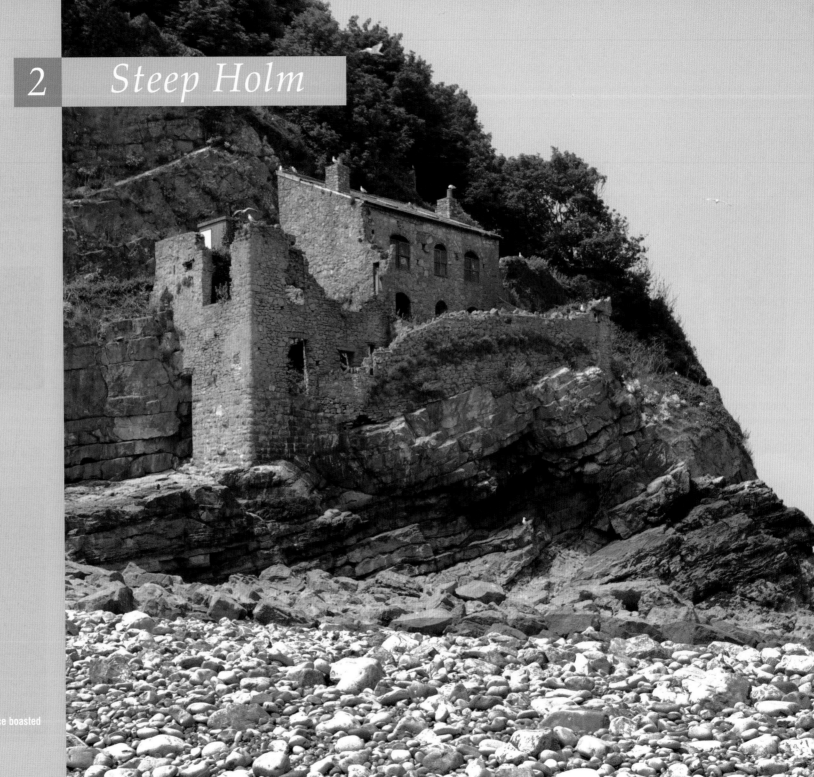

# 2 Steep Holm

The ruined pub, which once boasted
a guard bear. Robin Jones

Old seagulls never die: they simply go to an afterlife on Steep Holm. Either that, or every seagull in the world comes from there. That is the distinct impression formed by visitors after just five minutes on the 63-acre twin island to Flat Holm, for as far as the gulls are concerned, it is their land, not the domain of man. As at Flat Holm, there are no natural predators, and they breed anywhere without fear.

Every sound sequence in a seagull's vocabulary, and there are enough of them to give the impression of a language, will be shrieked over and over again. They will not actually attack, but if you inadvertently approach their nests or chicks – you will be told in no uncertain terms you are not welcome. The usual practice is to dive at you directly from the front or rear, and then apply wing uplift seconds before contact, so you just feel the jet stream passing millimetres above your head. As you continue along an island path, the gull families which moved aside to make way quickly reassemble into their former positions: it is as if nature is immediately sweeping up after man has passed by, and reclaiming this part of the earth for itself.

It may be small and largely inaccessible, the 'liveable' part comprising the plateau above jagged Mendip carboniferous limestone cliffs, but I have rarely come across a location which offers more of archaeological and biological interest per square foot, thanks to the various 'layers' of history that are visibly overlaid and remain intact. Owned by a volunteer trust set up in 1974 in memory of the television broadcaster and writer Kenneth Allsop, Steep Holm, which is also a Site of Special Scientific Interest, is managed as a nature reserve.

Depending on the tides it can be accessed by boat from Weston-super-Mare's Knightstone quay on select days in the summer. Landing is made on the island's small pebbly beach in front of the remains of a World War II quay wall. To the right, the ruins of an inn built in 1832 can be seen on top of the dramatically tilted exposed limestone beds. The inn, built to serve sailors on ships becalmed in the Channel while waiting to enter Bristol, was popular in the 19th century. One true story relates how a visitor from Cardiff liked the owner's guard dog so much that he offered to swap it for his pet bear. The exchange went ahead, and so the Steep Holm Inn uniquely acquired a guard bear.

A harbour built at the same time as the inn was washed away in 1860. The only surviving remains of a wartime jetty are rusting stanchions, meaning that visiting boats today have to be beached and offloaded in an extreme hurry before the tide races out. The inn fell into disuse and disrepair long before the arrival of the Royal Engineers who blasted off its top storey and widened the zigzag path up the island in 1941.

Walkers are surprised to find the rails, iron sleepers and pointwork of a narrow-gauge winch-hauled railway still intact beneath their feet. These are the last vestiges of a 1ft 11in gauge military field railway used on the Western Front during World War 1 and placed in cold storage, until its time came again. The Holms were heavily refortified to defend Cardiff from the Luftwaffe and the railway was used to winch supplies from the beach to a network of lines on the summit, where a diesel locomotive pushed trucks around. There was also a second incline railway servicing the more difficult South Landing. Because the scrap men did not consider its post-war reclamation sufficiently worthwhile or even feasible, it too is largely intact. The railways were used to transport the vast quantities of sand and cement needed to build the network of gun batteries and searchlight posts which, in a reasonable state of repair, still adorn the plateau today. The zigzag path passes the remains of a cottage set back into the cliffs and used by fisherman and inn staff in the 19th century.

Gildas, a disciple of St Cadoc, is believed to have written the first history of Britain while living on Steep Holm in the late sixth century.

In springtime, alexanders, a biennial herb which grows five feet tall, cover the island. Their broad, shiny green leaves and umbels of yellow flowers stretch to the skyline of the 250ft summit. Augustinian monks who established a small priory on the island in the 12th century at the behest of the owner – in order that they could pray for his family and speed their progress through purgatory to heaven – brought the alexanders with them, and possibly the beautiful wild Mediterranean peony, which for centuries grew in Britain only on Steep Holm. Dedicated to the Archangel Michael, the little priory was occupied by only a handful of monks, and was abandoned in 1260 after being taken over by Studley Priory in Warwickshire.

For centuries after the monks left, the island was used by rabbit warreners, who lived in a cottage on the site and harvested rabbits for sale on the mainland. Its thick walls stood firm until Palmerston's engineers arrived in the late 1860s and used much of the stonework to build a series of forts before filling the site with excavated earth and rubbish. Kenneth Allsop Memorial Trust members are attempting a careful excavation of the site while preserving the surviving walls and keeping the rampant vegetation at bay.

Military buildings dominate Steep Holm to a far greater extent than on Flat Holm. Because the hilly terrain limited available sites,

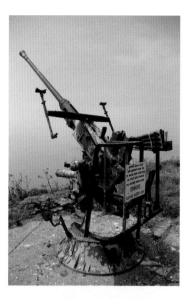

**World War II Bofors anti-aircraft gun, long since non-operational, still guards the island plateau.** Robin Jones

**The World War II railway line still in situ up two inclines.** Robin Jones

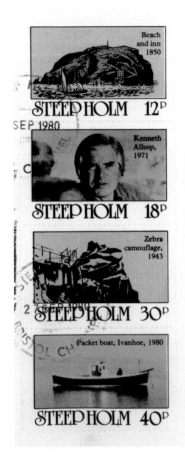

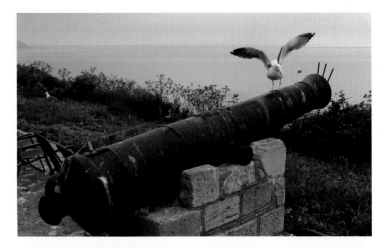

many of the World War 2 gun emplacements either modified the Palmerston sites or were built on top of them. The six Victorian emplacements – Split Rock, Rudder Rock, Summit, Laboratory, Tombstone and Garden batteries – had seven-inch rifled muzzle-loaded cannon, of which all but one survive. The heavy iron gun-barrels, also snubbed by the scrap men, are now protected ancient monuments. After the tiny Victorian garrison left in 1901, the barracks were abandoned and later rented as private accommodation before seeing use as a coastguard station.

The island was refortified after 1940 with four batteries – Garden Battery East and West and Summit Battery East and West – guarding the channel and its ports from E-boat attack. The hub of activity during both military occupations was the 1867-built barracks which provided dormitories, store rooms and an officers' mess. They were served by a huge underground reservoir which collects and filters rainwater from the roof. The barracks somewhat resemble a country railway station of that period. Now splendidly restored, the barracks provide a dining hall, café, souvenir shop and museum run by trust members and is a tribute to many hours of dedicated unpaid work.

A stroll round the island's perimeter path takes just 90 minutes, which allows pauses for inspections of the army searchlight posts, light anti-aircraft gun positions, observation posts and other World War 2 structures.

A mammalian newcomer is the Muntjac deer. Four examples of this dog-sized Asian species were taken from a Hertfordshire wood ahead of a shoot in 1977, and their offspring can occasionally be seen through the scrub. The island is home to just one reptile, the slow worm, the longest ever recorded in Britain, 21in in length, was found on Steep Holm.

Owing to huge tidal variations, day trips can mean nine hours or more on the island before the possibility of departure but it takes less than a third of that time to see everything. But that is not the point of Steep Holm, which is to exploration and discovery what Hawaii is to surfing. It offers a unique 'natural world' ambience, and although mobile telephone reception across the Bristol Channel is crystal clear, a day on Steep Holm offers peace, uncluttered calm, and the chance to immerse yourself in a unique and largely overlooked backwater where nature remains in charge away from the modern mainland world.

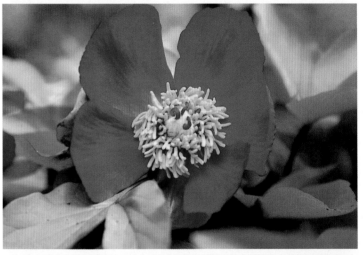

Above: **Some of the many beautiful stamps issued by Steep Holm to take letters to the mainland for onward posting** Robin Jones Collection

Top right: **Restored cannon outside the barracks.** Robin Jones

Centre right: **The famous wild Mediterranean peony paeonia mascula in full bloom.** Andre Wilson/Permission Kamt

Bottom right: **'Keep away from my nest!'** Robin Jones

Far left: **The Victorian barracks which now form a dining hall, souvenir shop and museum.** Robin Jones

Left: **View from the top of the sheer cliffs on the northern side of Steep Holm.** Robin Jones

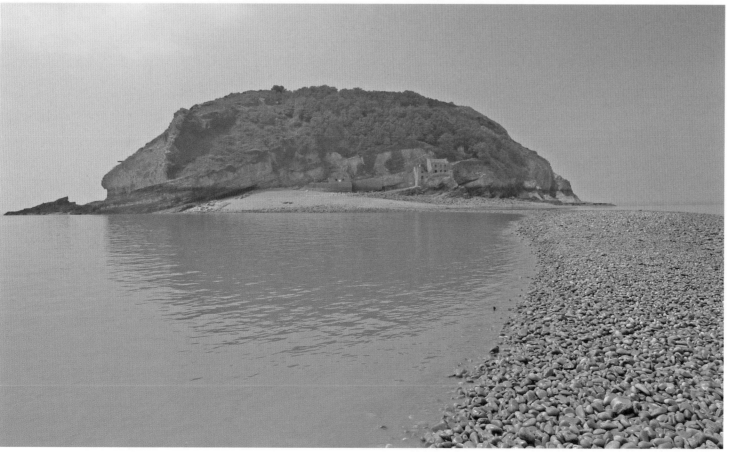

Left: **Steep Holm, as pictured by the 400-yard shingle spit that quickly appears at low tide. The phenomenal speed of the tidal race and currents which sweep past the island can clearly be seen. Bathing would almost certainly prove fatal. A visitor once kicked a football into shallow water off the spit and was left dumbstruck by the pace at which it was carried irretrievably away.** Robin Jones

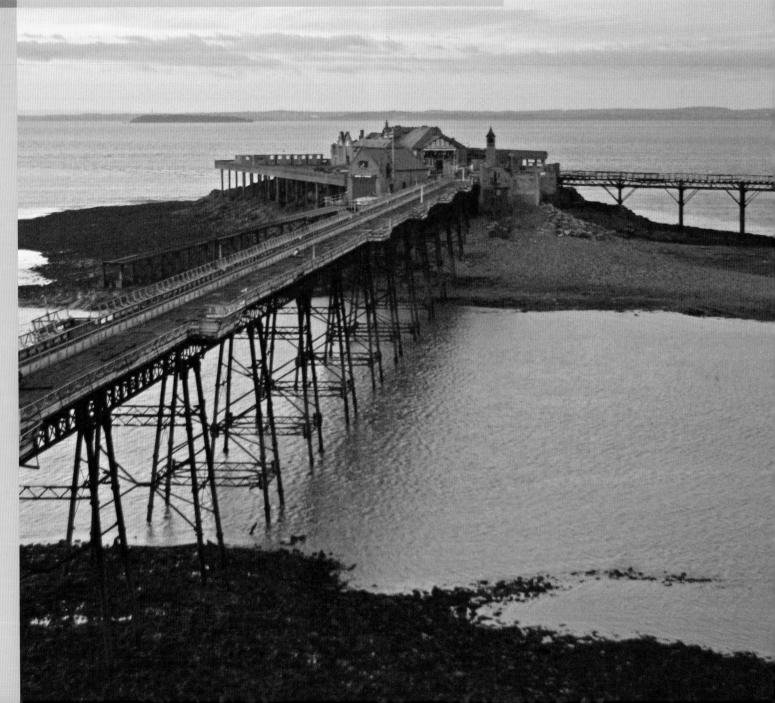

Derelict Birnbeck Pier uniquely linking the mainland to an island. The red door is that of the Weston-super-Mare lifeboat station, which is still in use. The island to the left on the horizon is Flat Holm.
Robin Jones

Tiny Birnbeck Island, little more than a lump of rock surrounded by shingle, is just 1,000ft off the headland of Worlebury Hill at Weston-super-Mare and was used for centuries by local fishermen to lay stakes for their nets in the surrounding estuarine mud.

Weston took off as a holiday resort as a knock-on effect from the popularity of Regency Bath and in 1845, architect James Dredge designed a suspension bridge to connect the island to the mainland. Dredge had lost out to Isambard Kingdom Brunel in a competition to design the Clifton suspension bridge, and if his Birnbeck plan had come to fruition, it would have been only the second chain pier in the country. It never happened. Dredge was bankrupted two years later when a masons' strike was followed by a storm which damaged the works.

Twenty years later, Eugenius Birch designed a 1,350ft pier which was able to cope with the 46ft tidal range, making it the only pier connecting an island to the British mainland. Built from prefabricated parts made and erected by the Isca Iron Foundry of Newport, Gwent, the foundation stone was laid on 28 October 1864 by Cecil Hugh Smyth-Pigott, the youngest son of the Lord of the Manor, who also opened the pier on 6 June 1867. The gothic toll house and pierhead buildings were designed by local architect Hans Price. The pier was an instant success, attracting 120,000 visitors in the first three months. Birnbeck Island soon became a popular calling point for steamships, particularly those of operator P & A Campbell.

The pier head had a café, pavilion, amusements and funfair, a shooting range and even its own bye-laws: visitors could be fined if they defied an order 'not to halloo, shout or call out, or blow, strike or sound any gong, or other instrument, or make any noise beyond that of ordinary speaking'.

The pier head was destroyed by fire on 26 December 1897 and replaced by the present buildings the following July. However, in 1904 work began on building the Grand Pier in the heart of Weston-super-Mare, a much more convenient proposition for holiday-makers which impacted on Birnbeck's trade.

In 1941, Birnbeck Pier was taken over by the Admiralty and became HMS *Birnbeck*. The Directorate of Miscellaneous Weapons Development used much of the surrounding coast, including Sand Bay and Brean Down, for secret weapons testing including the Bouncing Bomb, made famous after the war by the film *The Dambusters*.

In 1962 the Birnbeck Pier Company sold it to P & A Campbell but by the late 1970s cheap foreign holidays curtailed demand and the firm ended its services in 1979. The pier was then sold to entrepreneur John Critchley who turned it into a 'Victorian pleasure centre', even issuing its own currency. Badly damaged by storms in 1990, closed for safety reasons in 1994, the pier fell into severe decay, with English Heritage placing the Grade II listed structure on its Buildings at Risk Register.

In 2006 the pier was sold to Manchester-based developer Urban Splash, which launched a competition for a scheme to restore the pier and island. Levitate Architecture and Design Studio Ltd came first out of 95 entrants, with a design for 12 luxury apartments and a futuristic 50-room hotel. Some local conservationists, however, remain unhappy about the non-traditional design. Ironically, Weston's Grand Pier, which killed off so much of Birnbeck's trade, was destroyed by fire in 2007, while the earlier pier a mile to the north still survives.

While awaiting redevelopment, Birnbeck Pier nonetheless continues in use as Weston's lifeboat station, which dates from 1882. The island was the perfect place for launching a lifeboat at all states of the huge tidal range. The present lifeboat house dates from 1902 and at 368ft has the longest lifeboat slipway in England.

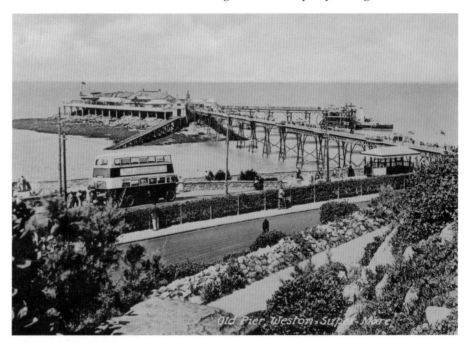

**Happier days when buses brought visitors to the pier entrance.** Robin Jones Collection

**A one farthing note issued by the 'Victorian pleasure centre'.** Robin Jones Collection

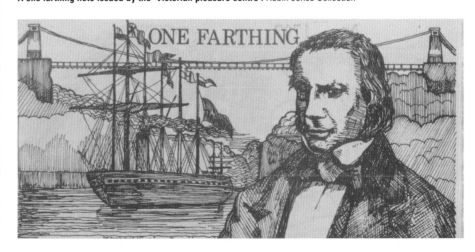

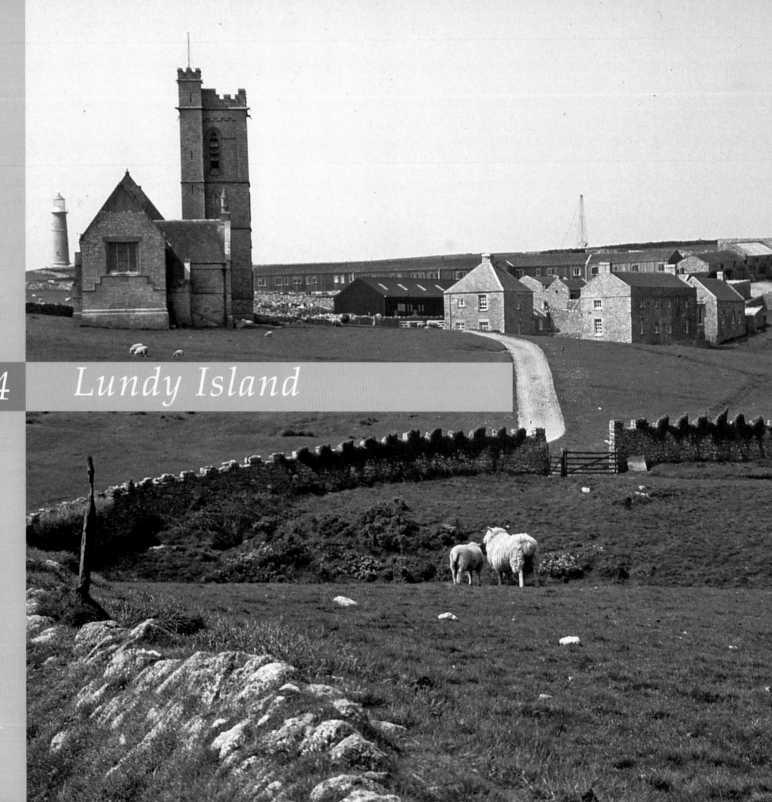

4     *Lundy Island*

The village dominated by St Helen's church, which had its peal of bells restored in 1994. Robin Jones

Opposite page: An aerial view of Lundy Island, a three-and-a half-mile long and half-a-mile wide environmental treasure. Landmark Trust

In 1628, in *The Institutes of the Laws of England*, Sir Edward Coke wrote, 'For a man's house is his castle, and each man's home is his safest refuge'. And if an Englishman's home is indeed his castle, it logically follows that a castle might well want a king – especially if it happens to be surrounded by water, and a considerable distance off the mainland. That might sum up the attitude of various owners of Lundy, the biggest island in the Bristol Channel, from the roguish family whose word was law a millennium ago, to the man who issued stamps and coins of his own 'realm'.

There is, however, truth in another immortal phrase coined by the great metaphysical poet John Donne, 'no man is an island'. For each Lundy owner was doomed to fail in his bid to turn the great granite mass into a kingdom of his own. Looking every bit as if it could have been hewn out of Dartmoor and dumped in the sea off North Devon, a 2005 *Radio Times* opinion poll named Lundy as Britain's tenth greatest natural wonder.

The name Lundy is widely held to be Old Norse for 'puffin island', but others point to Norman de la Lounde, a name recorded in medieval Tipperary and Kilkenny.

A splendid natural fortress and refuge, Lundy has been inhabited since the Stone Age. There are Bronze Age burial mounds, four inscribed gravestones from the fifth or six century and the remains of a medieval monastery, possibly dedicated to St Elen or St Helen.

In 1160 the Knights Templar, an 11th-century monastic military order, was granted Lundy by Henry II, but its ownership was disputed by the Marisco family who were already living there and were first recorded as residents in 1154. The dispute led to the Mariscos being fined and essential supplies denied to the island. However, when King John came to the throne in 1199, he confirmed that the Mariscos were the rightful owners.

At the time, William de Marisco used the island as a pirate base for raids on the North Devon coast until 1216 when he was captured while helping the Scots and French against the by-then widely hated King John. When Henry III ascended the throne in 1217, he restored Lundy to William in return for promises of loyalty and good behaviour.

The promises held good for two decades until 1235 when William was involved in the murder of Henry Clement, a messenger of Henry III. Three years later, a man who tried to assassinate Henry confessed to being an agent of the Mariscos. William, having sought revenge on Henry for seizing some of the family's other properties, fled to Lundy, built a refuge with walls 9ft thick, now known as Bulls' Paradise, and declared himself king.

In 1242, a landing party sent by Henry scaled the island's cliffs and took William and 16 of his followers prisoners. William was subsequently executed and the island taken from the Mariscos.

Henry then built a castle, often wrongly called Marisco Castle, in an attempt to impose his authority on the island and its waters.

It was not that simple. Both English and foreign pirates, including other members of the Marisco family, seized Lundy at various times, using it as a base to launch raids on Bristol merchant shipping which, because of the Channel's huge tidal range, had no option but to sail close to the island.

In Elizabeth I's reign, Lundy's owner, Mary St Leger, married Sir Richard Grenville, the famous sailor and explorer, but it again became notorious as the haunt of pirates, much to the consternation of the Queen.

In 1645, Barbary pirates from Morocco under Dutchman Jan Janszoon took control of Lundy, and reportedly raised the Islamic flag there. The island was later seized back by the Crown. Henry's castle was rebuilt and garrisoned by Charles I's supporter Thomas Bushell during the English Civil War: indeed, it was the last royalist stronghold to surrender, and then only after a year-long siege.

Lawlessness on Lundy continued in the 18th century, when Barnstaple MP Thomas Benson, the Sheriff of Devon, leased the island and used it to house convicts he had been paid to transport to Virginia, instead turning them into his personal slaves, who lived in the derelict castle. He also staged an insurance fraud, his convict slaves unloading a valuable cargo of pewter and linen and hiding it in a Lundy cave,

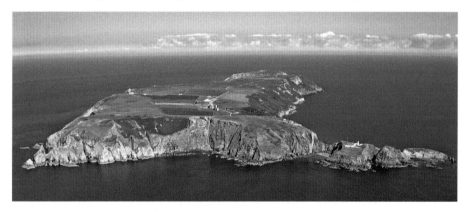

before setting the ship on fire and claiming the goods had been lost with it. Benson eventually fled to Portugal where he died.

The de Vere Hunt family, owners of Lundy in the early 19th century, suggested it could become a fully-fledged Alcatraz-style penal colony, but the government was not interested.

The Old Light is the highest lighthouse in Britain, its 97ft tower resting on a base above sea level. It was built by Trinity House in 1819 on foundations laid 32 years earlier, but it became redundant when the island's North and South lighthouses were built in 1897. In 1834 the island was bought for £9,870 by Jamaica sugar-plantation magnate William Hudson Heaven who, following the manner of several of his predecessors, declared it a free island, successfully placing it outside the jurisdiction of mainland magistrates. He built the road from the beach to the island village and a Georgian villa now known as Millcombe House. Intended as a holiday home, and nicknamed the Kingdom of Heaven, the cost of running Lundy all but ruined the family. In 1896 Heaven's son, the Reverend Hudson Grosset Heaven, built St Helena's church, now a Grade II listed building.

In 1918 the Heaven family sold the island to Augustus Langham Christie; six years later his family sold it to businessman Martin Coles Harman. In true Marisco fashion, Harman declared himself 'King of Lundy' and in 1929 issued his own currency, the puffin and half-puffin pieces corresponding to a mainland penny and ha'penny. This action led to his prosecution under the Coinage Act of 1870, after police visited the island and saw the coins being used in the village pub.

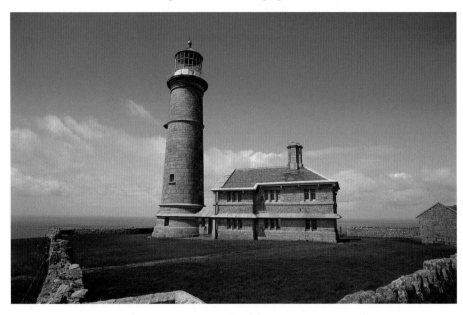

**The Old Light is now self-catering accommodation for visitors.** Landmark Trust

Harman claimed that Lundy was a little kingdom in the British Empire, but out of England. He recognised George V as the head of state, but remained adamant that Lundy was a self-governing dominion. However, in 1931 the High Court of Justice upheld his earlier conviction at the Petty Sessions in Bideford, fining him £5 with 15 guineas expenses. He was forced to withdraw the coins, which became collectors' items.

After Harman's son Albion died in 1968, fears arose that Lundy was to become an offshore gambling haven, but millionaire Jack Hayward bought it for £150,000 and gave it to the National Trust. It was leased to the present custodian the Landmark Trust, which has since overseen many restoration projects.

Today, the island has a resident population of 28, including a warden, island manager, and farmer, as well as a pub and housekeeping staff. There are 23 holiday properties, the first made available in 1954, and a campsite for visitors.

One fascinating aspect of islands is the tendency for unique species to evolve in isolation, and this is certainly true of many around the British coast. Lundy not only has the Lundy cabbage, a species of primitive brassica, but an accompanying Lundy cabbage flea beetle which feeds on its leaves. Lundy is also home to the sole British bird-eating spider, the purseweb spider.

The puffins for which the island was famous all but died out, being reduced to just three pairs in 2005. The cause is believed to be a combination of rats and commercial fishing for the puffins' principal food, the sand eel. Until they were recently eradicated from Lundy to protect the puffins, the island was one of only two places in Britain where the black rat could be found, the other being the Hebrides.

Lundy mainly comprises granite, with slate at the southern end and there are igneous dykes composed of a unique kind of orthophyre, or closely-packed feldspar crystals, named Lundyite – a prime example of an island which has its own exclusive type of rock.

Many unusual mammals were introduced by Harman, including a breed of wild pony now called the Lundy pony, sika deer, feral goats and Soay sheep. Yet it is not only the island that is a unique wildlife haven, but the waters and skies around it. In November 1986 the Environment Minister designated Lundy as a statutory Marine Nature Reserve because of its outstanding marine habitats and wildlife, including many rare and unusual species; seaweeds, branching sponges, sea fans and cup corals.

In 2003 the waters to the east of the island were made Britain's first mandatory No Take Zone for marine nature conservation. Controversial amongst local fishermen, its effects were soon noticeable and included an increase in the size and numbers of lobsters.

Lying on major bird migration routes and offering a safe haven well away from mainland predators, Lundy is a stopping-off point for many species, including black-legged kittiwake, razorbill, guillemot, herring gull, lesser black-backed gull, fulmar, shag, skylark, oystercatcher, meadow pipit, and peregrine falcon.

Several migrant species, including many from North America, have arrived on Lundy, sometimes the only place in Britain where they have been recorded. Such rarities include ancient murrelet, eastern phoebe and eastern towhee. A total of 317 bird species have been recorded.

Lundy is a brilliant first place to visit for those who fancy their own British island hopping. From April to October visitors are carried on the Landmark Trust's sizeable vessel, MS *Oldenburg*, which sails from both Bideford and Ilfracombe usually on Tuesdays, Thursdays and Saturdays, and on Wednesdays during July and August. The journey takes about two hours, depending on ports, tides and weather. From November to March, a scheduled helicopter service from Hartland Point operates on Mondays and Fridays.

In 2007, it was feared that the island would have to be evacuated permanently because the mile-long 19th-century Beach Road, which takes supplies from the landing jetties to the top of the plateau and the village, needed repairs costing £250,000. However, an appeal raised the money by March 2009, and all was well again.

Far from being a separate kingdom, Lundy is part of Torridge district of Devon and the parliamentary constituency for Torridge and West Devon, and the pirates have long since gone.

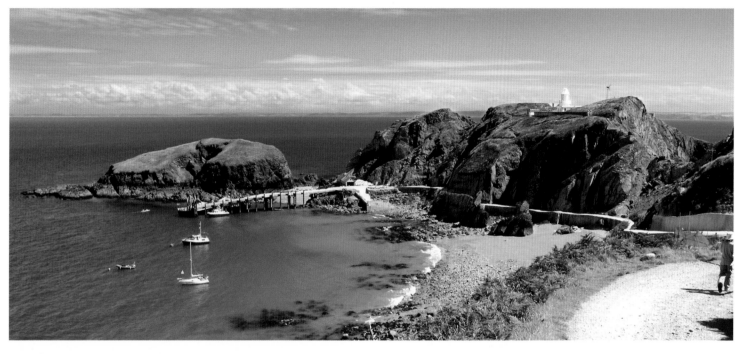

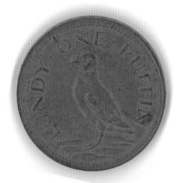

Above: **The only beach on Lundy contains the landing jetties and a road leads from there to the village.** Landmark Trust

Above right: **The Lundy Puffin coin which saw island owner Martin Harman fined by the House of Lords.** Robin Jones Collection

Below: **Because of the decline in population, the GPO ended its presence on Lundy at the end of 1927, but Martin Harman responded by issuing his own set of stamps, to cover the cost of sending letters to the mainland. The practice still continues today, while many of the early issues have become prized collectors' items.** Landmark Trust

Below: **A puffin on Lundy.** Landmark Trust

Below right: **The unique Lundy cabbage.** Landmark Trust

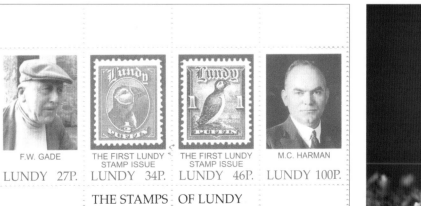

F.W. GADE
THE FIRST LUNDY STAMP ISSUE
THE FIRST LUNDY STAMP ISSUE
M.C. HARMAN

LUNDY 27P. LUNDY 34P. LUNDY 46P. LUNDY 100P.

THE STAMPS OF LUNDY
75 YEARS 1929-2004

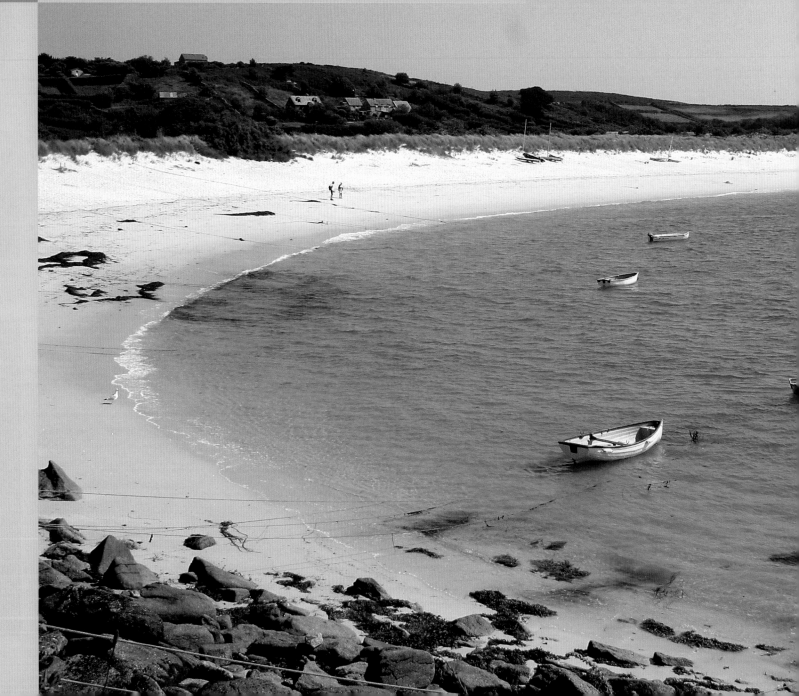

St Martin's is famous for white sand
beaches that never become packed.
Tim Saunders

The lost land of Lyonesse, a mythical kingdom to the west of Land's End, has inspired poets, painters and dreamers for centuries. According to legend, Lyonesse consisted of the City of Lyons, several towns and 140 churches which came to grief in a single night.

Following the death of King Arthur at the hands of the traitorous Mordred, his supporters fled the excesses of the victorious rebel forces. Merlin the magician raised an earthquake and tidal wave which engulfed Lyonesse, drowning Mordred's forces and allowing Arthur's followers to reach the safety of high ground beyond, in the form of the Isles of Scilly. Of the lost land only the islands and the rocky reef known as the Seven Stones midway between them and the mainland, remain. For centuries the pealing of church bells from the drowned settlements could be heard from the deeps, and there are accounts of fishermen finding fragments of doors and windows in their nets.

Other accounts say that Lyonesse disappeared long after Arthur's time in the great storm of 11 November 1099 which devastated large parts of the English coast elsewhere.

Versions of the deluge story hold that only one person survived, a man named Trevelyan, who escaped the inrushing waves on horseback and reached the safety of dry land, his survival remembered in Padstow's 'Obby 'Oss rituals held every 1 May.

Sceptics point to the possible confusion between southwest England and Celtic Brittany, which also has a Cornouaille (Cornwall) and a sister region of Leon (Lyonesse), and the artistic embellishment of scant anecdotal 'evidence' by much later writers such as Tennyson. Although it's unlikely that there has been dry land between the Scillies and the mainland in historical times, Cornwall was once larger than today, sea levels were lower and, even in recent times, parts of the region have been prone to earth tremors. Geologists also believe that in Roman times many of the present-day isles formed a single island known as Scillonia Insula or Ennor, which split into islands when the central plain was inundated around the fifth century.

Low tide at Scilly reveals not only enormous expanses of sand that were probably once dry land, but ancient stone walls, and at such times it is possible to cross on foot between some islands. Remains of a prehistoric farm have been found on the tiny island of Nornour, which is now much too small for agriculture.

Yet while the old legends of Lyonesse are rolled out once more, visitors to the isles, a designated Area of Outstanding Natural Beauty, are left asking the question – why bother with romance and legend, when reality is better than both? For the sun-kissed Isles of Scilly, with their swathes of white sand and sub-tropical

temperatures, are nothing less than a true-life fairytale landscape, widely considered an earthly paradise. They are to England what Hawaii is to the United States.

Lying 28 miles to the southwest of Land's End, the Isles and the rocky islets comprise the last of a series of huge granite bosses on the south-west peninsula, beginning with Dartmoor and extending westwards via Bodmin Moor, Hensbarrow Downs, Wendron Moor and Penwith. The granite is soft and in places has been carved into spectacular shapes by erosion.

Burial chambers and a wealth of other Bronze and Iron Age remains are evidence that the Islands were inhabited long before the Romans invaded Britain. There are several theories about the derivation for the name of the islands, all of them Roman. It could be from a Roman goddess of water, Sulis, or Sulis Minerva, as

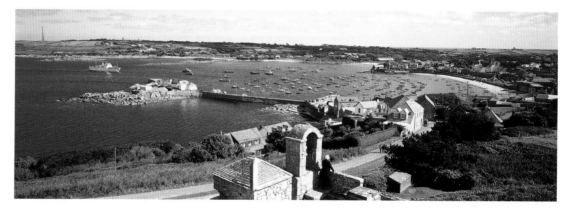

St Mary's Harbour, as seen from the battlements of Star Castle.
Star Castle Hotel

celebrated in the Roman name for Bath, Aquae Sulis; a Roman sun-god, meaning 'Sun Island', or Sillina; or Latin for 'place of' or 'island of' a water or sea deity.

There are about 140 isles, islets and clusters of rocks, but only six are inhabited today. As with so many of the other islands in this book, each of the major Scilly isles has evolved its own distinct character, while dovetailing into that of the archipelago as a whole. The largest, at 2.4 square miles, is St Mary's, which has the islands' administrative centre, Hugh Town, a population of about 1,660 and the airport. It is also the place where the passenger ship *Scillionian III* brings passengers from Penzance and is for many the gateway to the islands.

In the 19th century, most of the islanders eked out a meagre existence, living in squalor and relying on shellfish for food. In 1819, *The Times* published a report into destitution on the islands which shocked the whole of Britain. Bad harvests, the failure of the fishing industry and, worst of all, the successful campaign by the

**The Isle of Scilly archipelago.**
Isles of Scilly Tourism

**Dwarfed by bamboo in Tresco Abbey gardens.** Robin Jones

authorities against smuggling, upon which the islanders depended, were blamed for their plight. Attempts to set up a pilchard and mackerel fishery with money raised by a nationwide appeal failed, and conditions grew steadily worse.

Fast forward two centuries and Scilly is a millionaire's paradise. During the boom of the 1980s, house prices in the archipelago were in line with those of central London. Among famous residents was the late Labour Prime Minister Harold Wilson, who retired to St Mary's, and to the surprise of day visitors, could often be seen walking around the island or taking a boat trip. He is laid to rest there.

Hugh Town lies on a narrow isthmus, with Porth Cressa Beach on one side and Town Beach and harbour on the other. It is from here that launches take visitors to the other islands and out to sea. The main sea link between the archipelago and the mainland runs to and from Hugh Town. The Isles of Scilly Steamship Company provides a passenger and cargo service from Penzance: *Scillonian III* is the passenger ferry and *Gry Maritha* the cargo ship.

The islands also have a variety of regular air links. Helicopter services, operated by British International Helicopters, from Penzance Heliport to St Mary's Airport just outside Hugh Town and Tresco Heliport. On 16 July 1983, British Airways Helicopters' commercial Sikorsky S-61 crashed in the sea while on its way to St Mary's, with only six out of 26 people on board surviving.

Fixed-wing aircraft services operated by Isles of Scilly Skybus run from Land's End, Newquay in Cornwall and St Brieuc in France to St Mary's.

Granite Hugh Town, the islands' administrative centre, grew up under the protection of the eight-pointed stone artillery fortress Star Castle, which is now a hotel. The castle was built by Francis Godolphin MP in 1593, in the age of Francis Drake and the Spanish Armada, and formed part of the town's defences. The beams of eight lighthouses can be seen from Garrison Hill. In the mid 19th century, Hugh Town replaced the smaller settlement of Old Town as the island's capital.

On the far side of the island lies Porth Hellick, with its memorial to Sir Cloudesley Shovell, commander-in-chief of the Royal Navy. The fleet was returning to England following the Battle of Toulon in France in 1707, when Cloudesley Shovell's flagship, HMS *Association*, and several others struck rocks near Scilly and sank within minutes. He died along with 1,400 other sailors. One local story relates that Shovell was still alive when he reached the shore at Porthellick (or Porth Hellick) Cove, but was murdered by

a woman for his emerald ring. She reportedly made a deathbed confession.

The loss of a large part of the fleet was the last in a series of maritime disasters and led to Parliament offering a prize of £20,000, a vast fortune in the 18th century, for anyone who could find a method to determine longitude within half a degree, thus making it possible to plot an accurate position at sea. The answer was finally found when an accurate marine chronometer was produced and the prize awarded to John Harrison in 1759, more than 50 years after the disaster.

The second largest island is Tresco, at just over 1.1 square miles, with a population of 180 and the village of New Grimsby at its heart. An island of dramatic contrasts, the northern half, open to the Atlantic gales, is wild and rugged, while the sheltered southern part contains the magnificent subtropical Tresco Abbey gardens, one of the real horticultural wonders of the British Isles. Part of Tresco's charm is the absence of traffic; the only way to get around is on foot or by a tractor and trailer which collects passengers from the heliport and landing stage.

In 1834, the Duchy of Cornwall, which still owns the islands, apart from Hugh Town, leased Tresco to the Dorrien Smith family. The first of them, Augustus Smith, became Lord Proprietor of the islands and carried out a series of social and economic innovations which were regarded as both beneficial and controversial. He had Tresco Abbey built on the site of a 12th-century Benedictine priory and imported plants from as far away as New Zealand; the gardens are home to many species that grow nowhere else in the open in the northern hemisphere. The Tresco gardens flourish because the Gulf Stream, which gives Britain its maritime climate and holds arctic temperatures at bay, surrounds the islands. Scilly has a near-Mediterranean climate in winter, allowing tropical plants to thrive. January nights are as warm as those in April in central England, There are also two freshwater lakes, Great Pool and Abbey Pool, and a heliport.

A significant landmark is Cromwell's Castle which controlled the narrow channel between Tresco and Bryher. It was built after the islands, a Royalist stronghold in the English Civil War, surrendered in 1651.The conflict marked the start of the Three Hundred and Thirty-Five Years War between the Isles of Scilly and The Netherlands – which was not settled until 1986. The Dutch navy supported Cromwell, and Royalist ships that had retreated to Scilly inflicted heavy losses on the Dutch fleet. On 30 March 1651, Admiral Maarten Harpertszoon Tromp arrived demanding reparation from the Royalists, and when it was not forthcoming, he declared war on the islands. In 1985, Roy Duncan, chairman of

the Isles of Scilly Council, invited Dutch Ambassador Jonkheer Rein Huydecoper to visit Scilly to sign a formal peace treaty. The historic signing took place on 17 April 1986.

Near Cromwell's Castle are the ruins of the so-called King Charles' Castle, which actually dates from a century before the English Civil War.

Glorious white-sand beaches are the defining characteristic of the third-biggest island, St Martins, which, at just under a square mile in size, has a population of about 140 with Higher Town as its principal settlement, the other two being Lower Town and Middle Town. It boasts two churches, St Martin's On The Isle hotel and The Seven Stones pub which recalls the reef and its lightship. A large red-and-white granite circular daymark, built in 1683, is the earliest surviving dated example of a beacon in Britain.

At low tide, St Martins is linked to White Island by a natural causeway close to where seaweed was once burned to produce alkali used in the manufacture of soap and glass, once a sizeable local industry. The Nance family introduced the kelp industry to Scilly around 1685. Here, as in many coastal communities around Britain, seaweed was burnt to obtain potash used in glass making. The Scillies kelp trade continued to about 1835.

The fourth largest island, St Agnes, along with its sister island Gugh to which it is joined by a sand bar at low tide, is just over half a square mile in size and has about 70 residents.

For me, the overriding aspect of this patchwork quilt of fields and heather moorland dominated by its lighthouse of 1680 (the second built in Cornwall) is its tranquillity, possibly arising from it being the most detached of the populated islands.

Other landmarks include the Old Man of Gugh, a standing stone, and the Troy Town Maze, believed to be of medieval origin. There is also the Turk's Head pub, a post office and general store.

The smallest of the inhabited islands, and the fifth biggest overall at half a square mile, is Bryher, Cornish for 'place of hills', which also offers a sharp contrast in landscapes from its gale-lashed western side (Hell Bay justifies its name) and its placid eastern shore facing Tresco. Its Anglican Church of All Saints is the most westerly in the provinces of Canterbury and York. The island also has a hotel, bars, a café, a safe anchorage for yachts and a population of 92.

Sixth in size is Samson, the largest of those islands now uninhabited; an eerie, barren, windswept place possessing a unique air of ancient mystery and intrigue. The dazzling sunsets behind Samson's trademark twin peaks are a magnet for photographers because of the brilliant hues in the archipelago's crystal-clear atmosphere.

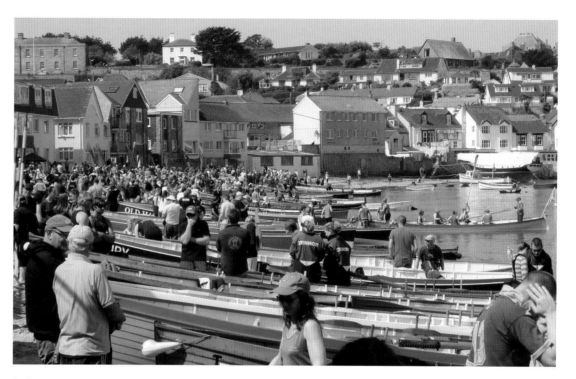

**A pilot gig racing event gets underway at Hugh Town.** Jeremy Pearson

**Vintage coaches run by Vic's Buses in service on St Mary's.** David M Stacey

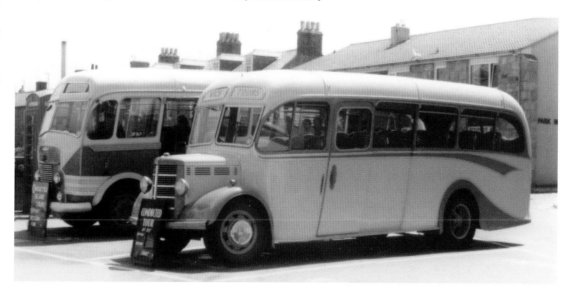

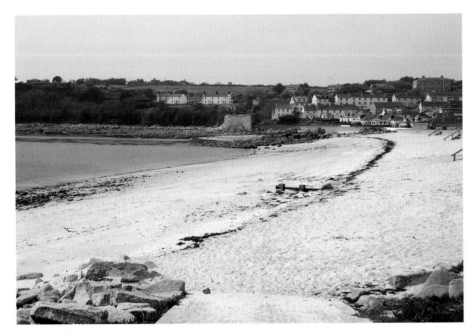

**Hugh Town's second coastline: the beach on the other side of the isthmus from the harbour.** James Stringer

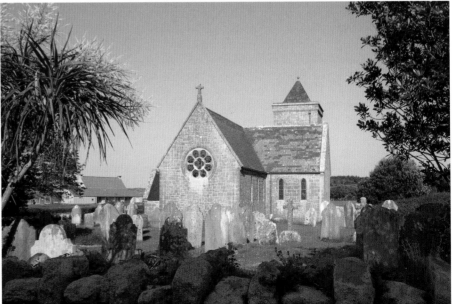

**Tresco Abbey Gardens takes Scilly into sub-tropical realms.** Robin Jones

**Cromwell's Castle, with Bryher in the background.** James Stringer

**Tresco's church of St Nicholas dates from 1877.** Tresco Estate

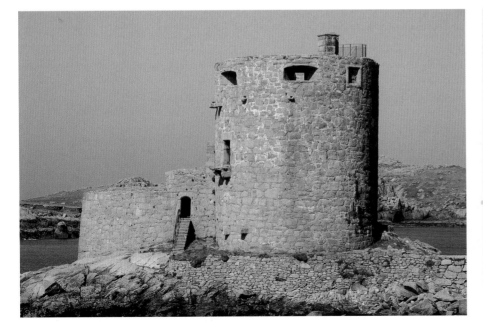

Samson, which had a population of about 50 in the 18th century, was said to be so out of touch that it was the last place in England to celebrate the 'old style' Christmas on 6 January, ignoring the calendar changes of 1752.

While larger islands just about survived the decades of grinding Victorian poverty, smaller communities went under. One legend about the depopulation of Samson relates that a French privateer drifted past the island and was boarded by 19 men and youths who captured the crew and took the ship into St Mary's harbour. The Samson men were ordered to take their prize and prisoners to the naval dockyards at Devonport, but when the ship was wrecked off Wolf Rock and sunk with the loss of all hands the women and children had no other course of action but to leave Samson.

Augustus Smith, nicknamed 'the Governor', found the poverty on Samson to be particularly abhorrent, and encouraged the inhabitants to move to St Mary's where better job prospects and a school were available. Indeed, he introduced the first compulsory schools in Britain on the more populated islands.

When Smith controversially ordered the final evacuation of Samson in 1855 only three hovels were still inhabited. It may have been a genuine humanitarian gesture rather than the autocratic 'Highland clearances'-style whim of a dictatorial local squire. For a short time it became a deer park. The ruined cottages later inspired the popular Victorian writer Sir Walter Besant's novel *Armorel of Lyonesse*. Besant's imagination worked wonders for tourism on the islands and his novel helped bring in much-needed revenue.

Smith's successor, his nephew Lieutenant T. Algernon Smith-Dorrien Smith, revolutionised the Scilly economy by establishing the flower industry, which began in 1879 when an inventive St Mary's farmer sent a trial consignment of wild narcissi to Covent Garden market – with instant success.

The much warmer temperatures allow an earlier growing season, with cut flowers carried to London from Penzance by train. Within a decade, nearly 200 tons of cut flowers were being shipped annually, and many island farmers never looked back. Along with a thriving shipbuilding business the impoverished island community became a thriving one, and today it has most of the facilities you would expect of a mainland town, including schools, shops, and sports facilities, including football played in the winter months (the world's smallest league). In the 1920s, the Lyonesse Inter-Island Cup took place between teams representing the five main islands, but only two clubs now remain, Garrison Gunners and Woolpack Wanderers, which share the same ground, Garrison Field on St Mary's – and play each other 17 times on Sundays between November and March to decide the championship.

The average age of both teams is said to be in the mid-to-late thirties. Because there is no sixth-form college on the islands, teenagers who might be interested in playing for the teams are away studying for their A-levels on the mainland. In addition, many younger people cannot afford the price of a house and are forced to leave the islands.

Football may be Britain's national sport but gig racing comes first and foremost in Scilly. Gigs are 32ft traditional wooden rowing boats, with six single-oar rowing positions and a cox. Drawing on the islands' great maritime tradition, they date from the 18th century when ships passing the treacherous coasts of Scilly and Cornwall needed a pilot to help them navigate a safe passage through the difficult waters. Gigs were the perfect craft to negotiate the numerous small islands and rocks and became a speciality of the islands.

Gigs would carry the pilot to the ship, where he would board and offer his knowledge of local sea conditions to the captain. The rewards for pilots giving assistance to ships in danger could be high and gigs from several islands would race to get to vessels in the area; first there won the pilotage contract. St Agnes alone had four pilots.

Today throughout Cornwall and Scilly gig races are held as sporting events. The islanders race against each other every week, the women on Wednesday evenings, and the men on Fridays. Since 1990, the World Gig Racing Championship, an increasingly-popular event, is held on Scilly each year, with teams from across the globe competing alongside locals.

Because of their unique position in the Gulf Stream, the islands are famous for birdlife, attracting species which make landfall in the archipelago after flying long distances from America. The islands of Annet and Samson have large tern populations, and Atlantic grey seals abound. All the uninhabited islands, islets and rocks are managed by the Isles of Scilly Wildlife Trust, which leases them from the Duchy of Cornwall for the rent of one daffodil a year. The isles are the only British habitat of the lesser white-toothed shrew.

A true Scillionian, as the islanders have come to be known, is someone who is born there. Sadly, they appear to be a threatened species, with more mainlanders wanting – and able – to buy homes on the islands, gradually pushing up the price and pushing out the indigenous population. In July 2009, the National Housing Federation named the Isles of Scilly as the least affordable rural area in England. Such is the price of prosperity.

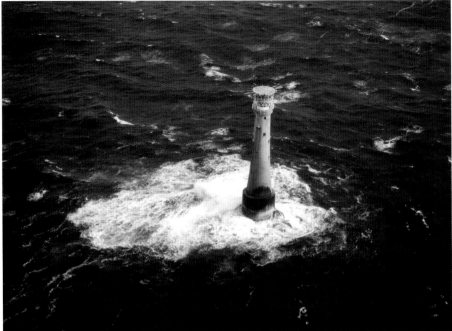

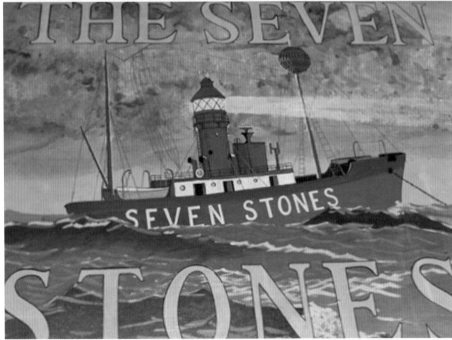

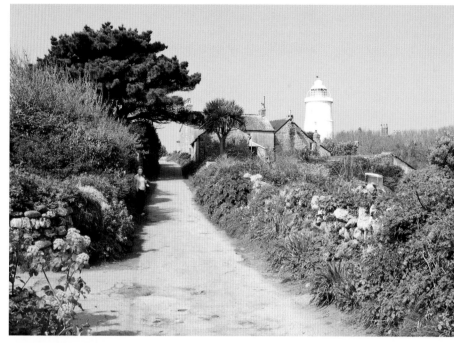

Opposite page:

Top left: **Evoking the days of sail: sunset over Samson.** Stuart Pratt

Bottom left: **Berthed on Bryher.** John Wesley Barker

Top right: **Bishop Rock lighthouse, the most westerly in the UK, is situated four miles off St Agnes. It stands on a rock ledge which rises from a depth of 146ft and is exposed to the full force of the Atlantic breakers, making it one of the most hazardous and difficult sites for the building of a lighthouse. It was washed away in 1850 shortly before completion, and the light was first displayed in its replacement on 1 September 1858. It became automatic in 1991.** Trinity House

Bottom right: **The Seven Stones pub on St Martins is named after the reef between the islands and Cornwall.** Robin Jones

This page:

Above: **Troy Town Maze on St Agnes.** James Stringer

Above right: **St Agnes: haven of tranquillity.** Murray Nurse

Right: **An early postcard view of granite Pulpit Rock on St Mary's.** Robin Jones Collection

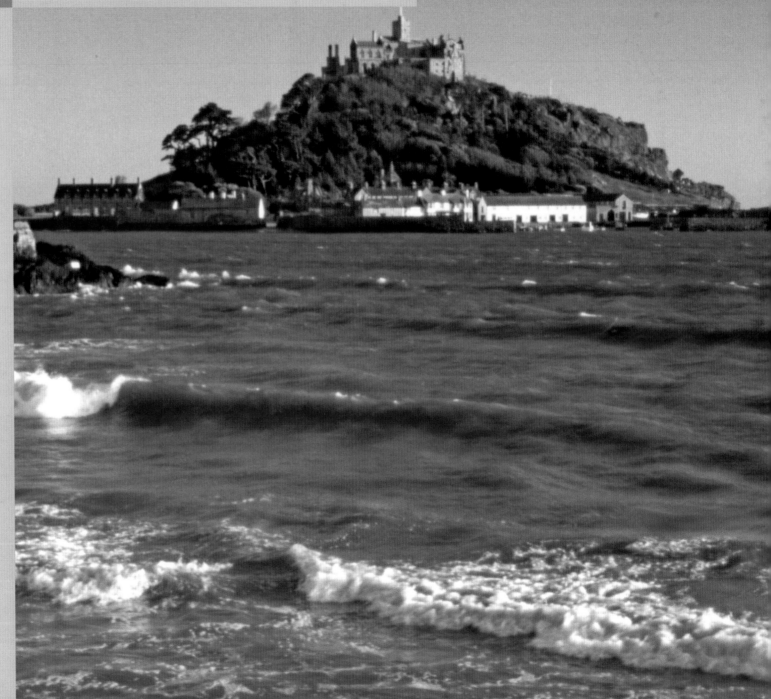

# 6  St Michael's Mount

**St Michael's Mount at high water.**
Robin Jones

Bearing in mind the instinct of man to fortify islands, it is inevitable that at least one of those around our coasts will boast a fairytale castle. And here we have it, built on the most romantic island in England. St Michael's Mount has been an inspiration for dreamers, mystics and visionaries as long as mankind has been around.

The granite and slate outcrop with its wooded slopes, little harbour and village at its foot and castle at its summit, connected to the mainland at low tide by a man-made granite causeway, is the centrepiece of one of the most striking seascapes in the British Isles, to be enjoyed by those who travel the last few miles of the Paddington-Penzance main railway line.

Not only is the island one of Britain's most popular coastal tourist attractions, but it is also a meeting and mingling point of myth, romance, legend and historical fact. Some historians believe that the island was Ictis, the place where the great seafarers of the ancient world, the Phoenicians, brought tin from the Iron Age Cornish mines. It's thought that the ancient Greek geographer Pytheas may have visited the island in the fourth century BC and called it Mictis.

Like Scilly, the island is also part and parcel of the Lyonesse legend: its Cornish name Karrek Loos y'n Koos means 'hoar rock in the wood', indicating that it once lay inland and was surrounded by trees – and yes, the stumps of a prehistoric forest can sometimes be seen at low tide. The chronicler John of Worcester wrote that the surrounding land was lost to the sea in a great storm of November 1099, while the Anglo-Saxon chronicle gives the date as November 1199. Neither of these dates fits with the fact that the stumps have been carbon dated to 1700 BC, before recorded history in these parts.

The mount's association with the Archangel Michael began in AD 495 when he appeared to a group of local fisherman. The archangel fought a great battle with the devil in the vicinity, the latter hurling a huge boulder at his opponent. The rock landed nearby and gave the town of Helston (Hell Stone) its name.

Mont St Michel on the Normandy coast is a mirror image of St Michael's Mount, a fortified isle linked to the coast by a tidal causeway. A group of monks from the French mount was given its Cornish counterpart in the 11th century and built a Benedictine priory on its summit. Accordingly, centuries before Cornwall became Britain's favourite summer holiday destination, the Mount attracted pilgrims. A tiny islet on the side of the causeway, Chapel Rock, was the site of a medieval chapel.

Over the centuries the natural fortress of St Michael's Mount saw much strife. In 1193 it was captured by Henry de la Pomeray for the Earl of Cornwall, later King John, after his soldiers arrived disguised as pilgrims; in 1473 it withstood a 23-week siege by Edward IV's army, and in 1497 was occupied by pretender to the throne Perkin Warbeck, who left his wife there for her safety.

The religious house lasted until the dissolution of the monasteries by Henry VIII. The remains of the monastery were later rebuilt into a castle. The island's governor, Humphrey Arundell, led the Cornish Prayer Book Rebellion of 1549, and in 1588 the first beacon to warn of the coming Spanish Armada was lit there. During the English Civil War, it was held by Sir Arthur Basset for the king until July 1646.

The Mount was sold in 1659 to Colonel John St Aubyn, who made the castle his family's home, and whose descendant, Lord St Levan, continues to be the island's 'lord', although his nephew James St Aubyn took over its management in 2004. The family lived in the Victorian wing of the castle built between 1873–78.

A village comprising a handful of fishermen's and monastic cottages grew up on the northern shore of the island. Harbour improvements in 1727 saw St Michael's Mount thrive as a seaport, and by 1811 there were 53 houses and four streets, with a population of about 300. It was served by three schools, a Wesleyan chapel and three public houses, mostly used by visiting seamen. However, the port was eclipsed by major improvements to Penzance harbour and the coming of the railway to the town in 1852, and many of its buildings were subsequently demolished.

In the care of the National Trust since 1954, St Michael's Mount is unusual in being a civil parish in its own right, rather than part of a mainland parish as is the case with most of Britain's smaller offshore islands. There is no parish council, but an annual meeting of all electors.

Yet what is a fairytale castle without a real-life secret? St Michael's Mount is no exception. Its secret is one which most visitors walk past without realising its existence and are astonished should they stumble across it. For the island has a working railway of its own, which has run almost every day since it was built in 1901.

The 2ft 5½in gauge line is an eighth of a mile long, has run at speeds of 40mph – and boasts a 1-in-1.9 gradient as it ascends 174ft from bottom to top, running partly through a tunnel hewn out of solid rock by Cornish miners. This incline railway ferries supplies from the quayside to the kitchen pantry in the heart of the castle on a daily basis – and has done so for the past century.

The only visible clue to the existence of the railway is the short length of rail laid tramway-style on the quayside beyond a set of wooden double doors between the harbour-side cottages that lead to its base station, the 'tramyard'. The line has a single item of rolling stock, a wagon which is hauled by a cable connected to an electric-operated winding drum at the summit station in the castle. Prior to upgrading in 1988, there had been several accidents on the railway, some of which led to the wagon overshooting the buffers, smashing through the quayside wall and ending up in the harbour.

I inspected the railway in 1999 and, while making the journey back to the mainland in the ferry, a set of black triangles was spotted moving at water level towards the open sea. Soon, a school of dolphins surrounded the boat, performing acrobatics in twos and threes for our pleasure. Island staff on board said that it was the finest display they had seen for years. Was it a case that after seeing architectural and technological excellence at close hand, Mother Nature wanted to show us that she could so easily trounce the lot? A magical island indeed.

# 7    Looe Island

**Looe Island, as seen at high tide from Hannafore Point.** Robin Jones

Opposite page top: **Looe Island House and cliffs.** Jon Ross

Many people wonder what it would be like to quit the pressures of the modern world and go and live on an island of your own. Few, however, do more than simply dream. Among the exceptions were sisters Babs and Evelyn Atkins, who in 1965 bought 22½-acre St George's or Looe Island, off Hannafore Point to the south of Looe in Cornwall.

It is an island steeped in mystery and legend, and remains unspoiled to this day. Legend has it that Joseph of Arimathea landed here with the child Christ, a story also related in Glastonbury. Some speculate that Joseph was a tin merchant, and therefore had good reason to be in Cornwall two millennia ago.

Evelyn was working as a teacher in Looe and could spend only the weekends and holidays on the island, but Babs lived there permanently. There was no telephone, and the only means of communicating with the shore was by flag or hand signal. Two books documenting their life on Looe Island were written by Evelyn, *We Bought an Island* and its sequel *Tales From Our Cornish Island*.

At times it was a paradise on earth, at others it was a life of hardship. Summer days were a delight, but while winters are mild when compared with most of the rest of Britain, with frosts and snow a rarity, and daffodils blooming in December, the island is lashed by storms, with spray sometimes going right over its summit. In stormy seasons, the boat which was the only means of communication with the outside world, including the supply of essential provisions, cannot approach Looe Island for days or even weeks at a time.

The island is normally accessible only by boat, but at exceptionally low tides, on perhaps just one or two days a year, it is possible to make a quick journey by foot over the rocky sea floor, preferably with expert advice.

Evelyn died in 1997 at the age of 87, but Babs continued to live on the island until her death in 2004, aged 86. She bequeathed the island to the Cornwall Wildlife Trust which has maintained it as a nature reserve so that others can enjoy it in perpetuity. In the summer, volunteer working parties live in a self-catering chalet, Jetty Cottage, on the island and undertake restoration and maintenance projects.

Landing fees from summer day visitors are ploughed back into maintaining the island's facilities and doing as much as possible to keep it in the way that nature intended.

The island has two beaches which offer safe bathing, a natural rock swimming pool, caves and walks through the woodland. A marked trail takes visitors to the main points of interest including the chapel. There are no shops or even roads on the island, which is a mile in circumference.

With its variety of habitats including woodland, maritime grassland, sand, shingle and rocky reefs, Looe Island is a sanctuary for sea and woodland birds, as well as a marine nature reserve teeming with life. Seals can be spotted swimming in the waters around its rocky coves.

The island, 150ft high at its central point, was settled by Benedictine monks who built a chapel dedicated to St Michael in 1139, the few remaining stones were excavated by Channel 4's Time Team in 2008 which also unearthed a hoard of Roman coins in one of the trenches.

The island later passed into the ownership of Glastonbury Abbey, which may have bought it to cash in on the medieval holiday trade; that is those making a pilgrimage to sites associated with St Michael. When Henry VIII dissolved the monasteries, the island passed to the Crown. As with many places along the coast of the southwest, it was later a haunt of smugglers.

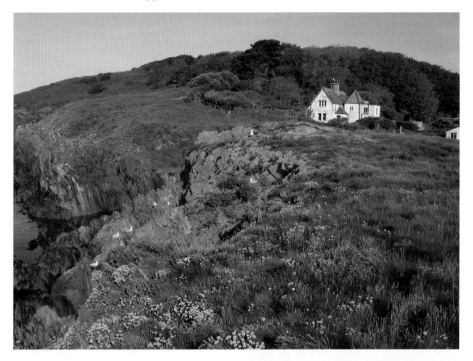

Above: **A Looe Island stamp.** Robin Jones Collection

Right: **An old Looe story from the days of smuggling tells how the local chief smuggler's sister, Bess, in tears told customs men that her rowing boat was adrift at sea. While they were went in search of it, the real smugglers' boat came in to land unnoticed.** Robin Jones Collection

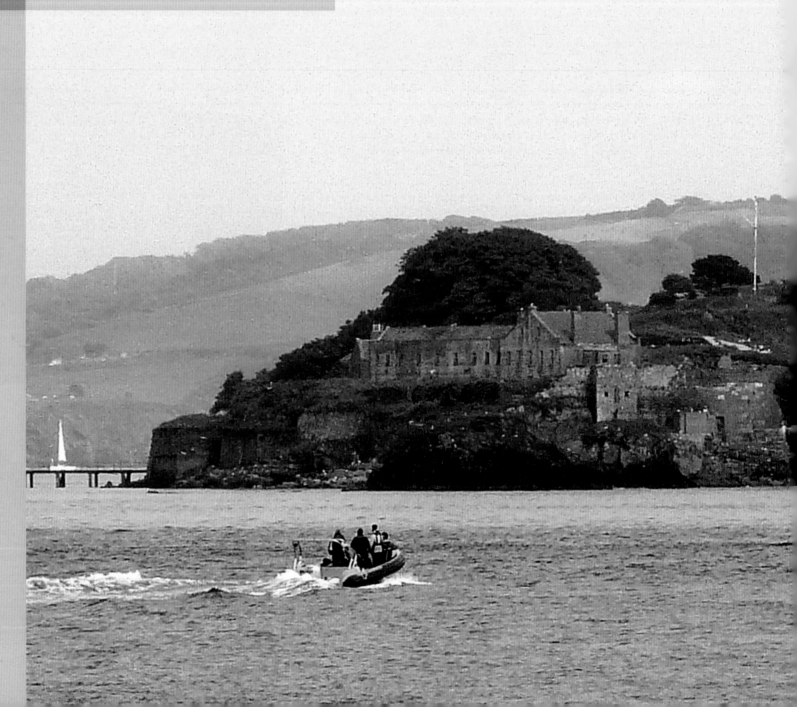

Drake's Island: centuries of military
history now stand deserted.
James R. Baines

One of Britain's most stirring seafront views is that from Plymouth Hoe. Laid out is a sweeping panorama from the Devon coast out across Plymouth Sound to the thin black line on the horizon that is the breakwater, over the mouth of the River Tamar, or The Hamoaze as it is known for its final stretch, and then westwards to the wooded cliffs of Cornwall.

Right in the middle of this breathtaking view – and therefore missed by many as just another part of its 'furniture' – is a small rocky island with some dauntingly grim barrack-like buildings. It is so easy not to give it a second glance or dismiss it as just another part of the city's once-bristling naval defences. Yet diminutive Drake's Island is no less than a six-and-a-half-acre miniature of Plymouth's enormous seafaring heritage: it also commands a place in Britain's maritime history.

Formed mainly of volcanic ash and reaching a height of 96ft at the centre, the island commands its own exceptional and strategic views across the Sound and lying off its western shore is Little Drake's Island which, except at high tide, can be reached on foot. Overlooking the main deepwater channel through which all large ships must pass to reach Devonport's dockyards, the island has until recent times been an essential part of Plymouth's defences.

It was first recorded in 1135 as St Michael's, named after the chapel erected on it, inviting comparisons with St Michael's Mount. The chapel was later rededicated to St Nicholas and the island adopted the same name. In the Middle Ages the island was used to breed rabbits for food, being isolated from the mainland and away from predators.

From 1549, in parallel with Britain's growing importance as a naval power, barracks for 300 men were built as part of the island's defences against the French and Spanish. There was a little chapel, sadly later demolished. The oldest surviving building is said to be an oubliette, a doorless dungeon in which prisoners were supposedly abandoned to die, with just one window and access through a hatch in the roof. This grim reminder of a barbaric past is to be found on the north shore.

Afterwards, the island remained the focal point of the defence of the three towns of Devonport, Plymouth and Sutton that became modern Plymouth. It was from here that Drake sailed in 1577, returning three years later after circumnavigating the world, and in 1583 he was made governor of the island. The government then took over ownership and maintenance of the island from the city fathers, and the island became known as Drake's Island.

Plymouth declared for Cromwell during the Civil War and Sir Alexander Carew became governor of Drake's Island. Suspected of treason as the Royalists besieged the city, he was executed on Tower Hill in London in 1644.

Charles II took a dim view of the city's past allegiances and for 25 years the island became a state prison for political opponents, including Colonel Robert Lilburn, one of the judges who had condemned Charles I to death, and leading citizens who had helped Plymouth withstand the siege. The king visited Drake's Island to see the incarcerated Major-General John Lambert who had vainly hoped to succeed Cromwell. He never regained his liberty, dying there in 1683.

A decision in 1691 to shift the naval dockyards from Cattewater to Devonport led to large-scale improvements to the island fortress.

By far the biggest wreck in the island's history was the 70-gun man-of-war HMS *Conqueror* which ran aground on the island in 1760 after being in service for only two years. The pilot was blamed and jailed for 18 months.

The island's defences were upgraded again after war with Revolutionary France broke out in 1793. From 1816–46, a Royal Artillery company of about 70 manned the island. Contemporary reports were highly critical of the men's living conditions.

Dramatic changes came in the 1860s, when it was recognised that the island's batteries were totally inadequate to face the firepower from Napoleon III's new class of warship.

Colossal granite casemates with iron shields designed to hold 21 12-ton guns for defending the approach to The Hamoaze were built. Five 23-ton guns were placed on the summit of the island, while interconnecting tunnels linking the casemates and batteries to ammunition stores and underground holds were expertly constructed. Drake's Island was left bristling with munitions and firepower – but as with the Flat and Steep Holm forts from the same period, the guns were never fired in anger.

New concrete gun emplacements and searchlights were installed as World War 1 broke out. In 1939, a new pier for munitions transport was constructed next to the two tiny sandy beaches along with concrete bunkers, a minefield control post for the Sound and an anti-aircraft gun. Nearly 500 soldiers manned Drake's Island as Nazi planes pounded Plymouth and its dockyards night after night. Yet despite the carnage on the mainland, the island sustained only minor damage from bombing. One person was injured and a roof was damaged.

The atomic bomb finally made the island redundant in military terms. Most World War 2 gun positions were demolished in 1956 when there were still 135 naval personnel manning it. When the government disbanded the Coast Artillery, centuries of military tradition on the island were brought to a close.

The Mayflower Trust developed the island in 1963 as an adventure centre for young people. A ferry service operated from Sutton Pool to Mount Edgcumbe allowing ordinary people to visit for the first time in centuries. On 1 May 1987, the island received its first telephone line – Plymouth 63393 – using a cable attached to the mains water pipe.

Two years later, the adventure centre closed down and the lease was handed back to the Crown, which sold it to former Plymouth Argyle FC chairman Dan McCauley for £384,000 in 1995. In 2003, the city council turned down his planning application for a hotel and leisure complex complete with helipad.

The island last made military news in 2005, when Trident Ploughshares, an anti-nuclear protest group, squatted there.

At the time of writing, Drake's Island is being reclaimed by nature. Mint and fennel run wild amidst the more common pink sea thrift and campion, while Scots pines add a shady sylvan touch to the Sound. Many of the Victorian cannon still lie in the undergrowth, too heavy to move.

# 9  Burgh Island

A sunset over former smugglers' paradise Bigbury Bay throws Burgh Island into silhouette, in a view from Bantham beach.
BIH

The fairytale castle at St Michael's Mount showed that art can add to or even enhance the beauty of nature. What medieval architecture did for the tidal island in Mount's Bay, 20th century art deco has accomplished over the border in Devon, at Burgh Island in Bigbury Bay.

Music hall singer George Chirgwin built the first hotel on the island in 1895, but his widow Rose had to sell up in 1927. Two years later, the island became a twenties version of St Tropez – a resort for the rich and famous. That year, wealthy industrialist and film producer Archibald Nettlefold built the Burgh Island Hotel, but it was less a hotel and more a luxurious and somewhat eccentric guest house where he could entertain his business associates and friends.

Its palm court roof was covered with coloured art deco glass, it had a casino and massive ballroom where London flappers danced to the top bands of the day, and a gold-tiled pool filled with goldfish and overhung with ferns. A natural sea pool called the Mermaid Pool had the gaps in the rocks infilled so it would remain full of water at low tide, the diving platform in the centre would be floodlit at night when a dance band would play on it.

Burgh Island – originally known also as St Michael's island and later Borough Island which became corrupted to Burgh, is linked to the mainland 270 yards away by a sandbar, covered at high tide. Cars and chauffeurs were left in a building on the Bigbury side so as not to interfere with the guests' privacy.

This period in the island's history is best reflected in Agatha Christie's Hercule Poirot detective story *Evil Under The Sun*, set in a very similar Devon hotel and written while she stayed there, as was *And Then There Were None*.

The Ministry of Defence took over the island in World War 2, but it did not become another Drake's Island-style fortress: instead, it was used as a recovery centre for wounded RAF personnel. Nevertheless, the top two floors of the hotel were damaged by a bomb during the conflict. It is believed that Churchill and Eisenhower met at the hotel in the build-up to D-Day, in which nearby Salcombe and Dartmouth played their part.

It reverted to a hotel after the war. In 1962 an over-ambitious scheme was devised to link it to the mainland with an aerial ropeway to carry guests across. It didn't happen and the hotel was converted to self-catering flats in 1968.

A failed attempt to turn the hotel into a timeshare complex preceded its purchase by Tony and Beatrice Porter, who restored the rundown hotel to its full art deco glory during the early nineties. Their excellent work has been carried on by the current owners Deborah Clark and Tony Orchard who continue to realise Nettlefold's vision and dreams for the unique establishment.

It was not just in the twenties and thirties that the island was associated with the rich and famous. Nettlefold's wife was a concert singer, and it attracted many showbiz personalities. In 1965, it was used as the setting for the finale of the Dave Clark Film, *Catch Us If You Can* and the 2002 TV adaptation of *Evil Under The Sun* used the island as a location.

Other famous visitors to the hotel have included the Beatles when they were playing a concert in Plymouth, Noel Coward, and Edward VIII and Mrs Simpson. Before them, the great 18th-century landscape artist J. M. W. Turner painted the island, along with the Great Mew Stone at Wembury.

One distinctive feature of the hotel over the decades is the world's only bespoke sea tractor. The original vehicle was built in 1930; a post war version based on a caterpillar track ferry was declared worn out at the end of the sixties, and a modern replacement built by Beares on Newton Abbot in 1969. Its rear wheels are 12ft in diameter and those at the front 10ft, and the tractor can carry up to 40 people and reach speeds of 4mph on firm sand. Its main purpose is to transport visitors to and from the

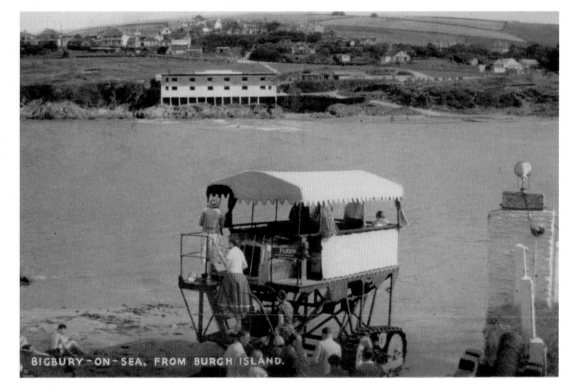

**The second sea tractor prepares to depart from the island, as depicted in this 1950s view.** Robin Jones Collection

BIGBURY - ON - SEA, FROM BURGH ISLAND.

mainland when the tide is in. The vehicle drives across the sandbar while its driver and passengers sit on an elevated platform on stilts. Power from a Fordson tractor engine is relayed to the wheels via hydraulic motors. Much anxiety was caused on 5 August 1971 when the sea tractor broke down in choppy seas. The Bantham Inshore Rescue Boat from the other side of the Avon estuary was called out to rescue the 13 people on board.

The magnificently-restored hotel, however, is not the only building of historic interest on this very unusual island. A colony of monks inhabited the island in medieval times, and the 14th-century Pilchard Inn may have started out as the guest lodgings for their monastery. The inn, which dates from 1336, has been said to be the oldest in south Devon. After the dissolution of the monastery, pilchard fishermen moved in, either adapting the old chapel on the island summit, or replacing it outright. This lookout was used to raise the alarm if shoals of pilchards were spotted.

Bigbury Bay and the island became notorious for smuggling, wrecking and piracy. The most notorious of the smugglers was Tom Crocker, who evaded capture for many years before being shot outside the inn. His ghost is said to haunt the place.

Fears of German landing forces using the island as a beachhead led to the bay's fortification with anti-tank defences as well as two concrete pillboxes with 17in thick walls and glazed gun slits, one on either side of the causeway leading to the mainland. An observation post was also established on the summit to monitor the coastline. In 2004, one of the pillboxes, converted to single-room accommodation, was sold at auction for £80,000; such were the high prices for coastal property in the South Hams at the time.

The glamorous past of the island will never be forgotten. In the hotel today, artefacts from the Jazz Age are everywhere, and where authentication has been possible, the bedrooms are named after former famous guests.

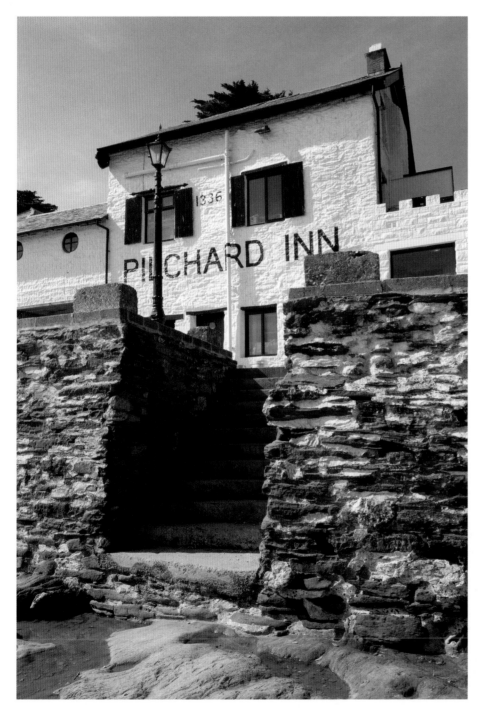

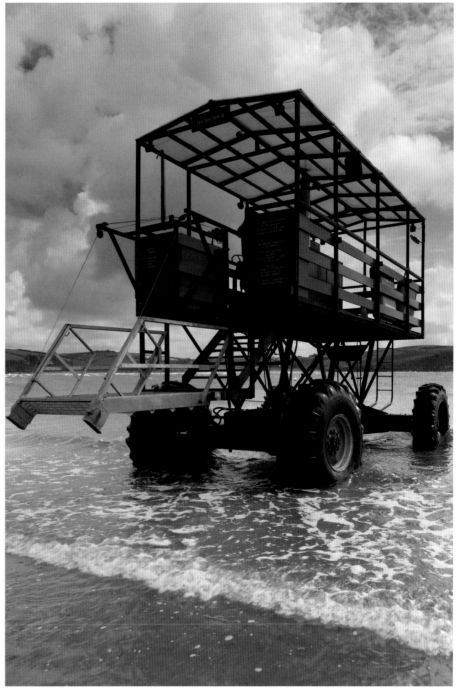

The seagull sanctuary and seal haven of Gulland Rock, which lies off Harlyn Bay, North Cornwall, and is best seen from one of the excellent boat trips run from Padstow aboard the pleasure cruiser *Jubilee Queen*. Believe it or not, a man once made serious plans to build a house and live on this wave-lashed island! Incidentally, the boat trip around Gulland Rock, which is run only in calm weather, offers unrivalled views of the coast, including a unique geyser-like wave effect at spectacular Tregudda Gorge near Trevone. Robin Jones

Many other islands in the West Country, too small to merit a separate chapter, have their own tale to tell. As we saw in Chapter 2, if you wish to visit Steep Holm, you have to catch the trip boat from Weston-super-Mare's Knightstone Quay. Historically, this is an island in itself. Weston, then a small fishing village, took off as a holiday resort in the 1820s, the new fashionable medical treatment of sea bathing attracting wealthy patrons from the spa resort of Bath. Tidal Knightstone Island, favoured by fishermen as an anchorage, and linked to the shore by a shingle path, had Weston's most prominent medicinal baths built on it in 1822. A subsequent owner, the Reverend Thomas Pruen, built a low causeway linking it to the mainland, and an open-air tidal pool. However, it really took off in 1830 when Bristol Quaker physician Dr Edward Long bought Knightstone and built a magnificent new baths building and lodging houses for patients.

As Weston mushroomed as a popular resort, the town's Pavilion Theatre was added to the island along with an Edwardian swimming baths complex, and the causeway widened so that Knightstone became freely accessible to cars. The tidal pool became popular as the Marine Lake, and remains full of water long after the tide has receded a mile or more, exposing the town's infamous mudflats.

Knightstone fell into decay and disrepair as the resort's fortunes dwindled from the 1970s onwards. Fast forward to today, however, and a very different story can be told.

For Cinderella has returned to the ball big time. On 20 July 2007, the Queen and the Duke of Edinburgh officially reopened the island following a £20 million scheme by developer Redrow to create 87 luxury apartments and two commercial units. The Queen reopened the Coronation Promenade, a walkway around the island. The following year, the island was named 'best redevelopment' project in the world at the International Property Awards in the USA for its sensitive restoration of the three Grade II listed buildings, the theatre, the Edwardian baths and Dr Fox's Bath House. It is a shining example of regeneration in the heart of what is still a busy resort and a far cry from the loneliness and solitude of the island a few decades ago.

If the concept 'desolation' could be magically transformed into reality, it would surely take the form of Stert Flats. Rarely on the English coast is there a spot more isolated, more extreme in loneliness, less tainted by the tourist, than the vast expanse of mudflats where the River Parrett estuary meets the Bristol Channel. Bleak is not the word: the silence is shattered only by the cries of birds. Stert, or Steart, takes its name from the old English word for promontory or headland. Its dreariness illustrates nature's cunning deceptiveness. These 'barren' wastes are teeming with an unrivalled abundance of life and are one of the richest habitats one might imagine. Millions of invertebrates and microscopic organisms thrive in every cubic yard of mud, each feeding on tide-born decaying matter, rotting salt marsh plants and

Knightstone Island in Weston-super-Mare and the Marine Lake. Robin Jones

dead seaweed. Creatures like the lugworm and ragworm digest large amounts of mud for food particles. In turn, huge flocks of birds base themselves on the flats for the rich pickings at low tide.

In 1954, Bridgwater Bay Nature Reserve was established to protect the moulting grounds of shelduck and 190 other species including white-fronted geese, curlews, oystercatchers and wigeon which winter there. Stert Island, which lies directly opposite Burnham-on-Sea, formed an extension to Stert Point until the two were split apart by wave action.

The island is fringed with low sand dunes which look inviting from across the Parrett estuary, but landing without a permit is prohibited by custodian English Nature. Nonetheless, an annual charity swim from Burnham to the island and back attracts scores of participants.

A local story tells that Stert Island was once inhabited but was home to a house of ill repute for the benefit of sailors aboard ships heading into the port of Bridgwater.

National headlines were made on 12 April 2008 when Royal Navy explosives experts detonated a 10ft long World War 2

**Winstanley's first Eddystone Lighthouse.**
Trinity House

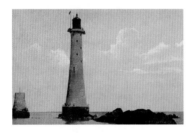

**The current Eddystone lighthouse a century ago, well before the modern helipad was fitted.** Robin Jones Collection

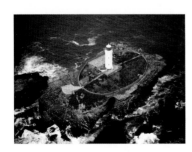

**Godrevy Island and its lighthouse.**
Robin Jones

German mine uncovered by the ever-shifting sands. The explosion sent a massive plume of water skywards and sent seagulls scattering into the air.

A dramatic contrast to Stert Island is presented by Gulland Rock, a small island off the North Cornwall coast near Padstow, a seagull sanctuary and home to Atlantic grey seals. In 1891, a local man decided to live on the surf-lashed rock, and commissioned workmen to level off a section for a house, which was to be built in wooden sections assembled on site. Many people pleaded with him to abandon the hare-brained scheme, which he eventually did. His house was instead erected in Trevone village, where it was consecrated and became a mission church, until a stone building later replaced it.

At Newquay, another island was not only deemed perfectly habitable, but a luxury house, now offering bed-and-breakfast, was built on it. The Island at Towan Beach, previously known as Jago's Island, is linked to the mainland, of which it was clearly once part, by a 70ft high suspension bridge built across a short chasm by William Billings in 1901, supposedly as a copy of Brunel's Clifton Suspension Bridge.

Island House has in recent years been home to the 4th Viscount Long, who had been a Tory whip in the Lords throughout the Thatcher and Major years, and his wife Lady Helen. Early in 2010, they placed in on the market for £1.25 million.

Decades ago, it was owned by spark plug inventor Sir Oliver Joseph Lodge, whose friend Sir Arthur Conan-Doyle, creator of Sherlock Holmes, is said to have stayed there. At other times it has been used as a potato farm, a chicken run, a Sunday School classroom, an art gallery, a guest house, and a tea room.

Another writer, Virgina Woolf, may have been inspired by Godrevy Island in St Ives Bay to write *To The Lighthouse*, although the lighthouse in the novel is placed elsewhere.

As a response to the loss of the SS *Nile* with all hands in 1854, 86ft high Godrevy lighthouse was built in 1858/9 on the uninhabited island to warn shipping of the danger of the Stones, a mile-long submerged reef. Originally manned by three men, it was automated as early as 1939 and is now monitored from Trinity House Operations Control Centre at Harwich in Essex.

Four miles south west of Land's End lies Wolf Rock, named after the distinctive howl heard when wind blows through the rock fissures. Henry Smith erected a daymark on this shipping hazard in 1795, but it was soon washed away by the Atlantic breakers. In the late 1830s, an iron beacon was positioned there. A granite tower and landing stage were built 1861–69 and entered service a year later. The lighthouse has generated its own electricity since 1955.

Standing 116ft tall it was the first rock lighthouse in the world to have a helideck placed on top. It was automated in 1988.

Nearer to Land's End, just one-and-a-quarter miles off the coast, is Longships lighthouse, originally built in 1795 but enlarged in 1873 because the first tower was just 40ft tall and often obscured by raging seas. It was last manned in 1988.

Nine miles south of Plymouth lie the treacherous Eddystone Rocks inhabited by a succession of lighthouse keepers until automation. The first Eddystone Lighthouse was built by Henry Winstanley 1696–8, during which time a French privateer took him prisoner. Louis XIV ordered his release, saying, 'France is at war with England, not with humanity'. Winstanley was upgrading the wooden structure when both he and it were washed away during the great storm of 27 November 1703. A replacement built of wood around a cone of brick and concrete designed by John Rudyard came on stream in 1709, lasting until 2 December 1755, when the lantern top caught fire and the whole structure burned down, leaving the three keepers to be rescued by boat. One, Henry Hall, died from poisoning after ingesting molten lead from the lantern roof during the fire. Dr Edmund Spry reported on this case of lead poisoning to the Royal Society, and the offending piece of lead is now in possession of the National Museums of Scotland.

The structure's replacement by civil engineer John Smeaton marked a major evolution in lighthouse building. He used hydraulic lime, a concrete that sets beneath water, dovetailed joints and marble dowels to secure the granite blocks for his 59ft tower, modelled on an oak tree, the light was first lit on 16 October 1759. Wolf Rock lighthouse was based on the design. In 1877, investigations to find out why the lighthouse shook from side to side discovered that the supporting rocks had eroded.

A replacement was ordered, but because of the success of Smeaton's design, his tower was rebuilt on Plymouth Hoe as a memorial. The foundations survive alongside Robert Stevenson's fourth tower, which began operation in 1882. A century later, the 161ft lighthouse became the first to be automated by Trinity House.

Finally, to the east of Plymouth Sound is the Great Mew Stone, a giant shark's fin-shaped lump of rock, but which, believe it or not, was once inhabited. In Victorian times, Sam Wakeham and his wife lived in a cottage there, employed by a local squire to look after the rabbit population which was bred for food. The island had a landing stage, and Sam boosted his low wage by smuggling. Important for its nesting seabirds – 'mew' means 'gull' – it is now in the care of the National Trust.

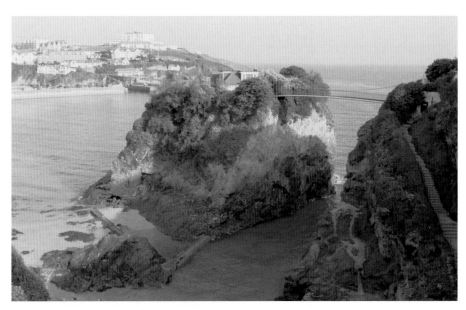

The sun dips over Stert Island, seen from the opposite side of the Parrett estuary. Robin Jones

The island at Newquay, divorced from the cliff by a chasm and reconnected by a suspension bridge. A café and then an art gallery occupied it before the present bungalow. Robin Jones

**Wolf Rock lighthouse and its helipad today.** Trinity House

**The Great Mew Stone at sunset.** Kate Jewell

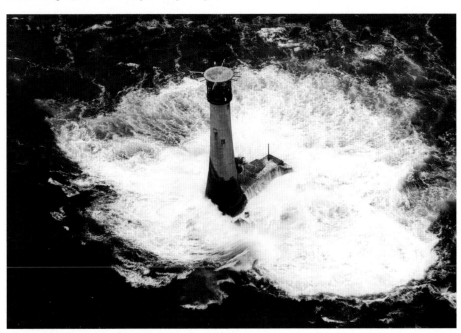

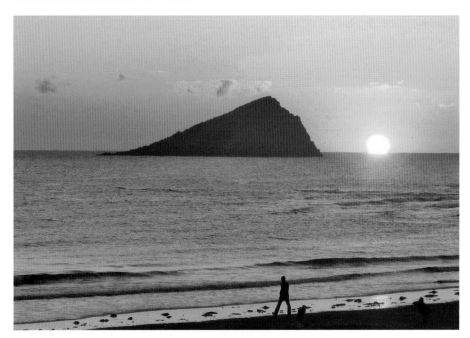

A hazy sunset throws the last rays of light of a spring day over Chesil Beach and Portland Harbour, as seen from the Heights Hotel in Portland. Robin Jones

Immortalised in literature by Thomas Hardy as the Isle of Slingers, Portland was named by him as the Gibraltar of the North – one great big lump of limestone four miles long and one-and-a half miles wide attached to the mainland by a shingle beach. Portland, unashamedly, is stone country through and through, and this is far and away its most distinctive feature.

The island – population about 13,000 – has long built its economy on Portland stone. The heart of the great mass that forms the southernmost part of Dorset and dominates the skyline has for centuries been excavated for its prized yellow-grey stone used on some of the England's greatest buildings: St Paul's Cathedral, the eastern front of Buckingham Palace and the Whitehall Cenotaph are all Portland stone. So too are the British Museum, Somerset House, the General Post Office, the Bank of England, the National Gallery and the award-winning BBC Broadcasting House in London. It's also been used in other countries on the United Nations' building in New York, Dublin's National Gallery and Belgium's Casino Kursaal.

In the 14th century Portland stone was used to build the Palace of Westminster in 1347, the Tower of London in 1349 and the first stone London Bridge in 1350. Architect Sir Christopher Wren, MP for Weymouth, used six million tons of Portland stone to rebuild London after the Great Fire of 1666. And it's the material from which all the gravestones for British servicemen killed in both world wars are made.

The Romans knew and appreciated Portland stone and used it to make coffins. The earliest known building to be constructed using the stone is Rufus Castle at Church Ope Cove, which dates from about 1080. Many of Portland's stone houses have walls up to 2 feet thick.

Portland cement is not a product of the island, but was given the name in 1824 by its inventor British mason Joseph Aspdin because, when mixed with lime and sand, its colour resembles that of Portland stone.

In 1838 it was recorded that there were about 100 quarries on the island. Indeed, it is surprising that with the amount of stone extracted from the island, it has not been levelled flat by now.

Hardy's pseudonym for the island, which features in *The Well-Beloved*, and *The Trumpet-Major*, is taken from the story that that Portlanders not only used to quarry stone but also used to throw lumps at strangers to keep them away. But don't mention the rabbits.

The Isle of Portland is physically linked to mainland Dorset only by Chesil Beach and to Weymouth by the A354 road bridge, which crosses the Fleet, the freshwater lagoon behind the great shingle ridge that empties into the expanse of Portland Harbour.

Because of its craggy slopes the island is all but inaccessible from the sea except towards the south. Portland's highest point is Verne Hill at 490ft. At its southern tip, the Bill of Portland, there are caves carved out of the rock by the force of the sea, a raised beach, the Pulpit Rock and three lighthouses, of which only one remains in use.

Portland lies at the centre of the 95-mile Jurassic Coast of East Devon and Dorset, awarded UNESCO World Heritage Site status because of its landforms and geology, and, of course, the famous white stone.

The island is divided into two areas: Underhill, which includes the main town of Fortuneswell and the villages of Castletown and Chiswell, and Tophill, which includes the settlements of Weston, Southwell, Wakeham and the Grove. Most settlements have grown up around, or because of, the giant quarries.

Portland stone has been quarried as long as history has been recorded. A series of mineral railways was built to serve the Isle and its famous quarries. The earliest was the Merchant's Railway which opened in 1826, the year after the Stockton & Darlington Railway, the world's first public steam line, started operating. It linked the quarries at the north of Tophill to the docks in Castletown.

The Weymouth & Portland Railway was built in 1865, and ran from a station in Melcombe Regis, across the Fleet and below sea level behind Chesil Beach to Victoria Square station in Chiswell. It continued in a semi-circular route over the island as the Easton & Church Hope Railway, running through Castletown and climbing the cliffs at East Weares on its way to the Easton terminus. It was to run for 100 years.

But as I said earlier, never, never mention the rabbits.

They have been regarded as bringers of bad luck on Portland as long as quarrying has been going on. Rightly or wrongly, workers would attribute landslides, rock falls and cave-ins to them. One crane operator died when his machine toppled over on ground made soft by burrows. If a rabbit was seen in a quarry, workers would down tools and go home until the area could be declared safe.

The use of the word is considered offensive to the older and more superstitious islanders, who refer to them as 'underground mutton' or 'long-eared furry things.' In October 2005, posters advertising the Wallace and Gromit film *The Curse of the Were-Rabbit* had the title changed to *Something Bunny Is Going On*.

Inhabited since the Middle Stone Age, the Romans, who introduced rabbits to Britain, named the island Vindelis.

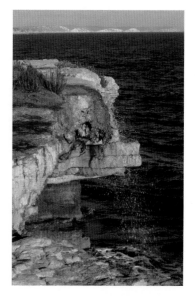

**This waterfall marks the end of Portland's only stream, which rises at Culverwell 450 yards inland.** Jim Champion

In 1539, Henry VIII ordered Portland Castle and Weymouth's now-ruined Sandsfoot Castle to be built as part of a chain of forts around the south coast to protect England from attack by France, preceding the Palmerston forts we saw on Steep and Flat Holm by more than three centuries. During World War 1 it became a seaplane station and in World War 2 it played a role in D-Day. Made from Ashlar, the finest Portland stone to be found, Portland Castle is considered the best preserved of Henry's fortresses, and is now in the care of English Heritage.

**A typical Portland stone quarry.**
Mark Wilson

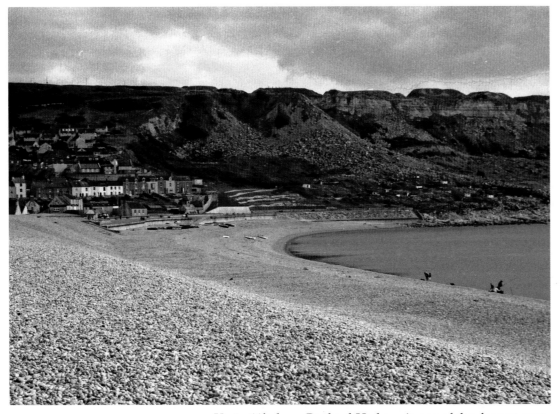

Up to 66ft deep, Portland Harbour is one of the deepest man-made havens in the world, and covers 2,125 acres. The harbour and Weymouth Bay have an unusual 'double low tide' because of the time that it takes water to pass Portland Bill. Queen Victoria's consort Prince Albert laid the first stone for the breakwaters in 1849, and Albert Edward, Prince of Wales, laid the last in 1872. Work is well underway on the Weymouth and Portland National Sailing Academy which will host the sailing events for the 2012 Olympic Games.

Convicts from a temporary jail known as the Verne Citadel were used to quarry the stone from 1848 onwards. The island still has two prisons, HMP The Verne, opened in 1949 on the site of a Victorian military barracks and a young offenders institute. Britain's only modern-day prison ship, HPP *Weare*, closed in 2005 but is still moored in the harbour. Using knotted sheets to climb down the stone wall, an inmate called John Hannan escaped from The Verne in 1955. In 2001, he was declared the longest prisoner anywhere still on the run. For him, Portland was no Alcatraz.

At the start of World War 1, HMS *Hood* was sunk in the passage between the southern breakwaters to block the entrance and defend the harbour from submarine raids and torpedo attacks.

The Royal Navy moved into Portland Harbour in 1919, establishing HMS *Serepta* as its first base there. Because of the naval vessels berthed in the harbour it became a prime Nazi target during World War 2. A heliport was added to the base in 1946 and in 1949 it was renamed HMS *Osprey*, with one of England's shortest aircraft runways, at just 751ft. The end of the Cold War preceded the closure of the naval base in 1995, and the naval air station followed four years later, but the runway remains in use for coastguard search and rescue flights.

Portland Bill is a narrow promontory forming the most southerly part of the island. The operational lighthouse was refurbished in 1996 and became computer-controlled. One of the two earlier lighthouses further inland is an important bird observatory, while the Old Higher Lighthouse offers bed and breakfast and self-catering cottages. Originally built in the 18th century and in use until 1906, its previous owners include Dr Marie Stopes, the pioneer of birth control.

The Shambles, an underwater stone feature also known as Portland Ledge, projects into the English Channel and disrupts the tidal flow, creating a tidal race to the south of the Bill, known as the Portland Race, which can reach speeds of 13ft per second at spring tides.

Like many other islands in this book, Portland has evolved its own unique life form, Portland sea lavender, which is found on the higher sea cliffs and is one of Britain's rarest plants. Chesil Beach is one of only two places in Britain which is home to the scaly cricket: it is wingless and, unlike other crickets, does not sing or hop. The limestone soil with its low nutrient levels favours smaller species of wild flowers, which in turn attract butterflies. More than half the 57 species of British butterfly are found on the island, including the very rare silver studded blue. And there are also the rabbits…

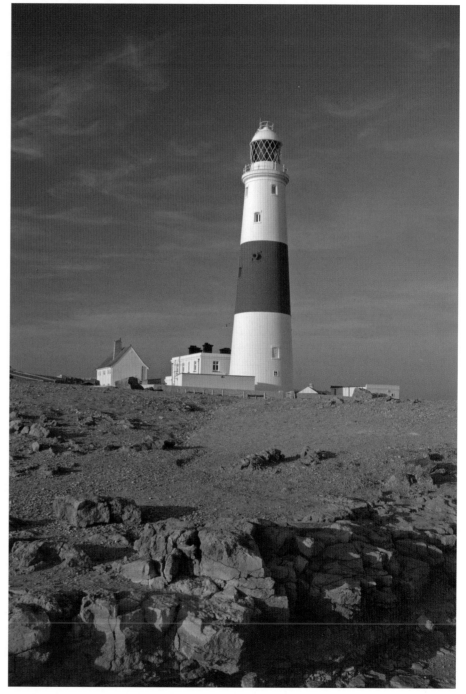

Above: **Abandoned overbridges from a long-disused mineral tramway built to carry Portland stone from Tophill to the harbour.** Robin Jones

Right: **Portland's most-photographed landmark is Portland Bill lighthouse.** Robin Jones

Below: **Portland Castle, a bastion of defence commissioned by Henry VIII.** Mark Murphy

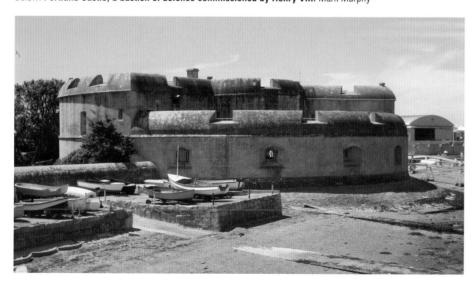

The private landing jetty on Long Island.
Robin Jones

The experiments with radio technology on Flat Holm were the start of global communications which made the world a smaller place. Another English island visited by Guglielmo Marconi also brought the world together, but in a very different way, that of social interaction among young people.

For it was on Brownsea Island in 1907 that Lieutenant-General Robert Baden-Powell, heroic defender of Mafeking during the Second Boer War and founder of the scouting movement, held his first boy scout camp. He made full use of the fact that as an island is cut off from the rest of the world, the occupants must by necessity learn to adapt.

At the time, the island was owned by Charles van Raalte who used it as a holiday home. He renovated Brownsea Castle, a former blockhouse which was one of the chain of forts across southern England built by Henry VIII in 1547, and used it to entertain celebrities, including Marconi. Van Raalte was a close friend of Baden-Powell, and he agreed to the experimental camp being held during 1–8 August, bringing together 22 boys from different social backgrounds. Camping, woodcraft, life-saving and observation were among the skills they learned, while qualities such as chivalry and patriotism were encouraged.

Following its success, in 1908 Baden-Powell published *Scouting for Boys: A Handbook for Instruction in Good Citizenship*, which not only launched the international scouting movement, but which is claimed to be the fourth best-selling book of the 20th century, being translated in 87 languages with estimated worldwide sales of up to 150 million.

Scout camps continued on Brownsea until 1934 when, following a wildfire which left virtually all the vegetation as ashes, reclusive owner Mary Bonham-Christie, who had bought the island in 1927 for £125,000, banned all public access for the rest of her life.

When she died in 1961 aged 98, her grandson handed Brownsea to the Treasury as payment of death duties. The Government transferred ownership of Brownsea to the National Trust, and a permanent 49-acre scout camp site was opened in 1963 in the presence of members of the 1907 camp by Baden-Powell's widow, Baroness Olive St Clair Baden-Powell, who had become Chief Guide for Britain in 1918 and World Chief Guide in 1930. The public were also finally allowed back, and now the island, accessed by ferry from Sandbanks, attracts more than 100,000 visitors a year. To mark the centenary of the first camp, worldwide celebrations took place on Brownsea in August 2007, with more than 300 scouts from 160 countries taking part.

Brownsea, at one-and-a-half miles by one mile, is the largest of the islands in Poole Harbour, a large inland sea which comprises a 'ria' or drowned valley formed at the end of the last Ice Age and into which several rivers empty including the Frome.

With the town of Poole on its northern shore, the harbour is very shallow, with an average depth of less than two feet and much of it is fringed by salt marsh. It is one of several places which claim to be the largest or second largest natural harbour in the world, another being Cork Harbour in Ireland.

An archaeological dig in 1964 uncovered the remains of a 2,300-year-old Iron Age longboat in the mud off Brownsea. The harbour became a strategic haven for the Roman conquest of southern England, with a settlement established at Hamworthy. The first recorded settlers were ninth-century monks from Cerne Abbey near Dorchester, who followed the early Christian trend of

**Brownsea Castle was built as a blockhouse for Henry VIII.** Robin Jones

selecting islands for a contemplative life and built a hermitage and a chapel dedicated to St Andrew.

The Viking King Canute used Brownsea as a base from which to raid Wareham and the abbey in 1015. The 11th-century owner of the island was the Anglo-Saxon Bruno, lord of the manor of Studland, and he gave his name to it. Br noces eg translates to Br noc's island. In 1154, Henry II handed control of the island to the abbey, which held it until the dissolution of the monasteries under Henry VIII. During the English Civil War, the island was garrisoned in support of the Roundheads, who were supported by Poole.

**Cottages on Brownsea Island's quay.**
Robin Jones

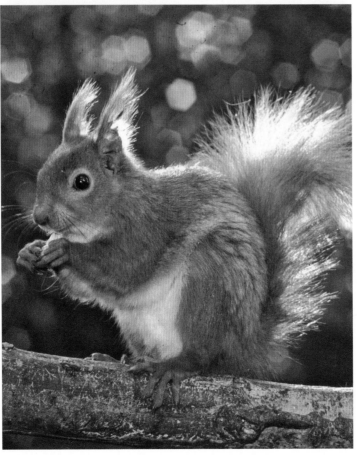

**Red squirrel on Brownsea Island.**
Kenin Cook

In 1707, following the death of owner Sir Robert Clayton, a Lord Mayor of London, Brownsea was sold to William Benson MP, who turned the castle into a home and introduced many varieties of trees on the island. The castle and gardens were later enhanced by another MP, Sir Humphrey Sturt, who bought Brownsea in 1765.

George IV visited Brownsea in 1818 and remarked: 'I had no idea I had such a delightful spot in my kingdom.'

British army colonel William Waugh bought the island in 1852 and founded a pottery-making industry based on Brownsea's white clay deposits, employing more than 200 people on the island. However, the quality of the clay turned out to be poor, fit only for bricks, tiles and sanitary ware, and the business closed in 1887. Another product of Brownsea is alum used as a colour fixer in the dying industry and in the manufacture of ink.

Waugh also created a workers' village, Maryland, and the Gothic St Mary's church, both named after his wife. The church is now partially dedicated to the scouting movement. He built a sea wall around what was St Andrew's Bay forming what is now the Lagoon on the east side of Brownsea. The Waughs fell heavily into debt and fled to Spain in 1857, leaving the island to be seized by creditors.

Following the introduction of electric lighting, the castle was gutted by a fire in 1896 and was later rebuilt.

World War 2 saw Brownsea pressed into service as a decoy to draw Nazi bombers away from Poole and Bournemouth. Large flares were placed on the island to attract fire and bombs fell on deserted Maryland which was completely destroyed. On 14 May 1940, Brownsea was 'invaded' by 3,000 Dutch and Belgian refugees, who spent several weeks there while medical checks were undertaken.

As we have already seen, the isolation of islands has the ability to protect species of wildlife from natural predators. Brownsea is, famously, one of the few places in Britain where indigenous red squirrels can still be seen, as they have not lost territory to the American grey squirrel.

The island provides a winter home for more than half of the avocets in Britain, and has large populations of common and sandwich terns. There is also a heronry, a sizeable population of introduced sika deer and a huge population of peacocks descended from those brought in for ornamental purposes by an earlier owner.

The island has a visitor centre and museum, with a display of horse-drawn agricultural wagons and equipment, along with a shop and café, while the National Trust runs several cottages as holiday lets. The Brownsea Open Air Theatre performs the works

of Shakespeare each year, while the Dorset Wildlife Trust has its base in an old villa. Lifeguards at Poole organise an annual four-and-a-half-mile swim around Brownsea.

Unlike Steep Holm and Lundy, Brownsea does not issue its own stamps, but has a single Royal Mail post-box which is emptied every Saturday.

On the far side of the water known as White Channel Lake lies Furzey Island, which almost hides a big modern-day secret. I say 'almost', because the top of the oil rig in the centre of the island gives the game away. Otherwise this pine-clad island manages to conceal an oil pump and gathering station for BP's Wytch Farm Oil Field, with the oil piped 57 miles via Fawley to a terminal on the far side of Southampton Water at Hamble.

Furzey is now Brownsea's smaller sister, but was much bigger two millennia ago. Channel 4's Time Team uncovered the remains of an Iron Age furnace, highlighting the fact that industry in Poole Harbour is nothing new. It is speculated that Furzey may have once been part of its twin, Green Island, which some believe was an important port in pre-Roman times, with products like shale jewellery exported to the continent.

The other big pair of islands comprises Long and Round islands, which are both in private ownership. Long Island, separate from Round Island by a channel only a few feet wide, is nine acres at high water expanding to 30 acres at low tide, and is a Site of Special Scientific Interest. There are no houses on it, but there is a private jetty and camping is allowed. Its only known residents were the late master potter Guy Sydenham and his family, who lived in a converted motor torpedo boat moored there in the 1950s. Guy worked with the island's clay and commuted to work at Poole Pottery where he was a leading designer.

At 15 acres, Round Island, which has its own water supply, is a mixture of woodland and grassy paddocks. In 1935, it was sold to Kathleen Laurence, daughter of Lord Illiffe. She had the main house, three cottages, a boathouse, slipway and a 110ft pier built. Two of the cottages are now holiday lets. During World War 2, Round Island was used by the Royal Navy as a training ground named HMS *Turtle*.

**The huge lagoon on the east side of Brownsea.** Kenin Cook

**The Gothic church of St Mary on Brownsea Island.** Robin Jones

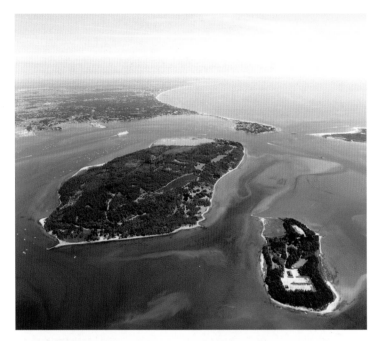

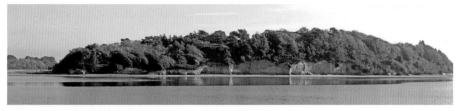

Opposite page:

Top left: **Aerial view of Brownsea (left) and Furzey islands.** BP

Top right: **A pond in the heart of Brownsea's woodland is one of many natural habitats that are preserved there.** Robin Jones

Bottom: **Beach on the west coast of Brownsea Island.** Robin Jones

This page:

Above left: **A bust to Baden-Powell near the entrance to the island.** Robin Jones

Above centre: **The Baden-Powell memorial stone on Brownsea's west side.** Robin Jones

Top right: **Green Island, an important port before the Romans came.** Robin Jones

Centre right: **The houses, boathouse and jetty on Round Island, as viewed from the Arne peninsula.** Robin Jones

# 13 The Isle of Wight

Sandown Bay and its pier. A century ago, the island had 10 piers, such was its enormous popularity with holiday-makers. IOW Council

Should we build a tunnel beneath the Solent and reconnect the Isle of Wight to the mainland after a separation of 8,000 years? Looking at a map of southern England, it seems an obvious course of action. Far narrower than the English Channel, the Solent is one of Britain's busiest shipping lanes, and aircraft apart, the only day-to-day means of getting on and off the island – the biggest in England by far, at 147 square miles – is by ferry, from Portsmouth, Southampton or Lymington. Talks about a tunnel took place with local authorities as long ago as 1886 and, in 1901 parliamentary powers for a railway beneath the Solent were obtained. However, the scheme failed to raise sufficient capital, fizzled out, was briefly revived after World War 1 and then died a death.

In 2002, a £60 million scheme for a railway tunnel between Portsmouth and Ryde was abandoned after a massive public outcry. Why? Because Wight residents are staunchly protective of their historic 'islandness', and want to stay detached from the mainland. Not that the tunnel idea will go away. At the time of writing, plans are afoot for a three-mile electric tram between Gosport and Ryde, with mile-long causeways from both coastlines leading to a mile-long tunnel in the middle. Residents fear that a car tunnel, estimated cost in 1998 was more than £300 million, would soon follow, and then Wight would be overwhelmed by an influx of traffic and pollution from the south of England.

The island became such after the last Ice Age, when melt waters flooded the valley of the River Solent and the future English Channel to the south, slicing Wight off from the mainland. Before that, Wight had been a continuation of the chalk Isle of Purbeck (never a true island) in Dorset: notice the similarity between the Needles and Old Harry Rocks at Swanage, and the richness of fossils of both areas.

Wight may have been known by the Celts as Ynys Gywth, while the invading Romans of the first century knew it as Vectis: historically, islanders have been known as Vectensians or Vectians. The future Roman emperor Vespasian lived there. The current name may come from the Anglo-Saxon 'wighte' meaning a creature, possibly a man: therefore it could be another Isle of Man.

In 534 Wight was conquered by the Jutish King Cerdic, but in 661 it was invaded by King Wulfhere of Mercia who at sword point ordered the islanders, the last pagans in England, to convert to Christianity. Fiercely independent, they reverted to paganism as soon as Wulfhere left. Worse was to come, in the form of ethnic cleansing, when Caedwalla of Wessex invaded in 685. The Jutish island King Arwald was killed in battle and his two nephews were forcibly converted to Christianity and then executed, before most Jutes were massacred and the rest ordered to abandon their pagan ways and accept West Saxon as their language.

Wight was hit hard by Viking attacks and during the reign of Ethelred the Unready (975-1014), it was used by the Danes as a base to attack southern England. Defeated, Ethelred spent Christmas 1012 on the Isle of Wight before fleeing to Normandy. Both Harold Godwinson, the last Anglo-Saxon king who died at Hastings, and his brother Tostig held manors on Wight. Harold used the island as a base to rebel against Edward the Confessor.

After the Norman Conquest, the position of Lord of the Isle of Wight was created, held by William Fitz-Osborne, who started building Carisbrooke Castle and founded Carisbrooke Priory. However, Wight did not come fully under the Crown until its last Norman lord, Isabella de Fortibus, sold it to the monarch in 1293.

Henry de Beauchamp, 1st Duke of Warwick was crowned King of the Isle of Wight in 1444 by King Henry VI, allegedly to place his playmate on a more equal standing with him, but when he died in 1446, aged 21 and with no male heir, the short-lived regal title passed away with him.

A schoolday myth holds that Britain was never invaded after 1066. Try telling that to the islanders. In July 1545, 2,000 French soldiers landed on Wight's southern shores, burning houses and crops and hoping to use it as a base to attack England, while the warships of both counties were engaged in the Battle of the Solent. Henry VIII, who created the Royal Navy and its central base at Portsmouth, had fortified Yarmouth, East and West Cowes and Sandown in readiness for such an event.

Holding the fort for all England, the Isle of Wight militia under Captain Robert Fyssher – some say including women archers – defeated the French in the Battle of Bonchurch, although one report claimed that the French won and were finally defeated instead at Bembridge. After the Hundred Years War of 1337 to 1453, Wight was in the frontline of England's defence against its old enemy France and every adult male undertook regular compulsory military training. Neither was it the first incursion by the French. In 1377, a raiding party destroyed much of the ancient borough and town of Newtown, later replaced by the better-defended Newport.

Charles I fled to Wight during the English Civil War, seeking succour from governor Robert Hammond – and was promptly locked up in Carisbrooke Castle. His 14 month stay was perhaps made more pleasant when an extensive bowling green was built for his use, but ultimately his incarceration at Carisbrooke ended with his execution in 1549.

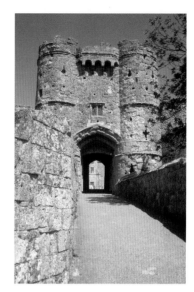

The entrance gate of mighty Carisbrooke Castle, added by Anthony de Wydville in the 15th century. IOW Council

The wall lizard thrives on Wight. IOW Council

The world's first hovercraft, SR-N1, was developed on Wight. Hovertravel

Three centuries later Queen Victoria fell in love with Wight, choosing Osborne House as her home for many years and making the island a prime holiday destination for European royalty.

Famous visitors to Wight were many including Alfred, Lord Tennyson, poet laureate under Victoria, Karl Marx, and later, Winston Churchill.

Previously part of Hampshire, Wight became an independent county in 1890, following a campaign for home rule. At high tide it

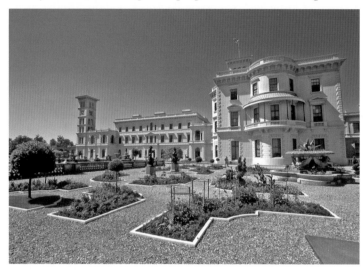

is the smallest traditional county in England – but at low tide, it becomes bigger than the other contender for the title, Rutland. Now having just one MP to serve 132,731 permanent residents (2001 census), Wight is also Britain's most populated Parliamentary constituency.

The island made its mark on global history in 1897 when Guglielmo Marconi established the world's first permanent wireless radio station at the Royal Needles Hotel in Alum Bay following his Flat Holm success. The billiard room was fitted with aerials while a 168ft mast was raised. Experiments began on 6 December 1897 and the signals were received by specially-equipped ships at a rate of four words a minute.

In January 1898, Marconi set up another station at Bournemouth where former Prime Minister William Ewart Gladstone was dying. After telegraph wires were brought down by snow, Marconi transmitted newspaper journalists' reports via radio back to the Needles – and so produced the world's first radio news. In June 1898 the scientist Lord Kelvin came to see for himself. He transmitted a message to Glasgow University and insisted on

paying a shilling, and so the world's first commercial radio transmission took place. That August Marconi was summoned to Osborne House and established radio communication between Queen Victoria and the Prince of Wales aboard the Royal Yacht, the pair exchanging 150 messages. On 15 November 1899, Marconi was travelling back from the USA on the SS *St Paul*, and while 50 miles from Wight, he received sufficient material transmitted from the Needles to produce the world's first newspaper published at sea, *The Transatlantic Times*.

Victoria's patronage also boosted Wight tourism for the general public, which was greatly aided by the very warm southern climate and the growth of a 55-mile railway network spanning the island. The first section completed was the Cowes & Newport Railway which opened in 1862, followed by the Isle of Wight Railway which opened its first line, from Ryde to Shanklin, in 1864, extending to Ventnor in 1866. The Ryde & Newport Railway and the Isle of Wight (Newport Junction) Railway followed in 1875.

Ryde Pier became a major point of entry for visitors. Before the first pier was opened on 26 July 1814, visitors to Ryde were carried ashore on the back of a porter and then had to walk half a mile across wet sand before reaching the town. A pier was a must, if the island was to attract the rich and famous who were patronising up-and-coming mainland seaside resorts. A second pier opened in 1864, carrying a horse-drawn tramway, and in 1877, the London, Brighton & South Coast Railway and London & South Western Railway were granted permission to add a third carrying a steam-operated line from the pier head to St John's Road.

In 1882, the Isle of Wight Railway opened a short branch line from Brading to Bembridge, from where a ferry to Hayling Island briefly operated. In 1889, the Freshwater, Yarmouth & Newport Railway opened, and finally, the Newport, Godshill & St Lawrence Railway reached Ventnor West in June 1900. Many railway closures took place between 1956 and 1966 but the Ryde-Shanklin section, recommended for closure by Dr Richard Beeching, was reprieved and electrified.

Because the track bed height in Ryde Esplanade Tunnel had been raised to alleviate flooding, it could no longer accommodate trains of the mainland loading gauge height, so second-hand London Underground tube trains with lower roofs were pressed into service - they are still running today. Even in the steam age, Wight's railways were the haunt of redundant engines and Victorian carriages shipped over from the mainland.

However, the island was the birthplace of a much newer form of transport, one which needed no tunnel to link Wight to the

Between 1845 and 1851 Osborne House was built as a summer home and rural retreat for Queen Victoria and Prince Albert, who also designed the building. It has a private beach where the royal family swam from bathing machines. It later became a naval college and is now open to the public. IOW Council

In 1970, the Isle of Wight Pop Festival near Tennyson Down attracted more than 600,000 music lovers and featured the last public performance by Jimi Hendrix before his death. The festival was revived in 2002. Robin Jones Collection

mainland – the hovercraft. On 11 June 1959, aero and marine engineering company and flying boat builder Saunders-Roe Limited, based at Columbine Works in East Cowes, demonstrated the Saunders-Roe Nautical 1 (SR-N1), the first hovercraft built to inventor Christopher Cockerell's design, under contract to the National Research and Development Corporation. A fortnight later, it crossed the English Channel from Calais to Dover.

The firm went on to develop more hovercraft, including the SR-N2, which began operations over the Solent in 1962, and the ASR-N6, which ran from Southsea to Ryde for several years.

Wight was to go one stage further than inventing a unique form of 'space age' transport to cross the sea. It took part in the space age itself. The Needles Battery, built on the cliff tops in 1861–3 to guard the western approach to the Solent, was replaced in 1895 by a newer version. It saw action in both world wars, Wight being regularly bombed by the Nazis; it was used to test early anti-aircraft guns and also fired on German torpedo boats attempting night landings. A nearby site on High Down tested rockets for the British intercontinental ballistic missile programme 1956–71, when Black Knight and Black Arrow rocket engines built in East Cowes were tested. The rockets later launched the Prosper X3 satellite from Woomera in Australia on 28 October 1971, the only one to be successfully launched by a British rocket. Deactivated in 1996, it is still in orbit. The site is now owned by the National Trust and is open to the public.

The major manufacturing activity today is making composite materials used by boat-builders. Unfortunately for local employment prospects, the Vesta wind turbine blade factory and testing facility closed down in 2009.

Wight has followed other islands both in becoming a wildlife haven because of its separation from the mainland and in having its own species. St Boniface Down is home to the largest cricket in Britain, the great green bush cricket, while the island, like Brownsea, is a major refuge for the threatened red squirrel. The island offers sanctuary to the dormouse and various rare bats, it boasts the biggest colonies of wall lizards and the glanville fritillary butterfly in the UK. A competition in 2002 named the Pyramidal Orchid as the Isle of Wight's county flower.

It even had its own disease. In 1904, the Isle of Wight Disease appeared and within three years had wiped out almost all honeybee colonies before spreading to the mainland. Only in 1921 was a tiny parasitic mite identified as the cause.

Wight folk are habitually known as islanders, with newcomers from the mainland referred to as overners, short for overlander. Those born on the island are often called caulkheads, pronounced and often written as corkheads, a name said to derive from the local industry of caulking boats.

There is even a pronounced local accent, said to be a stronger version of the traditional Hampshire dialect, but which is now in decline. Wight also had its own words, including 'somewhen' meaning sometime, 'nammit' (food), 'gallybagger' (scarecrow), 'mallishag' (caterpillar) and 'gurt' (great).

Surveys of public opinion have found most islanders are opposed to a physical link with Hampshire: indeed, there have occasionally been voices demanding greater independence, such as the Vectis National Party of the early seventies, which claimed that the sale of the island in 1293 was unconstitutional. It disappeared, but in 2001, the Isle of Wight Party contested the General Election, campaigning for a fixed link to the mainland. Its candidate received 1.8 per cent of the vote.

It has been claimed that outside the sailing mecca of Cowes, Wight's isolation has deprived much of the island of the prosperity of southeast England. Many islanders, however, proudly point to the strong agricultural economy, and five centuries after the battle of Bonchurch, Wight is now selling garlic to the French, with an annual Garlic Festival held at Newchurch. The climate has also led to vineyards thriving, including one of the oldest in Britain.

Less welcome residents are the inmates of the three prisons, Albany, Camp Hill and Parkhurst, located on Wight because of its detachment. Parkhurst has housed Yorkshire Ripper Peter Sutcliffe and the Kray twins. No doubt there are many inside who would welcome a tunnel or two, both beneath the Solent and out of jail.

**Tennyson Down, one of Wight's best-loved coastal features.** IOW Council

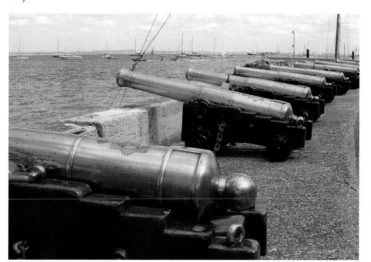

**Fortress island guarding the Solent: the row of cannon on Cowes sea front.** Gillian Moy

Modern hovercraft in action on the Solent: BHT 130, *Solent Express*, which takes visitors to and from Wight, was designed and built by Hoverwork, at Hovertravel's boatyard at the Duver on Bembridge Harbour. Hover-travel

The Needles, one of the great landmarks of southern England. Trinity House

Cowes is internationally renowned for sailing. Cowes Week is the longest-running regular regatta in the world, with over 1,000 yachts, 8,500 competitors and more than 50 classes of yacht. The festival originates from George IV's interest and the first race started at 9.30am on 10 August 1826. IOW Council

The inland picture-postcard village of Godshill has long been a magnet for visitors. David Reynolds

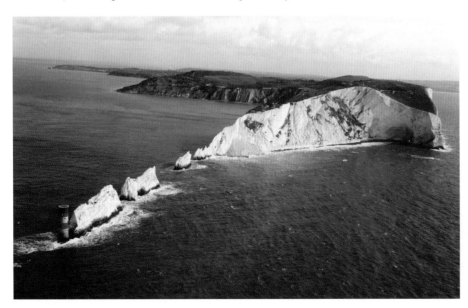

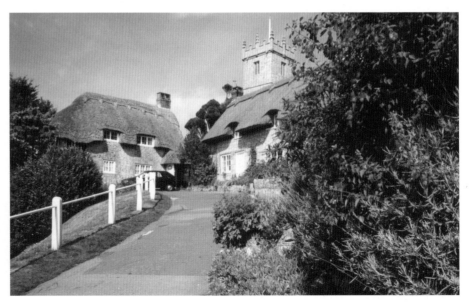

**Rainbow over the Solent and the Isle of Wight as seen from Milford-on-Sea. Would a tunnel ever justify its cost?** Robin Jones

**Ventnor grew up on the slopes of St Boniface Down.** IOW Council

**The Isle of Wight Steam Railway between Wootton and Smallbrook Junction maintains locomotives and stock from the island's past, including 'Terrier' tank engine *Freshwater*.** IOWSR

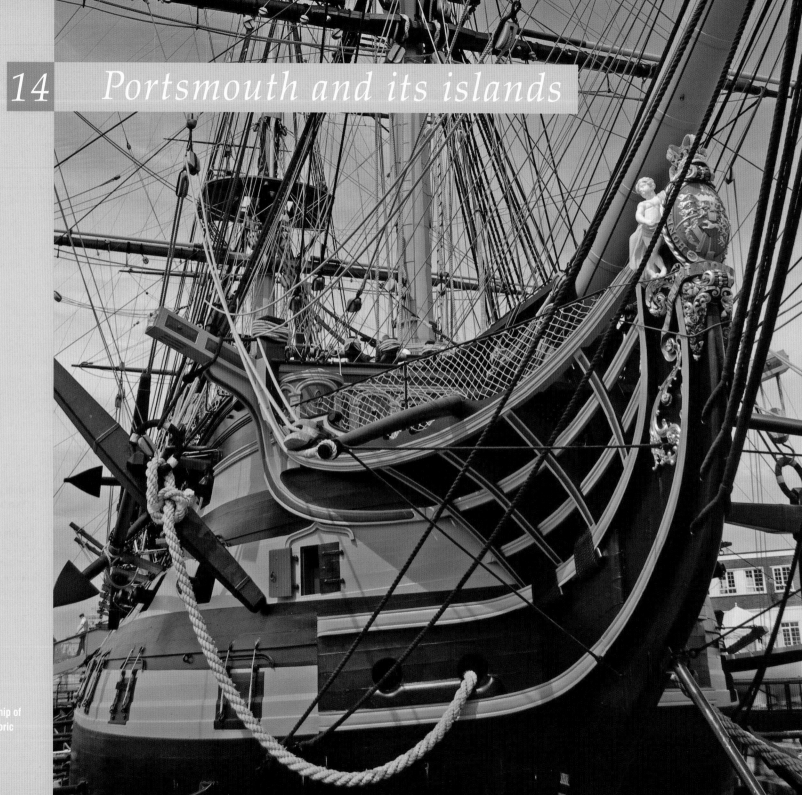

Arguably Britain's most famous ship of them all, HMS Victory, in the Historic Dockyard. Robin Jones

This chapter is the joker in the pack, for surprisingly few people realise that island-nation Britain's great naval port of Portsmouth is itself built on an island. Not only that, but it has a collection of surrounding islets, both natural and manmade.

Portsea Island is divided from the Hampshire mainland by a narrow creek which is crossed by two major roads and one railway bridge, and at first glance gives the false impression that it is a peninsula.

What is Britain's only island city has a population of 147,888, making it the most populated of any island in this book, and is the fifth largest in England, at 9.36 square miles. The 'Portsmouth conurbation' which extends beyond the island is also the 13th most densely populated place in Europe, and the second most densely populated area in Britain after inner London.

The island, like Hayling and Thorney islands to the east, protrudes into a series of rias, river valleys that have been submerged by rising sea levels since the Ice Age. To the west lies Portsmouth Harbour, dividing it from Gosport, and to the east is Langstone Harbour, with Hayling on the far side, ferries running to both. The skyline is dominated by Portsdown Hill, while much of Portsea is just 10 feet above sea level, making it prone to flooding through the effects of global warming.

Portsmouth's rich and proud history would justify a book this size on its own, so for brevity I must limit myself to basic facts. The Romans had a base at Portchester on the mainland, and several smaller settlements grew around it. Its name may derive from 'mouth of the Portus harbour'. Its first permanent church, a chapel dedicated to Thomas à Becket was built by Augustinian monks in 1181: the city's modern Anglican Cathedral is built on the site.

In 1194, Richard I granted Portsmouth a royal charter to hold a 15-day annual free market, and also summoned a fleet and army there following his release from captivity in Austria. His brother King John established a permanent naval base from which to invade Normandy, and in the 13th century it was frequently used by Henry III and Edward I as a base for attacks on France. In 1338, the French took revenge when a fleet under Nicholas Béhuchet raided Portsmouth, destroying virtually all the town. The French sacked Portsmouth again in 1369, 1377 and 1380. In 1418, Henry V, the victor of Agincourt, ordered the first permanent fortifications of Portsmouth, a wooden Round Tower at the harbour entrance. Henry VIII rebuilt it in stone, constructed Southsea Castle and helped with the building of England's first dry dock. In 1545 Henry's vice-flagship *Mary Rose* sank off Southsea, Portsmouth's close suburb, with a loss of about 500 lives, while going into action against the French fleet. It was from Portsmouth

on 13 May 1787 that 11 ships sailed to establish the first European colony in Australia and marked the start of the transportation of criminals to the continent.

Portsmouth not only became a great naval base but a prime supplier to the Royal Navy. In 1802 Marc Isambard Brunel, the father of Great Western railway pioneer Isambard Kingdom (who was born in Portsmouth) established the world's first mass-production line at Portsmouth Block Mills, to turn out pulley blocks for ships' rigging. At one time the dockyard became the biggest industrial site in the world.

Portsmouth will forever be associated with Nelson, and it was from the harbour in 1805 that the admiral left for victory and death at Trafalgar.

The strategic importance of the city, nicknamed Pompey, led to it becoming the most fortified in Europe, surrounded by a network of Palmerston forts. The first attack from the air as opposed to the sea came during a Zeppelin raid in 1916. Portsmouth was granted city status in 1926 because it was the 'first naval port of the kingdom'.

Heavily bombed during World War 2, Portsmouth Harbour and Southsea beach
were embarkation points for the 6 June 1944 D-Day landings, when Supreme Allied Commander, US General Dwight D. Eisenhower oversaw the operation from Southwick House, on the mainland north of Portsmouth.

Portsmouth has declined as a naval base in recent years, but one in ten of the local population are still employed at the dockyard. The centrepiece of the Historic Dockyard is, of course, Nelson's flagship HMS *Victory*, while the raised wreck of the *Mary Rose*, Britain's first iron-clad steamship HMS *Warrior* and the Royal Naval Museum are other major attractions, as is the D-Day museum in Southsea.

For centuries, Portsmouth also flourished as a major commercial port. The oldest part of the city, Old Portsmouth, the core around which it grew, is also known as Spice Island, because of its imports. Not an island but a peninsula, the area was renowned for its sailors' pubs. Today, 80% of the bananas imported into Britain pass through Portsmouth.

It is also a major passenger ferry terminal. Because of its excellent transport links, Portsmouth is also a vibrant shopping centre with more than 100 high street stores around Commercial Road and in the Cascades Shopping Centre. A major recent development is Gunwharf Quays, with its fashion stores, restaurants and cinema, while there is also Ocean Retail Park and the Bridge Centre.

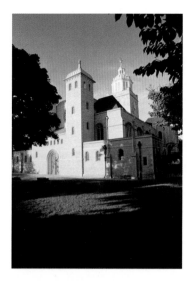

**Portsmouth's Anglican cathedral.**
Portsmouth City Council

**Aerial view of HMS Warrior.**
Portsmouth City Council

Above: **Statue of Horatio Nelson in Old Portsmouth.** Robin Jones

Top left: **The restored ruins of the Royal Garrison Church, gutted by an incendiary device during a Luftwaffe raid in 1941.** Robin Jones

Top right: **Salty days: a mural depicting life in Portsmouth in the days of sail on the side of the Bridge Tavern.** Robin Jones

Famous Portsmouth residents have included Sir Francis Austen, the brother of Jane Austen, former Prime Minister James Callaghan, Charles Dickens, Arthur Conan Doyle, H. G. Wells, Rudyard Kipling and single-handed yachtsman Sir Alec Rose.

During the early 21st century housing boom, prices soared at a rate bettered only by London.

To the north-west of Portsea Island, but within the city boundary, lies Horsea Island, which was once two islands, Great and Little Horsea. Using convict labour they were joined in 1889 to form a torpedo testing lake.

In 1909, the navy established one of three high-power shore wireless stations on Horsea, populating it with a forest of masts. The telegraphy station closed in the sixties and part of Horsea became HMS *Phoenix*, the Royal Navy's school of fire fighting and damage control. The navy still maintains a strong presence on Horsea, with facilities centred on diving and underwater engineering.

Horsea, however, ceased being an island in the early seventies when the mudflats dividing it from the mainland became a landfill site, later developed as Port Solent, a leisure complex which has a marina, housing, shops, a multiplex cinema and business units.

To the west of Portsea and linked to the mainland by a causeway, lies Whale Island, home to HMS *Excellent*, headquarters of the Royal Navy's Commander-in-Chief, Fleet and its oldest shore training base. The area between Big and Little Whale islands was infilled with deposits dredged from Portsmouth Harbour in the 19th century to create the site for the base, again using convict labour.

Before World War 2, Whale Island had a zoo. However, today, the base is off limits to the public, apart from special open days. The gun carriage that carries the coffin in British state funerals is kept on Whale Island.

Four artificial islands guard the eastern approach to the Solent, and are all part of the area's Palmerston chain dating from the 1860s. They are Spitbank Fort, Horse Sand Fort, No Mans Land Fort and St Helens Fort, which at certain very low tides can be reached by wading from the Isle of Wight, although it is privately owned and not open to the public. They helped defend Portsmouth from the Luftwaffe, the shock waves from their heavy armaments was blamed for breaking windows on the mainland. They later became lighthouses for navigation.

Spitbank, which lies nearly a mile offshore, was decommissioned in 1962 and sold 20 years later. It has a supply of fresh water from a 400ft well drilled beneath the seabed into a chalk aquifer. Virtually unchanged since 1870, it is now a museum and is available for parties, weddings and other private functions with accommodation available. In 2002, Spitbank was home to the late TV presenter Jeremy Beadle, who was locked up in its dungeons for six weeks as part of his *Banged Up With Beadle* sketches on the Saturday night *Ant and Dec's Takeaway*.

In modern times, No Man's Land Fort became a luxury hospitality centre for guests, with an indoor swimming pool and two helipads, but the venture collapsed and it was sold in 2009. It was also used in BBC's 1972 Dr Who adventure *The Sea Devils*.

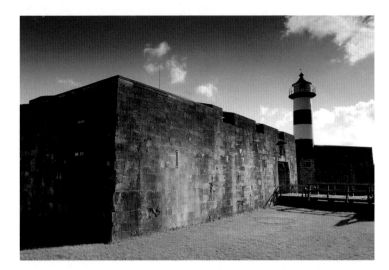

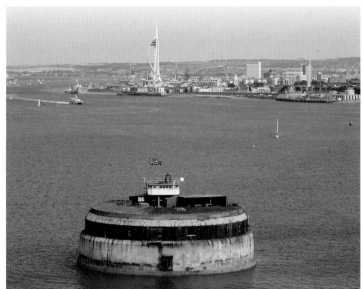

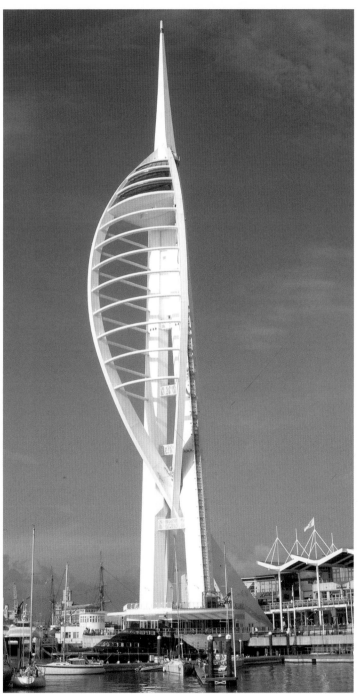

Top left: **Southsea Castle, built by Henry VIII in 1544, with the Southsea lighthouse of 1828.** Portsmouth City Council

Centre left: **Spitbank Fort in the Solent.** Spitbank Fort

Left: **Completed in 2005 as part of the redevelopment of Portsmouth Historic Dockyard, the Spinnaker Tower is Portsmouth's most modern landmark and at 558ft is the tallest accessible structure in the UK outside London. Representing sails billowing in the wind, it is two and a half times taller than Nelson's column.** Portsmouth City Council

Bottom left: **Leaving the island: a train runs over the bridge across the tidal channel that divides Portsea and Portsmouth from the mainland.** Jane Ring

Above: **The Spice Island Inn recalls the name given to the heart of Old Portsmouth.** Robin Jones

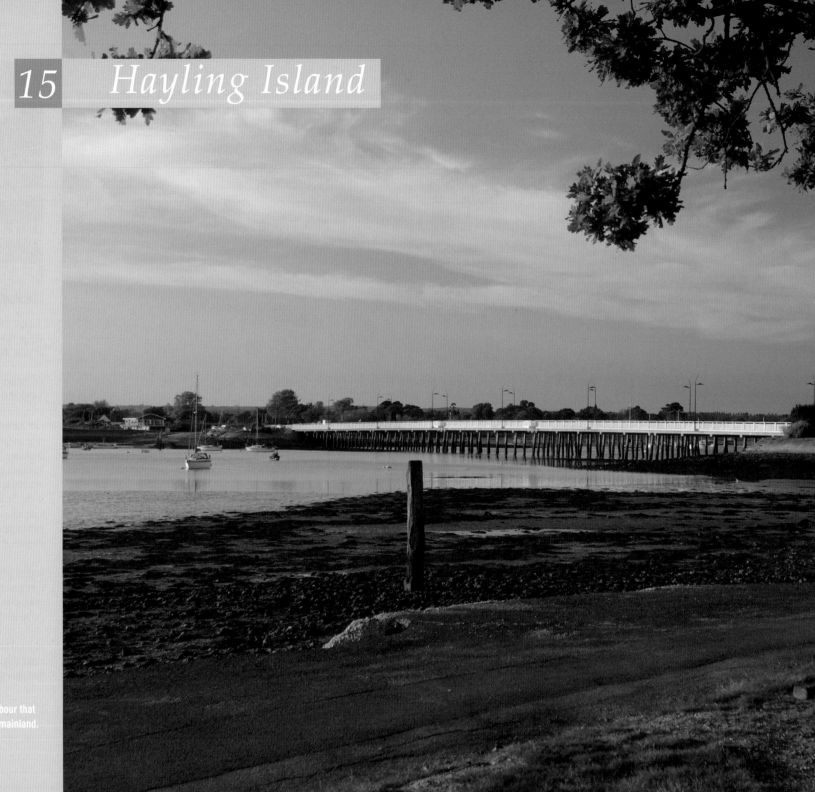

# 15 Hayling Island

The bridge over Langstone Harbour that connects Hayling Island to the mainland.
Robin Jones

Think of surfing and Malibu immediately comes to mind, but what about windsurfing? An English island has claimed that as its own.

The Isle of Wight gave us the hovercraft, while across the Solent, Hayling Island, is the place where, as far as the law is concerned, windsurfing was invented. In 1985, British courts ruled in favour of one-time Hayling resident Peter Chilvers, who claimed to have invented the sport in 1958, when at the age of 12, he innovatively attached a sail to a board. Admittedly it was a basic affair, with a straight split boom rather than the curved wishbone booms of modern windsurfers. The court upheld his claim based on film footage, saying that later modifications by other designers were just 'obvious extensions'.

Chilvers went on to become a successful engineer for Lotus cars and set up his own sailing and windsurfing centre in London, while the sport became hugely popular back in Hayling, where participants use the open beach and the Channel breezes to maximum effect.

Hayling, lying between Langstone and Chichester Harbours, is the third biggest island in England, four miles long and four miles wide at the southern end. A single bridge takes the island's spine road, the A3023, over the quarter-mile channel that divides it from the mainland. There used to be a second bridge, carrying the much-loved Hayling Island branch line from Havant. Built by the London, Brighton & South Coast Railway it opened for goods on 19 January 1865, and to passengers on 16 July 1867. The line famously used the company's little A1X class 'Terrier' 0-6-0Ts because of the weight restriction placed on the timber swing bridge crossing Langstone Harbour.

British Railways closed the branch despite it making a small profit, because the bridge needed replacing and the cost was deemed excessive. The last service train ran on 3 November 1963 following by a closure special the day afterwards. The last three 'Terriers' to have run on the line have all been preserved, Nos 32650 and 32670 on the Kent & East Sussex Railway, and No 32636 on the Bluebell Railway. A pub on the island is called the Hayling Billy after the nickname for the train, while the foundations of the old bridge can still be seen.

The station is now a theatre. Rather ironic, as some historians have conjectured that the concept of railways began with ancient Greek drama, when trolleys guided by stone grooves in stages were used to move scenery.

A railway has returned to the island in recent times. The 2ft gauge Hayling Seaside Railway runs a mile along the coast from the Beachlands amusement complex to Eastoke Corner.

The island's other communication is a subsidised ferry from its western side at, where else but Ferry Point, to Portsea Island.

Hayling's beach was sandy, but is now largely comprised of shingle dredged from the floor of the Solent and used to stop beach erosion and protect low lying land from surges. There was a temple on the island in Roman times and it is believed that much land has been lost to the sea since then, a considerable amount of it in the 14th century, including that on which All Saints Church stood - it is said that its ghostly peals can still be heard.

Hayling's oldest surviving church is that of St Peter, built as Northwode chapel by the monks of Jumiéges in Normandy from 1140. Its three bells date from 1350 and it is said to have one of the oldest peals in England. The grave of Scotsman George Sandeman, who concocted Sandeman Port, is in the churchyard.

Mengham, the largest settlement on the island, includes the church of St Mary which harbours a centuries-old secret. A grave marked as Mary Gritt's conceals the entrance to a half-mile-long tunnel, supposedly built by smugglers.

Hayling was invaded by armed troops in May 1944. However, while the soldiers were for real, it was just a practice run for D-Day the following month.

The island, once famous for its oyster beds, has been a holiday destination for more than a century, and although it has largely avoided the rampant commercialisation seen elsewhere, offers all-year entertainment because of its proximity to Portsmouth and Southampton, and an easy journey from London, although it is now primarily residential. A total of 1,600 people lived at Hayling in 1901: the figure is now nearer 17,000. If only that branch line had survived.

Above: **Traditional seaside fare on offer on the beach.** Robin Jones

Left: **Windsurfing – the sport that began on Hayling Island.** WILL.BLAIR.COM

Above centre: **The beach at Eastoke on Hayling Island, now covered with shingle and heavily reinforced by groynes to prevent further erosion.** Robin Jones

Above: **A modern-day Hayling Seaside Railway service returns to Beachlands.** Robin Jones

The Great Deep, which empties into Chichester Harbour, still divides Thorney Island from the mainland. Robin Jones

In contrast to both Hayling and Portsea islands, Thorney became one with the mainland in 1870 when a new sea wall reclaimed 170 acres of land. However, the channel that made it an island survives as the Great Deep, allowing it to retain a semblance of island identity.

Thorney – the isle of thorns – today comprises pasture, marshland and a military base; accordingly, it is off limits to the public. You can, however, walk the seven-mile coastal footpath, entered through a gate in a barbed wire-topped fence at which you have to give your name, mobile telephone number and postcode over an intercom. You are also reminded that your walk will be monitored, and CCTV cameras are positioned at regular intervals.

Despite these restrictions, the walk offers sweeping views of Chichester Harbour of which Thorney Island forms the western bank. The harbour itself is an Area of Outstanding Natural Beauty, an internationally-important Site of Special Scientific Interest, and a Special Protection Area for wild birds because of its wetlands which provide breeding grounds for waders and wildfowl.

Walkers are allowed to visit the Norman church of St Nicholas at West Thorney, a village incorporated into the RAF base after the airfield was built in 1938. The church dates from 1100 and contains rows of servicemen's graves. RAF Coastal Command used the base during the war, but the RAF closed the airfield in 1976. Six years later, the base was taken over by 47 Regiment Royal Artillery, joined in 2008 by 12 Regiment Royal Artillery on its return from Germany.

To the south of the island you will see tiny and inaccessible Pilsey Island, a sandy nature reserve.

Pilsey became the focus of a major international incident when a headless body, said to be that of missing Navy frogman Commander Lionel 'Buster' Crabb, was found there on 9 June 1957. The British claimed that Crabb died accidentally in the cold waters of Portsmouth Harbour but it transpired that when he disappeared he had been investigating a visiting Soviet ship, the *Ordzhonikidze* nearly 14 months earlier. It has always been claimed that the UK government tried to cover up the whole affair, and at least 10 books have been written on the mystery. The official papers will not be released until 2057, but a former Soviet naval intelligence officer said in 1990 that Crabb had been shot in the head by a member of the ship's crew.

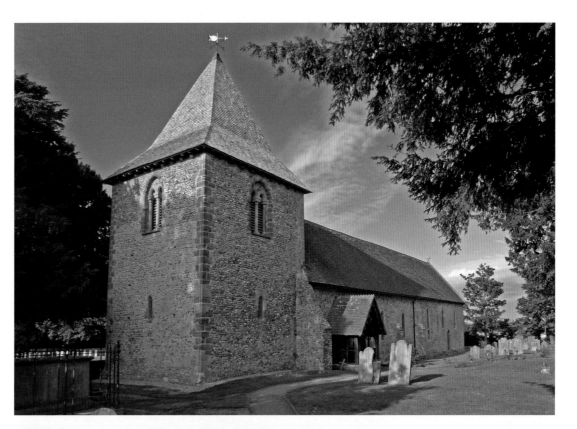

Above right: **The Norman church of West Thorney.** Robin Jones

Right: **The MoD gate controlling public access to the coastal footpath.** Robin Jones

The best way to reach the Goodwin Sands today is by helicopter. Edward W Turner

*Why, yet it lives there uncheck'd that Antonio hath*
*a ship of rich lading wrecked on the narrow seas;*
*the Goodwins, I think they call the place; a very*
*dangerous flat and fatal, where the carcasses of many*
*a tall ship lie buried, as they say, if my gossip*
*Report be an honest woman of her word.*
(William Shakespeare, *The Merchant of Venice*, Act 3 Scene 1).

A long time ago there existed an island in the English Channel off the coast of Kent.

Nobody knows for sure how long ago. Some legends say that as recently as the 11th century it was the site of a fertile low-lying island called Lomea, which the Romans knew as Infera Insula.

Lomea was supposedly owned by Godwin, Earl of Wessex. He fell from favour and the island was given to Canterbury's St Augustine's Abbey but the monks failed to maintain the sea walls and the island was overwhelmed in the great storm of 11 November 1099 that according to some accounts also destroyed Lyonesse.

All that remains of Lomea is the great sandbank off Deal. Exposed at low tide it is 12 miles long and up to five miles wide and named the Goodwin Sands, after Godwin. Dig 15ft down through the sands, and you will find London clay resting on a bed of chalk.

However, neither the Domesday Book nor other contemporary sources mention Lomea. The waters of the Strait of Dover divided England from France in the Pleistocene era, which ended about 8,000 BC. While geologists accept that the Goodwin Sands were once dry land, they remain sceptical as to whether that was within historical time.

The Goodwin Sands is notorious as the most treacherous sandbank in British waters, with the Doom Bar on the Camel estuary at Padstow in Cornwall coming second. The sands lie next to one of the world's busiest shipping lanes, and more than 2,000 vessels have been lost there – including the South Goodwin lightship itself in November 1954.

The great storm of 1703 saw 13 warships and 40 merchant vessels lost in the Channel, with 2,168 seamen perishing. HMS *Mary* went down with the loss of 343 men, while HMS *Northumberland*, HMS *Restoration* and HMS *Mortar* were lost with all hands.

According to 18th century legend, the skipper of the *Lady Lovibond* went mad, steered the ship on to the sands and killed the entire crew. As a ghost ship it is said to reappear every 50 years, and is next due in 2048. In November 1991, the great sixties cultural phenomenon that was pirate radio came to an end when the Radio Caroline ship MV *Ross Revenge* struck the sands. The sandbank has also been the site of great naval battles, like the Battle of Goodwin Sands in 1652 and the Battle of Dover Strait in 1917.

The sands are marked by three lightships maintained by Trinity House; the North Goodwin, the East Goodwin and the South Goodwin. Two lighthouses were built on the Kent mainland to warn shipping: the one at the northern end of the sands still operates while the southern one is now owned by the National Trust. Constant watch, visual and by radio and radar is kept over the Goodwins by HM Coastguard Station at St Margaret's (Dover Straits).

This book is about islands that have seen human habitation, or at least activity, and the Goodwin Sands are no exception. At high water the sands are completely covered but at low tide about a tenth of the golden sands are exposed – with some parts up to 13ft above the waves. Cricket was played on the sands at low tide in Victorian times and an annual game took place until 2003. The BBC television series *Coast* attempted a reconstruction of a game in 2006, and had to be rescued by the Ramsgate lifeboat. When hovercraft still ran from Dover, occasional public trips were made to the sands.

The Goodwins were the subject of a 1974 scheme to build a third London airport together with a huge harbour complex, but the idea fizzled out. Who knows – one day it might be revived, and make a new chapter.

**Flying the flag for England: city slickers on the Goodwins during a filming session.**
Edward W. Turner

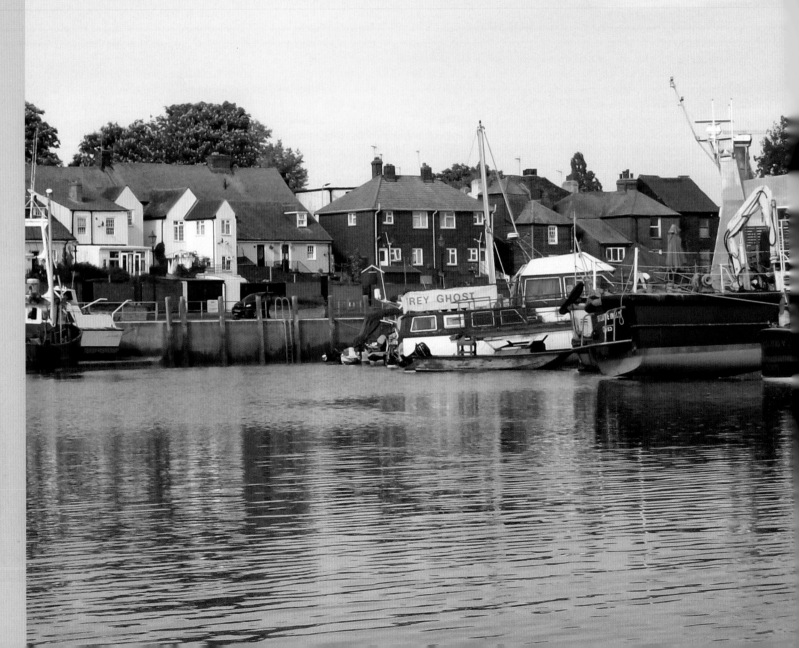

The little harbour of Queenborough, where a castle was built in the 1360s by Edward III to protect The Swale, a major seafaring route, and named in honour of his wife Queen Philippa.
John Lenton/Queenborough TC

The Romans may have called Sheppey 'Insula Ovinium', and the Saxons knew it as Sceapige – all three names meaning 'isle of sheep' – and there are still plenty to be seen on this mainly agricultural Kent offshoot.

Although it's usually bypassed by people travelling through the county en route to the Channel ports, Sheppey is the second biggest island in England and has the third-largest population, at 37,852. Nine miles across and four miles wide, Sheppey is divided from the mainland by the deep channel known as The Swale.

As with the long-since silted-up Wantsum Channel that once separated the nearby Isle of Thanet from Kent, The Swale was a preferred route for wooden ships to reach London and Chatham avoiding bad weather in the Thames estuary. The Swale needs constant dredging to allow its continued use by large craft.

Before Ice Age melt waters drowned much of eastern Britain, The Swale was a river valley. In Roman times, it was much wider, and one part of modern Sheppey, the Isle of Harty, was a separate island. Until mid-Victorian times Sheppey's traditional isolation was maintained by the lack of a bridge over The Swale. The Tremsethg Bridge at Elmley, built during the reign of Edward I, was washed away by a tidal wave and for centuries afterwards islanders relied exclusively on ferries.

There were three principal ferries: the westernmost, the King's ferry; another at Elmley; and the Harty from Faversham. Later, the South Eastern Railway ran a passenger ferry to Sheerness from its Port Victoria terminus on the Isle of Grain. Ferry tolls remained in place until 1931.

On 19 July 1860, the London, Chatham & Dover Railway began operating trains on a bridge carrying both rail and road traffic over The Swale. It was a naval design with the central span raised between two towers to allow the passage of ships. It was replaced in 1906 by a structure with a 'rolling lift'. In October 1959, Kingsferry Bridge was installed, and was able to lift both road and railway to allow ships to pass. Sheppey still reverted to full island status in recent times when it was cut off by snow or floods in 1978, 1979 and 1987. The spectacular four-lane A249 Sheppey Crossing opened on 3 July 2006, soaring 65ft above The Swale, but is only for motor traffic. In 1876 the opening of a large ferry terminal by the railway at Queenborough Pier allowed ferries to sail to Vlissingen in The Netherlands.

However, Sheppey's claim to transport fame has nothing to do with bridges or ferries but is because much of the very early history of powered flight in Britain took place on the island. The first successful powered flight in Britain was undertaken at Laffan's Plain, Farnborough, by American showman Samuel Franklin Cody on 16 October 1908. However, it was on 2 May 1909 that John Theodore Cuthbert Moore-Brabazon, later 1st Baron Brabazon of Tara, became the first resident Englishman to make an officially recognised aeroplane flight in England when he flew at Shell Beach near Leysdown-on-Sea. On 30 October that year, Moore-Brabazon flew a circular mile there winning a £1,000 prize offered by the Daily Mail. Could pigs fly? Moore-Brabazon proved they could. On 4 November 1909, he placed a small pig in a waste-paper basket tied to a wing strut, arguably achieving the first live cargo flight. On 8 March 1910, Moore-Brabazon became Britain's first

**Leysdown-on-Sea is a popular family holiday resort.** Jon Combe

qualified pilot and was awarded Royal Aero Club certificate No 1. His car had the number plate FLY1.

Sheppey's aviation history had begun in 1901, when Charles Rolls (of Rolls Royce fame), Frank Hedges Butler and his daughter Vera Butler formed the Royal Aero Club, choosing Shell Beach as a site because it was free of obstructions. Balloon manufacturers Horace, Oswald and Eustace Short, later Short Brothers Ltd, were appointed as the club's official engineers.

When the club set up a flying ground at Shell Beach in 1909, Shorts erected workshops – the world's first aeroplane production line and Muswell Manor became the clubhouse.

**Sheerness is now the largest port in the UK for importing new cars.** Swale BC

**John Hayls' portrait of Samuel Pepys, who brought the naval dockyard to Sheerness.**

Right: **The Sheppey Light Railway, engineered by legendary light railway empire builder Colonel Holman F. Stephens, ran from Queenborough to Leysdown. It opened in 1901 and closed on December 4 1950. Pictured is Leysdown station in February that year.** Robin Jones collection

Sheppey's isolation played a key role in early aviation. The club advocated that while more accessible flying grounds elsewhere would host public demonstrations, Sheppey should be reserved for the scientific investigation of new devices in secrecy.

Aviation pioneers the Wright brothers visited Shell Beach and Wilbur commented: 'Here we have ample room for a ten-mile flight without obstruction, as against our four or 500 yards in the States'. They gave the Shorts sole rights to build six 'Wright Flyers', their first powered aircraft. When the site turned out to be uneven, Shorts relocated to a more suitable location at Stonepitts Farm, Eastchurch, which became a haunt of many famous early aviators like Frank McClean, who bought the site, and John Dunne.

Soon, the Shorts were employing 80 men in aircraft production. To win government support, McClean set off from Harty and flew down the Thames in a Shorts seaplane, passing through the arches of Tower Bridge and under other bridges before landing opposite the Houses of Parliament. As a result, the Admiralty accepted his offer to use Eastchurch airfield, and sent four volunteer officers for training there in March 1911, and so, the first Royal Naval Air Service station was founded. McClean himself joined the RNAS, flying Channel patrols before returning to Eastchurch as an instructor.

The coming of the military eventually ended civilian flying on Sheppey. Both World Wars had repercussions for islanders. Eastchurch airfield was heavily guarded and residents and visitors needed a pass to enter Sheppey, which became known as 'Barbed Wire Island'. Among VIP guests at the airfield was Winston Churchill, then First Lord of the Admiralty, who was given two long instructional flights by RNAS officer Captain Lushington.

In 1918, Eastchurch became an RAF establishment, a status it retained until its closure in 1947. Sheppey's island character played a role in its future, for it was later used to build three prisons. As on Wight, islands are deemed less 'escapable'.

One flight from Sheppey which failed was that of James II. In 1688 he was deposed by William of Orange and fleeing England he landed at Elmley, only to be mistaken for the locally hated Jesuit Edward Petre and robbed of his money, watch and coronation ring. Eventually James was recognised, arrested, and taken in custody to Faversham, but William freed him to go into exile.

Sheerness, the main town of Sheppey and a commercial port with much heavy industry, has diary-keeper extraordinaire Samuel Pepys to thank for its prosperity, for he established the Royal Naval dockyard there in the 17th century. In June 1667, 72 Dutch navy ships attacked the town and briefly occupied it.

Sheerness was the scene of the Nore mutiny of 1797, when Royal Navy sailors demanded better conditions. On 12 May, the crew of the *Sandwich* seized control of the ship, and other vessels joined them. At first they attracted public support; every day the mutineers would march into Sheerness amidst a carnival atmosphere, and hold meetings in pubs: the Chequers Inn became a headquarters. However, the tide turned when the mutineers refused to negotiate with the Admiralty, which offered talks if they surrendered and asked for a pardon. When the leaders planned to take the ships to France, many mutineers pulled out. Ringleader Richard Parker and 29 other leaders were hanged, and others were transported to Australia. The Royal Navy left the dockyard in 1962.

Sheppey deserves a place in any book called 'Island Fever', for it was there that the last Briton killed by malaria after contracting the disease in this country died in 1952. Before that, Sheppey was the site of the last major British outbreak, during World War 1 when

soldiers returning from Macedonia and infected with malaria parasites were billeted on the edge of Queenborough. The infection was picked up by local mosquitoes biting the convalescing troops, and went on to infect 32 people over several years. Nowadays we regard malaria as a tropical disease, but it has a long history in the salt marshes of southern England: two centuries ago, it was a prime cause of death in many marshland settlements. In recent times, fears of another outbreak of the disease on Sheppey have been sounded following a massive increase in anopheles mosquitoes, perhaps owing to global warming.

Sheppey is the northernmost place with a population of scorpions. The yellow-tailed scorpion euscorpius flavicaudis has been there since the 1860s after having arrived on a ship. Today there are an estimated 3,000, and yes, they do have a sting in their tails.

Some Sheppey dwellers call themselves swampies, a name which started out as an insult and became a term of endearment reinforcing their island identity.

Elmley Island is typical of the south of Sheppey, a landscape of marshes lined with a maze of creeks and drainage channels. Paul Grover

The Kingsway Bridge (left) and the new Sheppey Crossing. Swale BC

The first English monastery was founded on the site of Sheppey's Minster Abbey in 670 by Ermenburga, granddaughter of St Ethelbert, the first Christian King of Kent. The original building was destroyed by Vikings in the 9th century, but it was rebuilt in 1027. Dissolved by Henry VIII, in 1937 it was taken over by Benedictine nuns from Bavaria. It may be the oldest inhabited house in Britain. David Davies

Home of heavy industry: Sheerness steelworks, with diesel shunters *Bill* and *Ben*. Mark Jansen

# 19 The Medway and Thames estuaries

**Four of the Red Sands Fort towers.**
Hywel Williams

istorically the Thames and Medway estuaries have been England's soft white underbelly as far as invasion threats from the continent were concerned. The Dutch attack of 1667 was mentioned in the last chapter, but while it was the last, it was by no means the first. The Vikings first struck Sheppey in 835, and continued their incursions into the 11th century. The rebel Earl Godwin raided Sheppey from Flanders in 1052, and French and Spaniards ravaged the north Kent coast in 1379.

The Medway estuary has one great geographical advantage in terms of defence, the plethora of small islets, mudflats and marshes which could be fortified. In 1860 fears about a potential war with Napoleon III's France led to the building of circular forts on Hoo Island and the smaller Darnet Island on the opposite side of the estuary. Part of the Palmerston defence scheme, the forts were maintained until early in the 20th century, and the buildings still survive.

Hoo, an uninhabited island a mile long and 700 yards wide controlled by the Admiralty, later had a 2ft 6in gauge steam railway system over three miles long laid in the early 1900s to transport materials for sea bank protection works. Steam was abandoned about 1926 in favour of petrol-engined locomotives. The railway was converted to 2ft gauge in 1952, and afterwards used diesels. It fell into disuse in the seventies when its role of transporting dredged mud from the island wharf to tipping sites was taken over by pipelines and tracked vehicles. The island remained out of bounds and the Hoo Island system is the most mysterious and little known of Britain's island railways.

A man-made island built on Grain Spit, a low-tide sandbank, the Grain Tower Battery was built in 1855 as part of the Chatham defences; a chain linked it to Sheerness to stop vessels entering the Medway. Joined to the Isle of Grain by a low-tide causeway, it was decommissioned in the early 1950s.

Two uninhabited flat marshy islands in the Medway are Burntwick and Deadmans. The latter so called because it was the burial place for seaman who died from cholera brought by ships returning from the Crimean War which were quarantined in this stretch of water. Some prisoners of war who died in the notorious hulks moored in the Medway were also buried there. Burntwick Island is the last resting place of a young naval surgeon who died helping the cholera victims. In the 18th century nearby Stangate Creek was home to a notorious gang of Kent smugglers.

Brief mention must be made of St Mary's Island, the northern tip of the Royal Dockyard Chatham surrounded by the Medway to the north and the dock to the south. It is believed to have been another site used for burying more of the French prisoners of war

who died in the Medway prison hulks during the Napoleonic Wars. The navy left the dockyard in 1983 and it has since been redeveloped for housing.

In World War 2 the advent of aerial bombardment meant defensive forts were needed in the gaping mouth of the Thames estuary, an area with no natural islands. The solution to this problem was to produce the most bizarre islands of all in this volume. Forts were needed and civil engineer Guy Anson Maunsell designed two types. The first, for the navy, comprised

**The Hoo Island railway as seen in the early 1980s.**
Industrial Railway Society

gun platforms mounted on top of a pair of cylindrical towers. They were built on land and towed into position on sandbanks where they were sunk. The four were Knock John, Sunk Head, Tongue Sands and Rough Sands, of which we will read more in a later chapter. Not only did they fire on enemy aircraft approaching the Thames but also extended radar coverage to detect aircraft dropping mines in the estuary.

Maunsell's second type of fort was designed for use as anti-aircraft defence for the army. Comprising seven interconnected steel platforms, made up of five gun platforms, a control and accommodation centre and a searchlight tower, they were sited in the estuary at Nore, Red Sands and Shivering Sands. Four civilians died when a Norwegian ship struck Nore in 1953. It was dismantled in the late fifties when the forts were decommissioned.

**The Grain Tower Battery.**
Mathew Marschner

In 1964 wind and tide monitoring equipment was placed on the Shivering Sands searchlight tower by the Port of London Authority, transmitting data back via a radio link. About the same time, others had similar ideas, especially as the forts made superb antenna platforms.

That year, shortly after the launch of pirate station Radio Caroline, rock musician Screaming Lord Sutch established Radio Sutch in the Shivering Sands tower. His manager Radio Calvert renamed it Radio City and expanded it into all five surviving towers. Red Sands was occupied by Radio Invicta, later KING Radio, an easy-listening channel, while Radio Tower briefly aired from Sunk Head. Calvert's later killing in a dispute with a director of a rival outfit was believed to be a contributory factor in the government's banning of pirate radio in 1967, when the BBC launched Radio 1.

**Knock John Fort in the Thames estuary.**
Hywell Williams

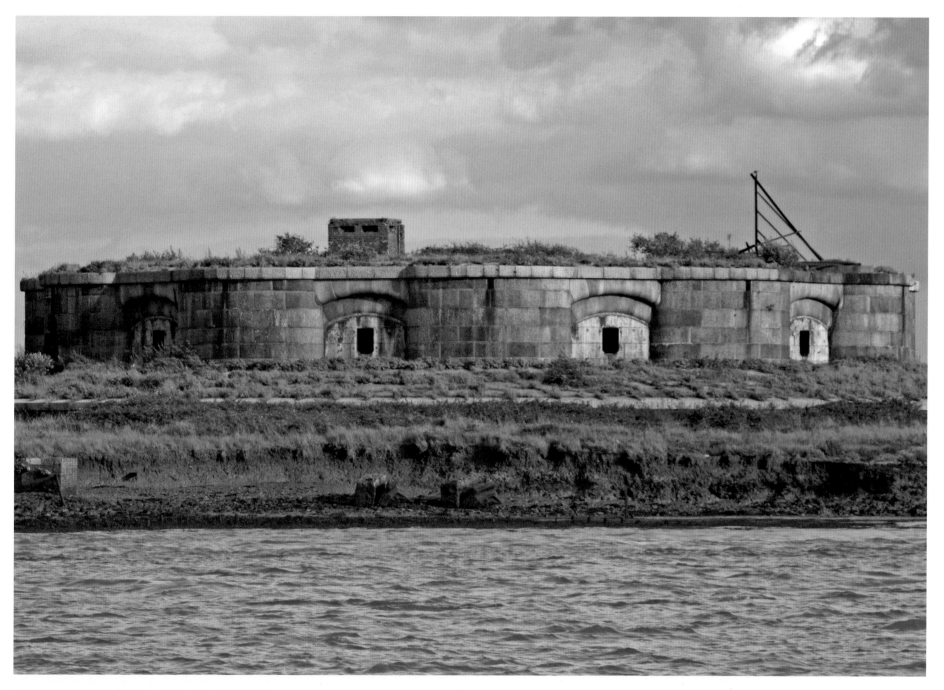

**Darnet Fort in the Medway estuary, a 'twin' to Hoo Fort.** Nick Drury

# 20 Canvey Island

Aerial view of Canvey Island from the north and east, showing the flood barrier and bridge at Benfleet Creek, which maintains its 'islandness'. Terry Joyce

So far, we have mainly visited islands in the traditional sense of the word, that is, a landmass which is above sea level and is surrounded by water. Canvey Island fulfils the first criteria – but certainly not the second, as the entire island lies about 10ft below mean high water. The island is ringed by 15 miles of concrete seawall. Without this stout modern sea defence a storm surge could lead to a repetition of the North Sea flood of 1953, when 58 islanders lost their lives and the entire population of 13,000 was evacuated.

Already settled by the Iron Age, Canvey has always been prone to flooding at exceptional tides. It's therefore surprising to learn that in the first half of the 20th century, it was the fastest-growing seaside resort in Britain. Londoners escaping the city smog swelled the population of the agricultural settlement from 300 to more than 40,000 today. Despite the danger of inundation people still choose to remain there.

The island is typical of others in Essex and the low-lying alluvial estuarine coast, with its networks of creeks, fringing salt marshes, mudflats and offshore sand banks.

Canvey takes its name from the Cana, descendants of both the ancient British tribes known as the Cantiaci and the Catuvellauni. Historically, it provided offshore pasture, mainly for sheep farming but salt extraction, fishing and cereal production took place from Roman to mediaeval times, with Chelmsford and London providing ready markets.

The first basic sea defences, built during the reign of Edward II, met with minimal success. That was to change in the 17th century when 200 Dutch immigrants arrived after fleeing the forces of King Phillip II of Spain under General Ferdinand Alvarez de Toledo, the third duke of Alba, known as the butcher of Flanders after he massacred thousands of men, women and children. These asylum seekers brought with them extensive knowledge of constructing sea walls and dykes to protect low-lying lands. Two traditional Dutch octagonal cottages from this era have survived: one is now a museum and the other, sited in Canvey village itself, is a private house.

The first sea wall to completely surround the island was built in 1622. The following year a local landowner reached agreement with renowned Dutch water engineer Cornelius Vermuyden to maintain the walls in exchange for a third of his land. The Dutch workers were also paid in land. About 3,600 acres were reclaimed by building stronger walls, filling in small creeks and digging a main drainage ditch with seven sluices to empty into the river. Nonetheless, Canvey suffered severe flooding in 1731, 1736, 1791, 1881 and 1897.

Even when reclaimed, the damp and foggy marshlands were an unhealthy place to live and like Sheppey, in times past there were malarial outbreaks. Daniel Defoe said that many islanders had married several times because brides brought in from outside had no immunity to the disease and quickly became sick and died – a classic British island fever.

The floods which devastated the east coast of England in 1953 reinforced the fact that the sea remains an ever-present danger to Canvey. While much of the island was inundated, Canvey village, the highest point at two feet above sea level, escaped the worst effects. The walls were subsequently raised and further major

The Canvey Island ferry, seen in 1821, was superseded by the first road bridge 10 years later.
Robin Jones Collection

defensive works were completed in 1982. They include flood barriers across Benfleet Creek to the north and East Haven Creek in the west. Natural and artificial dykes, culverts and lakes feed seven pumping stations and gravity sluices, which in turn discharge water into the Thames and the creeks. Yet how long can the walls hold back the tides?

Since the end of the Ice Age, the land continues to readjust to the removal of the huge weight of glaciers. South east England is still sinking at the rate of 2mm a year and northwest Scotland is rising.

Add that to the current melting of the polar ice caps through global warming, and the long-term survival odds of places well below sea level start to diminish.

Canvey became a fashionable place to visit in Victorian times when its sea air was believed to have healing properties, and in 1903, developer Frederick Hester unveiled major plans for Canvey, with a six-mile-long Winter Gardens housing exotic plants, fishponds and fountains. He sold plots of land for holiday homes and laid out streets, giving many Dutch names – but his dream was shattered when a high spring tide in 1904 again caused flooding and deterred potential investors.

Canvey was then still an island in the truest sense of the word: to access the mainland you had either to catch a ferry across Benfleet Creek or use the stepping stones at low tide. Cars, carts and lorries were often abandoned when the drivers left it too late and were caught by the rising tide.

The 20th-century transformation of Canvey from a farming community to a sizeable town has seen it split into two communities. To the east lie housing estates, public facilities, a small holiday camp and seafront, although Canvey has severely declined as a resort since the seventies because of cheap Mediterranean holidays. To the west lie marshes, farmland and industrial areas.

In 1936, the oil refinery business took off on Canvey and, despite public opposition, the western side at Hole Haven was given over to this purpose along with oil and gas storage.

When a gas terminal was opened in 1959 Canvey was the site of the first delivery in the world of liquefied natural gas by container ship. The terminal built by the British Gas Council was designed to store and distribute imported gas to the whole of the country, but progress in this field halted when North Sea oil and gas were discovered. In the mid-1970s, an official report raised concern about the risk to local residents of oil refineries on Canvey, and the fears were underlined by a failed IRA bomb attack on the Texaco oil terminal in 1979.

Much of the abandoned land on which Occidental Petroleum began building (but never completed) a refinery in the 1970s has now been reclaimed as Canvey Wick nature reserve and is designated a Site of Special Scientific Interest. Many endangered species of wildlife thrive here, including the emerald damselfly, the shrill carder bee, and the weevil hunting wasp, while West Canvey marshes were acquired by the Royal Society for the Protection of Birds in 2007.

It has now been suggested that West Canvey should be allowed to flood. In its Thames Estuary 2100 project flood defence plan, the Environment Agency mentions west Canvey as a site which could be temporarily used to contain floodwaters at times of risk to London and the Thames estuary. An alternative proposal was for the site to be turned back into wetlands which can absorb excess water.

Again, maybe the dark day will come when Canvey, like Canute, will have to accept that it cannot halt the inevitable forever.

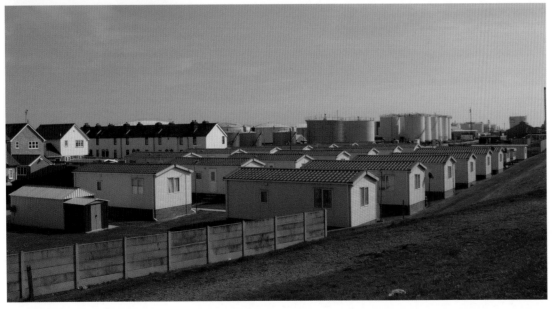

**Canvey conflict: suburban houses and holiday homes sit amidst oil storage tanks on the west side of the island.** Robin Jones

In 1931, the Colvin Bridge from Canvey to South Benfleet was completed. The day it opened was declared a local holiday and celebration parties held all over the island. In 1972, the new A130 provided a second road to the island, with a bridge across East Haven Creek. Without the impediment of a tidal crossing, Canvey Island became highly urbanised with a mixture of suburban development and holiday homes; the remaining green spaces are preciously guarded.

Top left: **Canvey Island's coat of arms: the snow-white droplets invoke salt extraction, the oyster shells mark another historic industry and in the centre is the fat-tailed sheep that formed the basis of the island's cheese-making industry. The sea walls are represented by the inner golden escutcheon divided into seven equal parts, representing the seven main drainage sluices that had previously been present. The Dutch cottage stands on the crest with the motto 'Ex Mare Dei Gratia' meaning 'from the sea by the Grace of God'.** Robin Jones

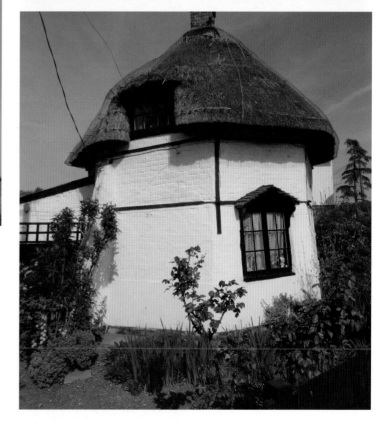

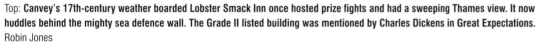

Top: **Canvey's 17th-century weather boarded Lobster Smack Inn once hosted prize fights and had a sweeping Thames view. It now huddles behind the mighty sea defence wall. The Grade II listed building was mentioned by Charles Dickens in Great Expectations.** Robin Jones

Above: **The magnificent restored modernist Labworth Café, a listed building on Canvey's sea front, was designed by Ove Arup in 1932 to resemble the bridge of the Queen Mary.** Robin Jones

Top right: **The Red Cow pub in Canvey village was used as headquarters of the emergency relief operation after the 1953 flood disaster. It was subsequently renamed the King Canute, recalling the Dane who became monarch of England and demonstrated that even he could not command the tide to halt.** Robin Jones

Right: **The surviving Dutch cottage in Canvey village.** Robin Jones

The Quay on the River Roach. Foulness was first mentioned as a port in 1326, and there were once several public landing places, including Fisherman's Head on the Thames estuary. In the 1850s there was a regular fortnightly barge service to London. Robin Jones

Foulness is a prime contender for the most mysterious island in Britain. In 1915 the Ministry of Defence began buying land and property on the island and has severely curtailed public access ever since.

If you thought Thorney Island was awkward to visit because of military restrictions, Foulness is all but impossible, unless you live there or have an invitation from a resident.

There is a concession for the general public to visit on one Sunday a month during the summer. You can sign in at the gatehouse at Great Wakering and obtain a permit for a single car trip along the military road as far as the island heritage centre in the old schoolhouse in the main settlement of Churchend where there is an exhaustive collection of local history artefacts. The time allowed on the island is just four hours.

There is one public road which can be used when the Shoeburyness firing ranges are not in operation, but one glance at it will deter most motorists. It is an ancient and very potholed causeway and public right of way known as the Broomway; at low tide it crosses the mudflat desert that is Maplin Sands. Once at Churchend, by either road, there are several footpath rights of way to the sister settlement of Courtsend, the island quay on the River Roach, a quite delightful spot, and to Crouch Corner on the Crouch.

The military road crosses Havengore and New England, the other two islands which make up the archipelago, to reach Churchend. Foulness is the biggest at 5.28 by 2.67 miles. Much of the flat, almost fen-like, landscape is purely agricultural, but there is also a wide and varied assortment of military buildings which have been omitted from Ordnance Survey maps for decades. Many appear to be standard World War 2 or 1950s brick-built structures, while others have weird and wonderful shapes which smack of 21st-century high-tech research. Elsewhere, tracts are used for weapons testing, with red flags to indicate when public footpaths may not be used. Needless to say, under the military bye-laws which govern the island, you are not permitted to stop and take photographs en route, and there is an uneasy sense throughout your journey that you are being watched.

The island is currently leased from the MoD by QinetiQ, an international defence technology company formed from the greater part of the UK government's Defence Evaluation and Research Agency, when it was split up in June 2001. DERA was Britain's biggest science and technology organisation, and in the absence of public data, what type of research is or is not being carried out in the Foulness establishments is unknown to the general public.

The military arrived in the locality in 1849 with the establishment of an artillery range at Shoeburyness, because the ranges at Woolwich Arsenal were unable to test new rifle guns. There followed decades of protests from fishermen and barge operators who complained about near misses.

Like Canvey, most of Foulness is below high-water level and is protected by an MoD-maintained sea wall 13 miles long and gravity drained through a network of ditches and sluices.

In 1973, an Act of Parliament authorised the construction of a

third London Airport on Foulness and Maplin Sands. The scheme was later dropped – partly because of the fowls that give their name to Foulness, the 'ness' meaning a promontory. It was feared that huge flocks of birds would present a real danger to jet engines.

The population of the island is about 200. About 6% are employed in agriculture, 7% by the military and 40% work on the mainland. The remainder are children or pensioners. Before the artillery moved in, farming was the principal occupation on Foulness. The marshes supported sheep in medieval times and were later turned into arable land, the crops raised on them winning many national and international prizes for their high quality.

On the mudflats, fishermen employed traps made from osiers, known as weirs, staked nets and baited hooks on 'long lines' anchored to pegs, with the catch finding its way to Billingsgate Market in London. There was also a strong regional dialect known

**The Royal Society for the Protection of Birds is behind a multi-million-pound project to create a bird reserve by returning part of Wallasea's farmland into wetlands, mudflats (pictured) and salt marsh by bulldozing 350 yards of the sea-defence wall. Wallasea comprised three islands in the Middle Ages before land was reclaimed.**
Ben Hall/RSPB

Right: **Churchend's 17th-century listed George and Dragon pub closed in 2007, the landlord blaming the restrictions on access to Foulness for its demise.** Robin Jones

Far right: **Churchend's post office and stores.** Robin Jones

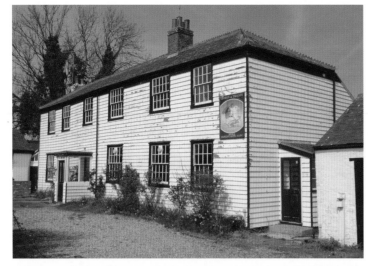

Right: **The present church in Churchend was consecrated on 3 July 1853, but there has been a place of worship since 1283.** Robin Jones

as the 'Foulness brogue' which has all but died out – was this a classic case of an island language in its very embryonic stage, I wonder?

HMS *Beagle*, the ship that took Charles Darwin on his landmark voyage of discovery, is believed to have ended its days on Foulness as a static coastguard watch vessel blocking one of the channels in a bid to curb smuggling. It was sent for scrapping about 1870.

Wallasea Island lies across the River Roach from Foulness, and though perhaps even more deserted, mainly comprises flat farmland whose principal crop is wheat. About eight miles of the sea wall can be walked. A marina and pub are to be found at the western end of the island from where there is a river ferry to Burnham-on-Crouch.

Opposite page top: **The busy marina at Wallasea Island presents a sharp contrast to secretive Foulness.** Robin Jones

Opposite page bottom left: **The old schoolhouse at Churchend has been converted into a heritage centre for secretive Foulness Island.** Robin Jones

Opposite page bottom right: **The only public road to Foulness Island is the ancient low-tide causeway known as the Broomway. Fancy driving over it for three miles? In 1973 this massive expanse of mudflats was earmarked for London's third airport.** Robin Jones

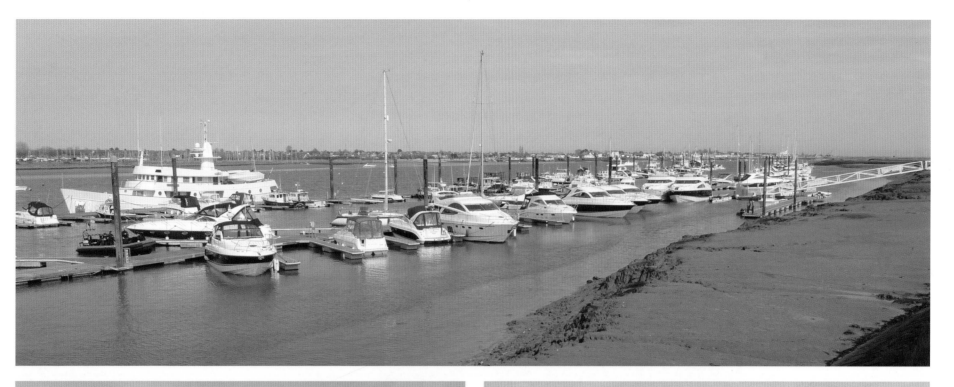

The parish church of East Mersea.
Robin Jones

It was on 10 August 991 that a band of men camped on tidal Northey Island in the estuary of the River Blackwater in Essex struck terror into the heart of all England. They were Vikings and had carried out a series of raids along the nearby coast.

Under their leader Anlaf, they made their base on Northey, prior to one of the Danes' greatest victories in Britain, the Battle of Maldon. They were confronted by an Anglo-Saxon force under Earl Byrhtnoth, and demanded Danegeld to withdraw. Byrhtnoth refused to pay, but had to wait until the tide went out, exposing the causeway leading to the mainland, before doing battle. He allowed the Vikings to use the causeway so they could fight, and the battle commenced a few hundred yards inland. Byrhtnoth was killed by a poisoned spear, and while some of the Anglo-Saxons panicked and fled, others stood by the earl's body, and fought to the last man. The battle inspired an epic poem composed four years later.

Northey Island today is a far more peaceful place, largely comprising salt marsh and inlets. Owned by the National Trust, which lets out one of two houses there, it's a nature reserve and birdwatchers paradise.

In 1933 the tower house was designed and built by writer, lecturer, political commentator and Labour MP Norman Angell, a member of the Executive Committee of the League of Nations and winner of the Nobel Peace Prize in the same year. He died in 1967 aged 94. Permission needs to be sought in advance to drive across the short causeway, accessed via a private drive from South House Farm, and only uncovered two hours either side of high tide.

Just over a mile downstream lies a second larger tidal island, Osea. In private ownership it claims to be the world's first and only island entirely dedicated to addiction treatment and mental health. It is connected to the north bank of the river by a long S-shaped tidal causeway, marked out by stakes in the glistening silver mud. The island had a small village community with houses dating back to the 16th century.

In 1903 it was bought by Frederick Nicholas Charrington, a member of the Charrington brewing family, and founder of the Tower Hamlets Mission, a Christian drug and alcohol dependence charity. He established a retreat for alcoholics on the island, after witnessing a drunken husband slamming one of his firm's pub doors in the face of the wife who was begging him to come home to his family. His conscience was touched.

He planned to turn Osea into a temperance isle, and brought in East End labourers to build houses, roads and a village store. Palm trees were planted and he even introduced wallabies from Australia.

Charrington's benevolent scheme was halted by World War1, when the island became a coastal motor torpedo boat base with 2,000 sailors billeted in temporary huts. Captain Augustus Willington Shelton Agar was awarded the Victoria Cross while based there. In 2004 the island was bought for £5.4million by Nigel Frieda, brother of celebrity hairstylist John Frieda, and became an exclusive and discreet rehabilitation centre specialising in the treatment of drug and alcohol dependency, stress-related illnesses and psychological problems. The private health care organisation is appropriately known as the Causeway Retreat.

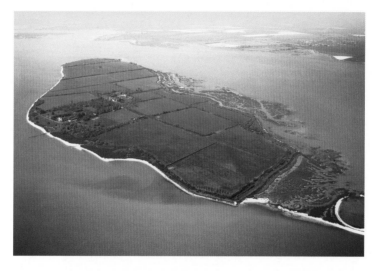

**Osea Island as seen from the air.**
Causeway Retreat

Its red-brick Manor House with its own power and water supply offers five-star rooms and sports facilities like tennis and fishing, and several celebrities have undergone treatment there. It was widely reported that the soul singer Amy Winehouse, who had a major chart hit with *Rehab,* had a brief spell on Osea.

The island is an ingredient of the therapy, cutting people off from the world and offering a sense of a new beginning. It has no pubs or bars and those on the mainland can only be reached via the causeway at low water.

The Causeway Retreat is not the only business run under the Frieda regime on Osea. Another building accommodates a state-of-the-art recording studio where top chart acts like the Sugababes have cut discs.

Osea is yet another island with early flying history. The British Deperdussin Aeroplane Company tested a newly-developed single-engined seaplane at Osea in 1913. Piloted by managing director Lieutenant Porte, it successfully flew for 10 minutes.

The third and biggest tidal island along the Blackwater estuary is Mersea, reached by a causeway and bridge known as The Strood (which dates from Roman times) it carries the B1025 from Colchester across Pyfleet Channel. It can become briefly impassable at high spring tides.

Mersea, formerly spelled Mersey, derived from the Old English 'meresig', meaning 'island of the pool' is the easternmost inhabited island in Britain and covers about seven square miles. It is one of the real gems of the Essex coast. With a population of about 11,000, the main centre is West Mersea, which has grown into a sizeable town with luxury houses and weekend cottages for the sailing community based there. Property prices are higher than average, but because of its island nature, the town boasts a lower than average crime rate.

The main industries on Mersea are farming, fishing, the gathering and breeding of oysters (known as 'West Mersea natives') and servicing the leisure boating industry. The eastern shore is taken up by houseboats accessed by plank walkways through the salt marsh.

The beach surrounding the island is mainly sand and shingle, turning into mudflats as the tide recedes, and in recent times a long row of multi-coloured luxury beach huts has been erected.

To the west of the main town lies the harbour and focal point of the sailing community.

Held in late summer the Mersea Regatta is a week-long festival of racing, some around tiny Cobmarsh Island. The regatta culminates in a grand finale on the Saturday, with street entertainment, a funfair and the presentation of awards for the week's racing. One highlight is the Greasy Pole contest. Contenders have to make their way over a telegraph pole/mast covered in thick grease and extended out over the water from the deck of a Thames sailing barge, retrieve the flag at the end and bring it back.

The 'in' place to eat at West Mersea is the 'Company Shed'. Opened in the 1980s to sell cockles and prawns to locals, it has evolved into one of the most renowned seafood restaurants in Britain, serving superb-quality fresh fish and shellfish. Housed in nothing more stylish than a large wooden shed, customers must bring their own bread and alcohol to accompany the food and can expect to wait 30 minutes for a table. Despite these shortcomings visitors come from as far away as Australia.

The scattered settlement of East Mersea has a parish church (where the Reverend Sabine Baring-Gould, who wrote 'Onward Christian Soldiers', was rector), a post office and even a vineyard. Baring-Gould was linked with tiny Ray Island, a sandy mound in the saltings, and which is now owned by the National Trust, which keeps a flock of rare Soay sheep there.

**Servicing pleasure boats is one of West Mersea's main industries** Robin Jones

**Pastel-coloured modern beach huts form a backdrop to West Mersea's sandy beach.** Robin Jones

**Where conquering Vikings marched to victory: the causeway to Northey Island.**
Robin Jones

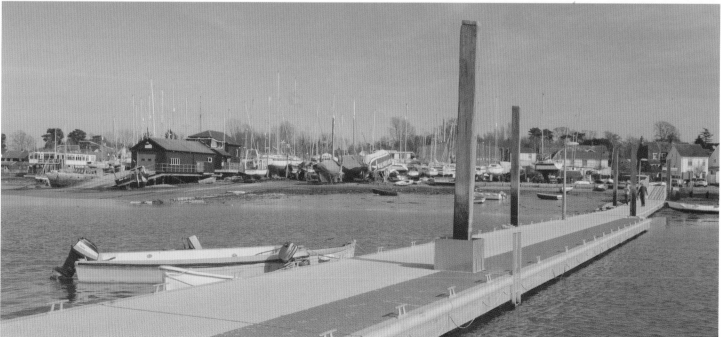

**The pontoon at West Mersea harbour.**
Robin Jones

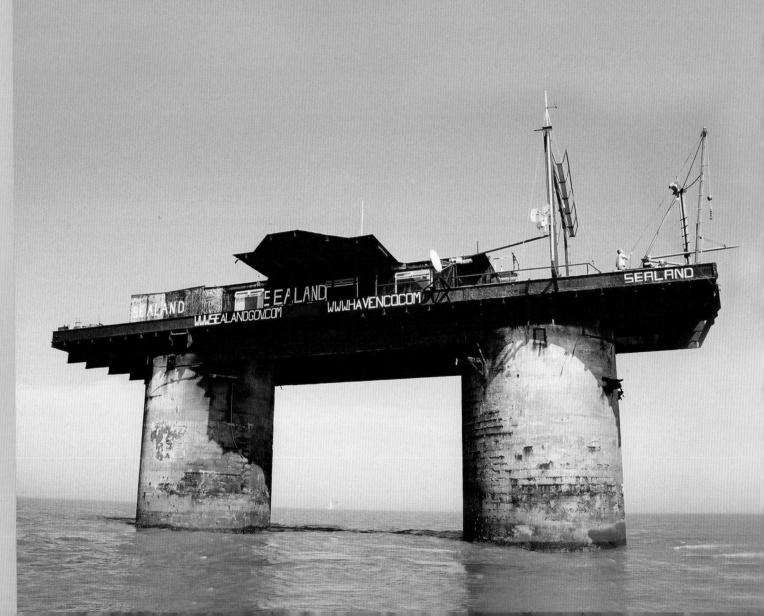

Sealand holds the Guinness World Record for the smallest area to claim nation status, and even has its own international sports teams. However, its ruler Prince Roy Bates cancelled all Sealand passports in 1997 after forgeries were used to open bank accounts under false names in various countries for criminal purposes. Many of the forgeries were sold to people leaving Hong Kong at the time of Chinese reoccupation for $1,000 each.

On 23 June 2006, the uppermost platform caught fire owing to an electrical fault. An RAF helicopter lifted one person from the platform to Ipswich Hospital, while the Harwich lifeboat turned out until the blaze was brought under control by a fire tug. It took five months to repair the damage. Kim Gilmour

This book set out to cover the coastal islands of England and Wales. However, a 'third country' has also been included: the Principality of Sealand.

Lying six miles off the Suffolk/Essex coast, and looking like a distant oil-rig platform, is another of the World War 2 Maunsell naval forts built to guard the Thames estuary. In 1967, the fort declared independence, issuing its own passports, stamps and coins and even having its own representative international sports teams.

The structure was built on dry land in 1942 as HM Fort Rough, and towed to Rough Sands sandbar where it was sunk. Occupied by up to 300 Royal Navy personnel, the last full-time servicemen left in 1956 and the fort, in international waters, was abandoned.

On 2 September 1967, during the heyday of pirate radio, the fort was occupied by Major Paddy Roy Bates, a British subject. He ejected a rival group of pirate broadcasters so he could use it for his own unlicensed station, Radio Essex, and settled there with his family. In 1968, the Royal Navy tried to service a navigation buoy near the fort. Bates' son Michael attempted to scare the workmen off by firing warning shots from the platform, by then renamed Sealand. As a British subject, Bates was accordingly issued with a summons. However, the court decided on 25 November 1968 that as Sealand was outside the three-mile limit of British territorial waters, it had no right to hear the case. Bates then argued that from a legal point of view, Sealand therefore constituted extra-national territory — and could be settled and claimed as a new state. In 1975, Bates produced a constitution for Sealand, complete with flag, national anthem, its own money and passports.

His country faced its first major crisis three years later, when, in Bates' absence, the self-styled Prime Minister of Sealand, German lawyer Alexander Achenbach, backed by a group of German and Dutch citizens, invaded the platform and took his son Michael prisoner. He was released several days later in The Netherlands. With armed back-up, Bates mounted a helicopter assault on the Platform and 'liberated' Sealand. The invaders were taken prisoner and repatriated, apart from Achenbach, who held a Sealand passport and was charged with treason. He was told that he would have to pay $35,000 for his release.

The governments of West Germany and The Netherlands asked Britain for his release, but the UK said that, in accordance with the 1968 court ruling, it had no responsibility for Sealand. West Germany sent a diplomat from its London embassy to Sealand. After several weeks of talks Bates released Achenbach — claiming a landmark victory as he reckoned that the diplomat's visit constituted official recognition of his country by West Germany. Achenbach was repatriated, but immediately established a Sealand

government in exile, handing over the position in 1989 to one Johannes Seiger, who continues to claim that he is the rightful ruler.

Bates, however, has declared Sealand a constitutional monarchy with himself, Prince Roy, as sovereign ruler, his wife as Princess Joan, and their son as His Royal Highness Prince Michael, Prince Regent since 1999. Michael's son, who represented Sealand at a conference of micronations at the University of Sunderland in 2004, was referred to as Prince Royal James. Under the constitution, Sealand has an appointed but advisory senate and legal tribunal (the legal system following UK common law), and a Sealand Guard which alone has the right to bear arms on the 'island.' Like many smaller nations around the globe, Sealand has issued many beautiful sets of stamps and coins for collectors, as an extra national income stream. Bates' coinage succeeded where Lundy's failed. The unit of currency is the dollar, in parity with the US version. The government in exile in Germany has also issued a coin. Another industry is the provision of an offshore internet hosting facility. It has an official Sealand government website and publishes Sealand News online.

On 1 October, 1987, Britain extended its territorial waters from three to 12 nautical miles, encompassing Sealand. The previous day, Bates also extended Sealand's territorial waters to 12 nautical miles, so that the right of way from the open sea to Sealand would not be blocked by British-claimed waters.

In 1990, warning shots were again fired when a ship came too close to Sealand and its crew complained to the British authorities, who did not pursue the case — adding weight to the Bates argument that the Home Office still considers Sealand to be outside its territory.

Sealand has its own national football team — but half the world away, at Muhlenberg North High School in Greenville, Kentucky, run by high school soccer coach Rory Miller. Its first official athlete was Darren Blackburn of Ontario, Canada, who since 2003 has represented the country in marathons. Mountaineer Slader Oviatt is said to have carried the Sealandic flag to the top of Muztagh Ata in the Tibetan Plateau in 2004.

In 2007, Michael Martelle represented Sealand in the World Cup of Kung Fu in Quebec City, winning two silver medals and becoming the country's first-ever athlete to appear on a world championship podium. Furthermore, Sealand won a world championship in 2008 — for egg throwing.

In 2007, Sealand was offered for sale for £600 million through Spanish estate company Inmo Naranja, but as a principality cannot technically be sold, the owners were offering to transfer 'custodianship'. By then Bates had retired to Essex, leaving caretakers to administer his principality.

**Coins of the realm.** Sealand

**A series of 'pirate' stamps issued by Sealand.** Robin Jones

A view across the saltings of Hamford
Water Nature Reserve to Horsey Island,
where the barn-like structure is close to
the point where the Explorers in Secret
Water would have made their camp.
Arthur Rope

We have already visited Foulness, the secret island of Essex. Now it is time to look at the county's *Secret Water*, the title of the eighth novel in Arthur Ransome's *Swallows and Amazons* series of children's books published in 1939.

The series is hugely popular in Japan and every year coach-loads of Japanese tourists turn up in the Lake District where the first novel in the series was set. Few venture to the opposite side of the country and the islands of Hamford Water near Walton-on-the-Naze, Horsey and Skipper's Islands, where *Secret Water* was set.

The novel draws the *Swallows and Amazons* characters together while introducing a new set, the Eels and the Mastodon. Ransome used to sail to Hamford Water in his yacht *Nancy Blackett*, and drew on his experiences of this tidal region which has surprises at every twist and turn. In the book, the Swallows intend to sail in the *Goblin* to Hamford Water and camp with their father, Commander Walker, but he is suddenly called away on navy business. Not wishing to disappoint them, he maroons them with a small dinghy on one of the islands, with an outline map of the area they decide to call Secret Water, and asks them to survey and chart it before he returns to pick them up. The father has also arranged for the Amazons to visit from the Lake District and join them with a second dinghy.

They see some mysterious footprints which turn out to belong to a local boy who lives on a derelict barge. They nickname him the Mastodon because of the huge circular footprints made by the giant mud-shoes which allow him to walk across the soft mud banks. In turn, he mistakes them for the Eels, a family of regular campers. The Eels arrive and are at first hostile – they are considered 'savages' – before the groups decide to engage in a friendly war. What with all this going on and being cut off by the tides, the task of completing the chart is jeopardised, but on the last morning, two groups of children complete it.

Hamford Water is a labyrinth of creeks, salt marsh, channels and marsh grasslands also known in part as the Walton Backwaters. The biggest island is Horsey (Swallow Island in the book) and, as in Ransome's day, it is reached via a half-mile causeway that forms a continuation of a lane from Kirby-le-Soken and still has a farm at its centre. The rutted causeway leads to a small jetty on the island from where a track leads to the farm and nowhere else. In the book, the children referred to it as a 'native kraal'. After landing on Swallow Island, the children unwrap their provisions: 'Three tins of pemmican... six tins of sardines... one tin of golden syrup... one stone jar of marmalade... six boxes of eggs.' Happy days indeed!

Today, a managed retreat scheme to allow parts of the island to be flooded and revert to salt marsh is in place.

Skipper's Island is next in size and was called Mastodon Island in *Secret Water*. It is also part of the internationally recognised Hamford Water National Nature Reserve managed by Natural England and the Essex Wildlife Trust, and a key breeding ground for little terns, and a breeding ground for dark-bellied Brent geese, waders and wildfowl. Its communities of coastal plants include species that are extremely rare in Britain, such as sea hog's fennel.

Visitors must have prior permission from the Essex Wildlife Trust to access Skipper's Island, which can be done on foot, across a series of wooden plank bridges on a path from the end of a private road leading from the same village, but via Birch Hall.

Both islands can also be viewed from the sea defence wall around the southern edge of Hamford Water, a public right of way, or, as in *Secret Water*, by boat.

The Walton Backwaters are home to a colony of more than 70 harbour and grey seals, who have acquired an unusual ginger colour due to the iron oxide-rich mudbanks that they lie on. Like the children in *Secret Water*, the seals adore the backwaters, in their case because, like the sea, they are permanently ice-free.

Above: **Editions of Secret Water by Arthur Ransome.**

Left: **The rubble-built tidal causeway to Horsey Island.** Robin Jones

Many of north Norfolk's beaches remain deserted, even in peak season, and few frequent the island on the far side of the creek, making it a rich haven for wildlife and an international environmental treasure. Robin Jones

Why search the Caribbean for sun-drenched deserted white-sand beaches when you have Norfolk on your doorstep? Much of the county's northern coast fits the description, but don't mention the wind that made Skegness in neighbouring Lincolnshire so bracing.

Rising sea levels following the end of the Ice Age inundated much of the rounded coastline of the county, leaving inlets through the sand dune belt in some places, in others, forming lagoons and marsh, and in one place, leaving part of it as an island.

A National Nature Reserve, Scolt Head Island is held to be the prime example of an offshore barrier island in the UK. Steadily growing westward, it is nearly three miles long and a third of a mile wide, and is a key centre for the study of coastal processes.

The north side is a sandy beach backed by high dunes, while the south comprises mudflats and salt marsh, also said to be the finest in the country, and one of the best documented environments of its kind in the world with rare plants including matted sea lavender and sea heath. It is internationally recognised as a key breeding ground for four species of tern – sandwich, little, roseate and arctic – and supports species of wader including shelduck, wigeon, teal and curlew.

One of the reasons why Scolt Head Island is so abundant in wildlife is because it is little frequented by humans. There is no bridge and it is only accessible by boat, although Overy Creek can be forded with great care at low tide. A ferry runs from the delightful sailing haven of Burnham-overy-Staithe during the summer months. The island is uninhabited and is in the care of Natural England, but an 'eco hut' has recently been erected for study purposes.

Top right: **Scolt Head Island, seen from the opposite side of Overy Creek.** Robin Jones

Above: **The new 'eco hut' on Scolt Head Island.** Paul McAlenan

Right: **Arctic tern. Scolt Head Island is a key breeding ground for four species of tern.**

A sandbank come good: aerial view of
Read's Island. RSPB

Is it real? That is the question that has long been asked about the only 'natural' island in the Humber, the great estuary formed by the merging of the River Trent and Yorkshire Ouse.

Read's Island, which lies just off the River Ancholme sluice in North Lincolnshire, is believed by many to be an artificial island. Others point out that for centuries it was a large sandbank named Old Warp, and marked as such on the 1734 customs map of the river.

Grass was recorded as appearing on Old Warp at the start of the 19th century as the Humber silt built up, and once walls of bricks and concrete were built, it was an easy task to reclaim the sandbank with a little help from nature. As further walls were added more of the sandbank was reclaimed from the Humber.

By the 1850s, there was a wooden cottage on the island supplied by a freshwater well. At one stage it was used for farming cattle; at very low tides the animals could cross the mud dividing the island from the mainland. The Read brothers of Burton Stather were believed to be the first farmers to graze cattle on the island, hence its name.

German prisoners of war rebuilt the flood defences during World War 1.

By the 1930s, Read's Island had extended to about 300 acres, and was renowned for its population of hares.

Every 20 years or so, the main shipping channel switches from north of the island to the South Channel, which separates Read's Island from the shore.

Today, the island is a Royal Society for the Protection of Birds reserve, considered particularly important as it hosts 6% of the British population of ground-nesting avocets.

Two other islands in the Humber are, however, undeniably man-made. They are a pair of forts built during World War 1 to guard the mouth of the river. Similar in appearance to the Solent forts, Haile Sand Fort lies on the low water mark between Cleethorpes and Humberston on the Lincolnshire coast, while Bull Fort rests on a sandbank in the middle of the river and was built with great difficulty as the sandbank is 11ft below low water. They formed part of a defensive chain which included fortifications and a military railway along Spurn Head, the great moving spit of sand that juts out into the estuary on the Yorkshire side, and which, should it be split off by a storm surge in future years, may become an island in its own right.

Bull Fort was constructed to a circular design on interlocking steel piles in the form of caissons. Its outer compartments were filled with concrete and the inner one with sand, the hole being capped with concrete. The individual floors were then added. The upper part of the fort is up to 50ft above high water and comprises three floors and a basement floor, with an outer wall of concrete faced with 12in thick armour plating.It accommodated a garrison of 200 men and provided all necessary facilities.

Haile Sand Fort is similar in design but slightly smaller. When completed, the Humber forts were hailed as an outstanding triumph of modern engineering.

The forts were pressed into service again in World War 2 and were a constant target for German aircraft and submarines. A net

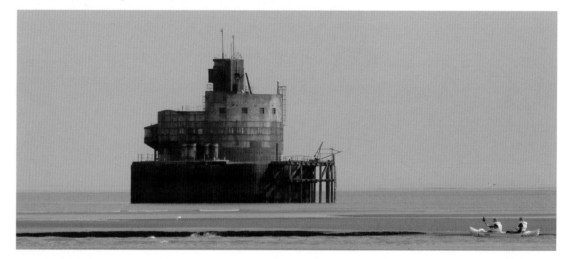

**Haile Sand Fort, off the Lincolnshire coast.** Ian Paterson

was installed to prevent the enemy submarines accessing Hull or Grimsby. The garrison was supplied with fresh water pumped up from an artesian well below the estuary bed. In 1956 the army left the forts, which were manned by civilians until the early sixties, when the Humber Conservancy Board took over.

Pre-empting the Principality of Sealand, it was suggested that if a quarter of a mile of Spurn Head was eroded away, Bull Fort would be outside the three-mile limit of British territorial waters and could become a duty-free haven.

Bull Fort became a navigational aid, topped with a huge bell automatically rung by a gas-pressure hammer. An automatic tide gauge was installed to inform ships whether they have sufficient clearance to navigate the Humber.

In 1997, the fort was bought by drugs charity Streetwise, with the aim of turning it into a sanctuary where hardened drug addicts could be isolated from their dealers and weaned off – a diametric opposite to a tax-free drinkers' paradise. Streetwise subsequently obtained planning consent to transform the fort into a residential centre providing a free on-demand 30-day detox programme.

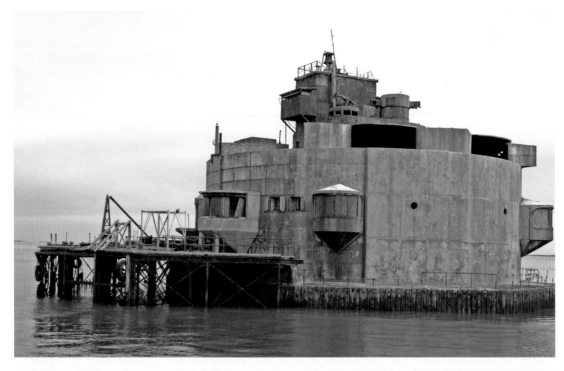

The charity said that the project, renamed Island of Hope, would be able to help 240 addicts every month and would be the largest facility of its kind in the world.

Streetwise trustee Philip Ball said: 'It may look like Alcatraz but to them it's an island of hope.'

At the time of writing, fundraising for the ambitious and very worthwhile project was still underway in earnest, while a team of volunteers have spent years making the fort fit for habitation once more. RAF helicopters lowered generators to provide power for the tools needed to convert the building.

Haile Sand Fort was bought privately in 1991. Although it too is not open to the public, it is physically possible to walk out to it at low tide, but that is not recommended because the speed of the incoming tide can cut walkers off.

Left: **Bull Fort was hailed as a marvel of engineering.** Streetwise

Below left: **All at sea: Bull Fort at the mouth of the Humber.**

Below: **The ongoing project to modernise the interior of Bull Fort in progress.** Streetwise

Opposite page: **Read's Island with the Humber Bridge in the background, as seen from the Lincolnshire shore at South Ferriby.** Robin Jones

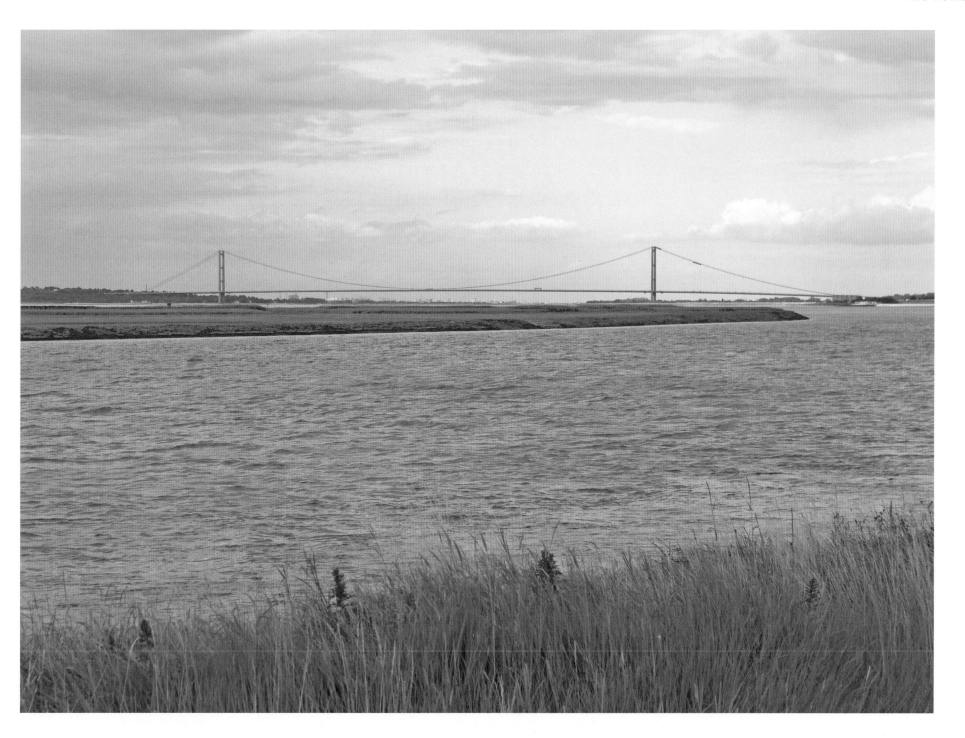

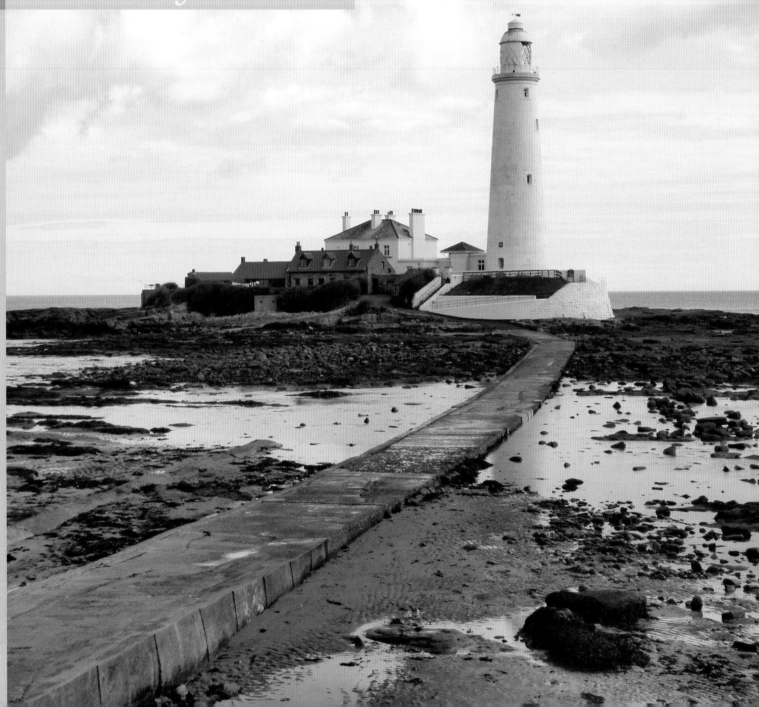

St Mary's island and lighthouse at low
tide with the causeway exposed.
Ray McNaughton

The popular Tyne and Wear beauty spot between Whitley Bay and Seaton Sluice that is the tidal island of St Mary has a rich history that belittles its tiny size. It is thought to have been the home of hermits in the early days of Christianity, prior to the Viking invasion of 800, and the monks associated with the priory of Tynemouth built a chapel dedicated to St Helen there about 1090. It was said to have had a tower where a lantern was kept burning to warn ships about the rocks below, starting a great tradition of lighthouses on the island which is still ongoing.

After the dissolution of the monasteries, the island passed to Queen Elizabeth I's surveyor for Northumberland, Thomas Bates, and was known as Bates Island. The current OS map has it as 'Bait Island' because the original mapmakers thought the name came from bait dug up by fishermen.

The deep channel in rocks on the north side is known as Smugglers Creek, and in 1722 Surveyor of Customs Anthony Mitchell was found dead nearby, thought to have been murdered by brandy runners.

Michael Curry, a worker at the Royal Sovereign Glass Works in Seaton Sluice, was executed in 1739 for killing Robert Shevil, landlord of the inn at Old Hartley, and his body hung from a gibbet at the landward end of the tidal causeway, at what is known today as Curry's Point. A plaque was unveiled there in 1989 to mark the 250th anniversary.

Pre-empting Flat Holm by a century, St Mary's was used in 1799 as a cholera isolation hospital for Russian soldiers *en route* to fight Napoleon, and those who died were buried here.

In 1855, fisherman and publican George Ewen built a cottage on the island and in 1862 turned it into a pub, the Freemason's Arms, with water piped from a stream on the headland. A skeleton found on site, maybe one of the Russians, was kept in the cellar and visitors were charged to see it. Ewen was evicted in 1894 in a dispute over the ownership of the cottage, and was replaced by a tenant John Crisp, who turned it into a temperance hotel.

Centuries of shipwrecks occurred on the island, finally the *Gothenburg City* from Montreal was wrecked in thick fog in June 1891. No lives were lost but it led to the erection of a fully-fledged lighthouse in 1898. Built by the John Miller Company of Tynemouth it took 645 stone blocks and 750,000 bricks and it quickly became a landmark for the area. After it was decommissioned in 1984, it was reopened as a visitor centre. Visitors can climb its 137 steps to reach the lantern and enjoy the sweeping views of the North Sea. The island also has a nature reserve, a beach and a shop.

**Former lighthouse keepers' cottages and a World War 2 pillbox.** Ray McNaughton

**An early 20th-century view of the island at high tide.** Robin Jones Collection

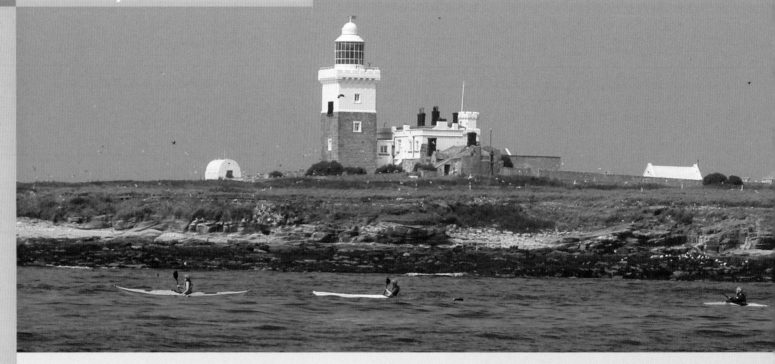

The lighthouse and keepers' cottages on
Coquet Island. Trinity House

Coquet Island as seen from the shore at
Amble. Ivor Rackham

One of the basic features of an island, even those which are tidal, is isolation. That, of course, can be a limiting factor or a prized asset, depending on a particular viewpoint.

In the early days of Christianity, holy men would isolate themselves from the rest of the world in a bid to attain a higher spiritual awareness. An island provides the perfect place for a hermit's retreat, as we saw at the start of this book with St Cadoc and St Gildas on the Holms, and the Christian chapels on other small isles.

Reclusive monks have long since departed from all but one of the islands around the coast of England and Wales. But the isolation offered is still much cherished today by people chasing different unworldly goals.

The general public are barred from landing on the 15-acre Coquet Island, a very environmentally-sensitive nature reserve which lies nearly a mile off Amble on the Northumberland coast, and which once had its own monastery. The island with its important seabird colonies is owned by the Duke of Northumberland and it is managed by the Royal Society for the Protection of Birds.

The most numerous species is the puffin with more than 18,000 nesting pairs, but more important is the colony of the at-risk roseate tern. Thanks to conservation work the population increased to about 100 pairs during the first decade of the 21st century and Coquet now accounts for has 90% of Britain's roseate tern population. Also to be found thriving in the solitude of Coquet are sandwich, common and arctic terns, fulmars, black-legged kittiwakes, three kinds of seagull and eider ducks.

Although landing is prohibited for conservation reasons, Amble-based Puffin Cruises runs trip boats as close to the island as possible so the birds can be glimpsed. You can still see the terns on Coquet at close quarters, by way of a CCTV system installed in the Northumberland Seabird Centre on Amble's quayside.

The island was renowned as a place of spiritual contemplation as long ago as the seventh century, long before it became a wildlife sanctuary. The remains of a medieval monastic cell which once belonged to Tynemouth Priory still stands on Coquet. Abbess Elflaeda of Whitby visited St Cuthbert there in 684, persuading him to accept the bishopric of Lindisfarne.

In Norman times, the island was home to St Henry of Coquet, a Danish nobleman who wished to found a hermitage and was allowed to live on Coquet by the monks of Tynemouth. He became famous as a prophet, and many travelled to Coquet to seek his advice. He died in 1127 and was enshrined at Tynemouth.

While Henry gave out a beacon of hope to the world around him, the building where he lived now emits a beacon of light to seafarers. Much of his monastery was incorporated into the lighthouse and keepers' cottage, built in 1841 by Trinity House.

The first keeper appointed to Coquet lighthouse was William Darling, elder brother of 19th-century heroine Grace Darling, whose exploits are covered in the next chapter.

The lighthouse is now automatic with no resident keeper, so the island is uninhabited in winter, but seasonal wardens are present on Coquet throughout the summer to protect the nesting birds.

**A pair of roseate terns, for which Coquet's isolation is crucial.**

**Coquet Island as viewed from a trip boat.**
Pat Pierpoint

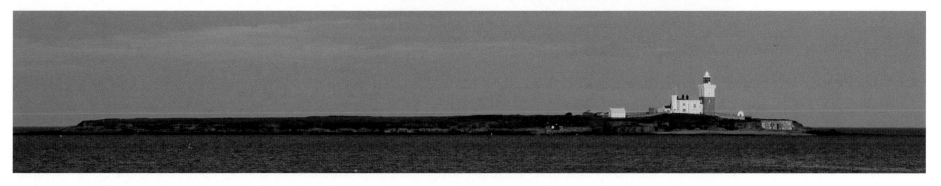

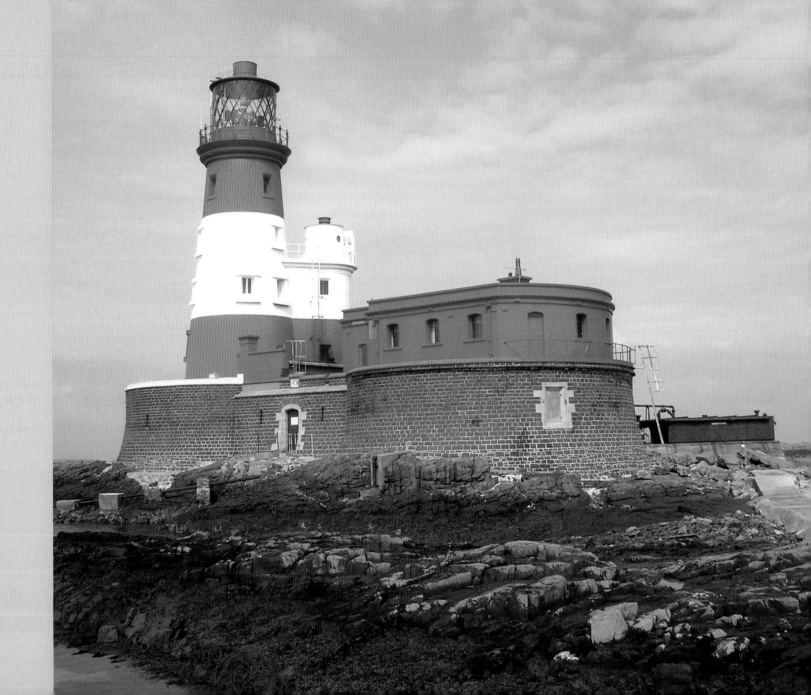

**Longstone and its lighthouse.**
Micheal Spiller

The scattered Northumbrian archipelago known as the Farne Islands owes much of its modern-day fame to the heroism of a lighthouse keeper's daughter, Grace Darling. Born into a seafaring life she spent her youth in the lighthouses at the Brownsman and Longstone.

Early on 7 September 1838, Grace looked from an upstairs window of Longstone lighthouse and saw the wreck of the SS *Forfarshire* on the rocky isle of Big Harcar. The vessel has been smashed in two and half sunk during the night, leaving nine survivors on the rocks.

Realising that the Seahouses lifeboat would not launch in such rough weather, Grace and her father William set out in a 21ft rowing boat and took on board three men. William rowed back to the lighthouse with the men while Grace and the fourth man comforted a Mrs Dawson whose two children had died in the wreck. William then rowed back with two of the ship's crew to collect the remaining survivors.

The Seahouses lifeboat set out, only to arrive at the wreck after the Darlings had rescued the survivors. By then it was too dangerous to return, so the crew of seven fishermen, which included Grace's brother William, took shelter at the lighthouse. They were there for three days before it was possible to return to shore.

Nine of the other 63 passengers and crew on board the stricken ship had escaped by lifeboat and were picked up by a passing ship.

Even in the days before newspapers were commonplace and electronic communication undreamed of, the whole nation was inspired by the heroism of Grace Darling. She was awarded an RNLI silver medal for bravery. The Royal Humane Society awarded gold medals to both Grace and her father and Queen Victoria gave the pair £50. Grace's exploit inspired William Wordsworth to write his poem *Grace Darling* in 1843. Several other books and paintings enhanced the legend that built up around her.

Grace died from tuberculosis in 1842, aged just 26. She is buried with her father and mother in a grave at St Aidan's church in Bamburgh, where a cenotaph was erected in her memory. The Royal National Lifeboat Institution has a Grace Darling Museum at Bamburgh, while the Seahouses lifeboat is named after her.

The 85ft-tall lighthouse, built in 1826, was converted to electricity in 1952 and automated in 1990. It is situated on Longstone Rock, one of the Staple Islands. Trips to the lighthouse can be booked with Golden Gate Boat Trips and visitors can view Grace's tiny bedroom from where she spotted the survivors.

Before modern towers were built, the hazardous rocks and islands were marked by primitive appliances often consisting of little more than an iron brazier and there are two older lighthouse beacons on the Brownsman.

There are up to 28 Farne islands or rocky outcrops, depending on the tide, scattered between one-and-a-half and four-and-three-quarters of a mile from the coast. Those that lie unseen at high tide present the greatest dangers to shipping. They are divided into the Inner Group and the Outer Group, separated by Staple Sound.

The main islands in the Inner Group are Inner Farne, Knoxes Reef and the East and West Wideopens, and at very low tides they

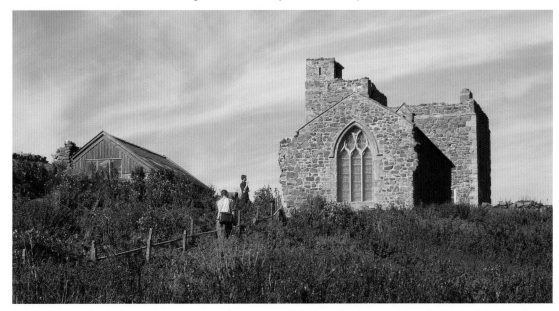

are joined together, while the Outer Group includes Staple Island, the Brownsman, North and South Wamses, Big Harcar and the Longstone. The highest point, on Inner Farne, is 62ft above sea level.

The Farnes are the most easterly outcrop of the Great Whin Sill, a strip of hard volcanic rock that stretches through Northumberland and became islands when sea levels rose after the last Ice Age. Composed of unyielding igneous dolomite, they were left intact when weaker limestone was eroded by the sea, leaving them detached from the mainland. The steep columns formed by fissured dolomite gives the islands their steep and often vertical cliffs and stacks up to 66ft tall.

Some of the islands are capable of supporting vegetation because of a clay subsoil and peat soil, but others are just barren rock. Several of the islands in this book have plants or animals that

**St Cuthbert's chapel with the pele house behind it.** Friends of Orthodoxy

**A clutch of seagulls' eggs on the islands.**
Robin Jones Collection

**An eider duck, the species so beloved by St Cuthbert.** Bristol Zoo

are unique to them, and the Farnes are no exception; it is the only place in Britain where a particular type of borage is found. It's thought that the seeds may have arrived in chicken feed brought over by lighthouse keepers.

From a modern point of view, it seems strange that anyone would want to live on any of the Farne Islands, but that does not take the viewpoint of the early Celtic Christian into account. The earliest record of habitation is by monastic communities, or culdees.

The first recorded visitor was Christian missionary St Aidan, the first bishop of Lindisfarne and the Apostle of Northumbria, followed by St Cuthbert, the patron saint of Northumbria and one of the most important saints of the Dark Ages.

As a young shepherd boy Cuthbert had a vision of the soul of Aidan being carried to heaven by angels, and decided to become a monk, although he spent several years as a soldier between his first and later but greater period of piety. In 676 he chose the life of a hermit and eventually settled on Inner Farne. Visitors made pilgrimages to see him: at first, he would wash their feet, but in later years would merely open the window of his cell to give them his blessing.

Cuthbert had a very modern outlook, being the first conservationist on the islands. He introduced a special law, possibly the first in the world, to protect the eider duck and other nesting seabirds. Eider ducks are often referred to as cuddy (or Cuthbert's) ducks in Northumberland. They are Britain's largest and fastest flying ducks.

Cuthbert was elected bishop of Lindisfarne in 684, but had to be persuaded to accept the post. After two years he returned to his cell on Inner Farne where he later died, to be replaced by Saint Aethelwold. Cuthbert is buried at Lindisfarne. A chapel was built on the site of Cuthbert's cell 600 years ago, and restored in modern times using old material from Durham cathedral.

Inner Farne, the biggest and closest of the islands, has a peel or pele tower, built for the prior of Durham, Thomas Castell, about 1500. Peel towers, fortified keeps or tower houses built in the border region between England and Scotland, were intended to act as beacons where fires could be lit to warn of approaching danger and to provide refuge if a locality was invaded.

Cuthbert's love for the natural environment is continued today, the only residents on the islands being National Trust wardens who live in the peel tower on Inner Farne, now supplied with electricity from solar panels, and the former lighthouse keeper's cottage on the Brownsman.

Regular boat trips from Seahouses will land visitors on Inner Farne, Staple Island and the Longstone, but the current custodian of the Farnes, the National Trust, bans landing on the other islands to protect wildlife.

The islands burst into life between April and early August with the shrieking, some would say, deafening cries of about 100,000 pairs of nesting sea birds. Puffins can be freely seen. In a natural partnership, they use the same burrows as rabbits at different times of the year. Centuries ago rabbits were introduced as a source of meat, a common practice on smaller islands; they have since gone wild.

Arctic, common and sandwich tern and the rare roseate tern, razorbill and guillemot, oystercatcher, shag, kittiwake, fulmar, greater and lesser black-backed gull, rock pipit, ringed plover, cormorant and gannet contribute to a total of 290 bird species recorded on the islands. Cuthbert would have been delighted. In 1760 the now extinct great auk was spotted and in 1979 an Aleutian tern from the north Pacific, the only example of the species ever recorded in Europe.

An Arctic tern chick ringed by conservationists on the islands in 1982 turned up in Melbourne, Australia three months later, having completed one of the world's longest recorded journeys by a bird.

The islands are also home to one of Europe's largest colonies of grey seals, the population numbering about 5,000, and they can often be seen lazing on the shorelines. The beaches on the Brownsman form a popular pupping ground each autumn.

The Farnes are a magnet for divers, attracted by the hundreds of shipwrecks as well as the seals, who will often investigate their rubber-suited 'counterparts' in the water. One of the favourite dives is the *Somali*, a 6810-ton passenger-cargo steamer built in 1930. In March 1941 she was bound for Hong Kong via the Firth of Forth when she was sunk by a German bomber. Sitting in 100ft of water near Beadnell, the 450ft hull is virtually intact.

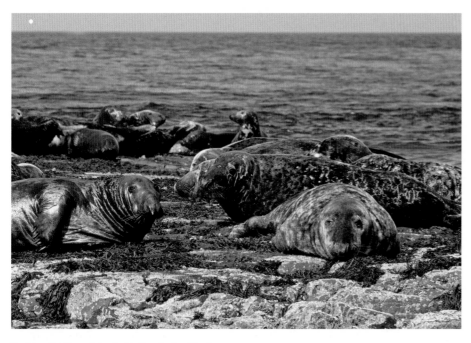

**Seals on the Farne Islands.** Northumberland Tourism

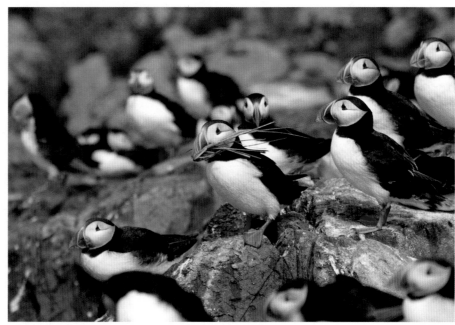

**Puffins on the Farne Islands.** Gail Johnso/Northumberland Tourism

**The giant stacks known as Pinnacle Rocks off Staple Island are home to a huge guillemot colony, as seen in this hand-coloured early 20th-century view.** Robin Jones Collection

**The interior of the Grace Darling Museum at Bamburgh, showing a Northumberland coble rowing boat.** RNLI

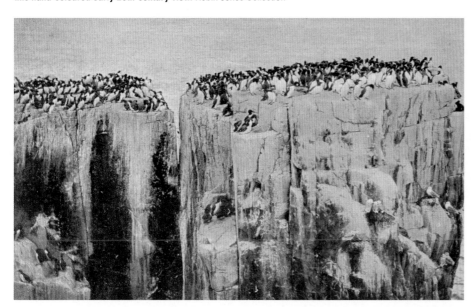

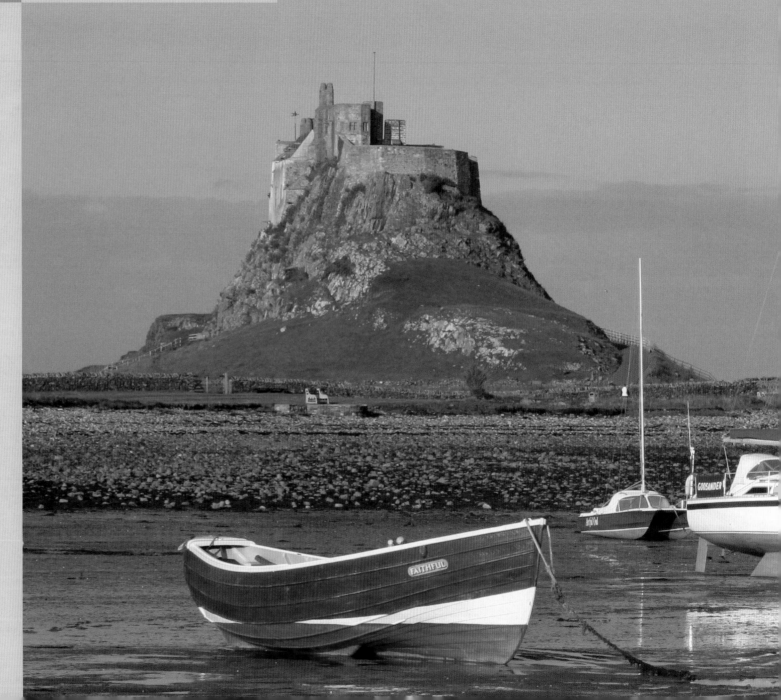

The harbour beneath Holy Island.
Friends of Orthodoxy

Lindisfarne is the island jewel of the north. A cradle of Celtic Christianity, a shining beacon of wisdom and learning that breaks the gloom of the Dark Ages.

Spectacularly linked by a tidal causeway (checking the tide times is essential), the name may have been derived from farne meaning 'retreat' – as was the case for the holy men on the nearby Farne Islands – and Lindis, a nearby river.

While the island, lying within the Northumbrian Coast Area of Outstanding Natural Beauty has been inhabited since the Stone Age – the Romano-Britons had a village there called Medcaut – the first recorded settler was an Irish monk named St Aidan who arrived there in 635 and founded a monastery.

Oswald, the Christian second son of the pagan Northumbrian King Aethelfrith, gained the throne in 633, choosing Bamburgh as his fortress. He invited the monks from the holy island of Iona off the west coast of Scotland, where St Columba had founded a monastery, to move to Lindisfarne, and Aidan set up a community with 12 brethren. From there, Aidan's monks went out converting the heathen population of England.

After 16 years as bishop, Aidan died at Bamburgh in 651. He was succeeded by St Cuthbert, whose miracles and life were recorded by the Venerable Bede.

After Cuthbert's death on the Farne Islands, his body was returned to Lindisfarne, attracting pilgrims to his grave and generating claims that miracles of healing had taken place there.

Cuthbert acquired medieval cult status, and it is believed that the Lindisfarne Gospels, one of the world's greatest treasures of literature from this period, were written in the late 7th century in his honour, possibly by Eadfrith, an island monk who became bishop of Lindisfarne in 698. The work is an illustrated Latin manuscript of the Gospels of Matthew, Mark, Luke and John which combined Anglo-Saxon and Celtic styles. In the 10th century, a word-for-word Old English translation was inserted into the gospels by Aldred, the provost of Chester-le-Street: this comprises the oldest surviving translation of the Gospels into English. The Lindisfarne Gospels were seized from Durham cathedral during the dissolution of the monasteries by Henry VIII, and are housed in the British Library in London, despite calls for them to be returned to the north.

Lindisfarne's darkest hour came on 8 January 793 when the island was pillaged by the Vikings and many of the monks either killed or sold into slavery. With much of their gold and silver carried off, the surviving community spent the next century on the mainland at Chester-le-Street, together with the venerated body of St Cuthbert which, it was said, had not decayed. It was eventually buried behind the high altar in Durham cathedral where it remains today. Because of the martyrdom of the monks at the hands of the Vikings and the lives of the saints who preceded them, Lindisfarne became known as Holy Island, and 793 is often regarded as the beginning of the Viking history of Britain.

Monks would, however, one day return to Lindisfarne. The priory was re-established in Norman times as a Benedictine house and survived until its suppression in 1536. The monks may have lived in isolation, but they certainly did not always live a puritanical life and took the view that if the soul was in God's keeping the body must be fortified with Lindisfarne Mead, a drink

Hobthrush, or St Cuthbert's Island, is the tidal island off Lindisfarne. Cuthbert retreated there when the bustle of Holy Island became too much for him, but unable to get enough peace even here, he moved to Inner Farne. Barbara Carr

for which they became famous. The recipe remains a secret of the family which still produces it at St Aidan's Winery.

The ruined monastery is now looked after by English Heritage while the neighbouring parish church, which dates back to before the Norman Conquest, is still used for the baptisms, marriages and funerals of islanders. The smaller United Reformed Church dedicated to Cuthbert dates from the 19th century.

Towering over the island is the Tudor Lindisfarne Castle, built in the mid-16th century, after the priory was forcibly disbanded, and

cannibalising some of its stones in its construction. It was built at the highest point of the island, the whinstone hill of Beblowe Crag, with the purpose of reinforcing English defences against the Scots. Elizabeth I added gun platforms, but her successor James I was monarch of both countries, and the need for forts diminished. Nonetheless, the castle was captured by Jacobite rebels in the 18th century, only to be quickly recaptured by English troops from Berwick. The Jacobites were imprisoned but dug their way out.

In 1901, the castle was bought by Edward Hudson, the owner of *Country Life* magazine and refurbished as a holiday home. He employed leading architect Sir Edwin Lutyens, who used upturned disused boats, known as 'herring busses' as sheds. The boats were cut in half and doors inserted at the wide end.

The castle, its walled garden and a complex set of lime kilns have been in the custody of the National Trust since 1944. Lindisfarne today may be renowned as a bastion of coastal beauty, but the lime kilns are testament to times when it was a hive of industry. Limestone was quarried and brought to the kilns via a waggonway where it was burned to make lime, a popular agricultural fertiliser. At its height of lime production in the mid-19th century, more than 100 men were engaged in quarrying on the island. Fossilised starfish-like creatures, crinoid columnals, extracted from the quarried stone were threaded to make necklaces or rosaries and became known as 'St Cuthbert's beads'.

However, fishing was traditionally the main source of income for islanders.

Today, Lindisfarne has become a centre for the revival of Celtic Christianity, and a modern centre for retreat, for those who wish to follow in the footsteps of Aidan and Cuthbert.

Like St Michael's Mount, the fairytale setting of Lindisfarne is a perennial source of inspiration to writers and artists. The island and its spectacular setting has been the background for many books, movies and TV productions. Roman Polanski's *Cul-de-Sac*, starring Donald Pleasance, was filmed in its entirety there in 1966. Taking their name from the island was legendary Tyneside folk-rock band Lindisfarne, who had hits in the early seventies with *Meet Me On The Corner* and *Lady Eleanor*.

History, heritage and culture apart, Lindisfarne is of immense importance as a bird sanctuary, with nearly 300 species being observed. Among the more important species are dunlin, bar-tailed godwit, merlin, pale-bellied brent goose, teal, pintail and wigeon. The island and sand flats, where many species spend the winter months, are protected as Lindisfarne National Nature Reserve.

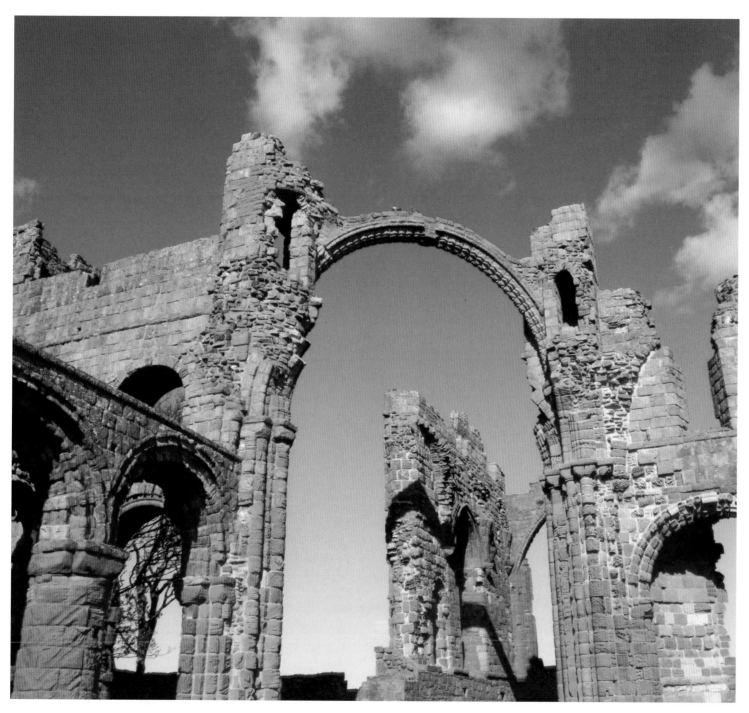

Opposite page:

**The unique boat sheds on the island.**
Rick Crowley

**'We might just about make it': crossing the causeway before the motor age.**
Robin Jones Collection

Left: **The ruins of Lindisfarne's priory laid bare by Henry VIII.** Barbara Carr

**Cars passing on the causeway in the fifties.** Robin Jones Collection

Above right: **The village's main street: further down from the Ship Inn is the former Iron Rails, another hostelry in the days of Holy Island's fishing heyday.** Barbara Carr

Right: **An engraving of 1887 showing a contemporary Roman Catholic pilgrimage to Lindisfarne in 1887, and (inset) a monk preaching in the priory ruins.** Robin Jones Collection

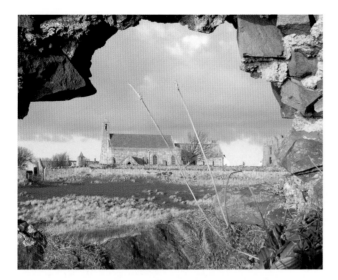

Above: **Lindisfarne's parish church dates from pre-Norman times.**
Friends of Orthodoxy

Right: **One of the folios of the Lindisfarne Gospels.**

Below: **The seminal Lindisfarne album Fog on the Tyne.**

# 31 The Cumbrian Islands

Earnse Bay, on Walney's north-western
shore, looking towards Black Combe.
Bill Wakefield

The name Cumbria immediately conjures up images of the Lake District, with its vast stretches of water, soaring mountains and spectacular passes.

Glaciation during the last Ice Age did much more than gouge out lakes and valleys. The debris left over from carving the world-famous upland scenery had to go somewhere, and it ended up off the region's southwestern coast where it formed a series of islands around modern-day Barrow-in-Furness. The key lies on the beaches: why else would you find pebbles made of Borrowdale slate, for instance?

The biggest of the Furness islands is Walney, and there are also Piel, Roa, Foulney, Little Foulney and St Michaels and the smaller Headinhaw, Dovahaw, Sheep, Ramsey and Little Hill, plus, until the 1980s when the dock dividing it from the mainland was infilled, Barrow Island itself. Another island once existed at the tip of South Walney, and now forms the gravel bank which comprises Haws Point.

Not all the Cumbrian islands were formed in this sedimentary manner. In south Cumbria, there are tiny Chapel and Holme islands, outcrops of limestone which, like the Holms in the Bristol Channel, became islands as water levels rose and the surrounding land flooded.

The long thin Isle of Walney, 11 miles long and less than a mile across at its widest point, is the eighth largest in England, at just over five square miles. With about 13,000 people living on it today, it is the seventh most populated. The island was recorded as Hougenai in the Domesday Book, perhaps meaning 'manor of Hougon', while the name Walney was first recorded in 1127. Biggar, its oldest settlement, dates from at least the 11th century, when it was recorded as Byggergh, the 'barley field'. In the 1600s, the island had a population of about 250, half of whom were wiped out by bubonic plague – which was not kept at bay by the water dividing Walney from the mainland.

Walney today is an island of dramatic contrasts. It has wide sweeping golden sand beaches, often overlooked by visitors to the Lakes, and nature reserves at either end, but it is reached through the very urban area of Vickerstown with its rows of terraced houses which would not be out of place in any major manufacturing town or city.

Since 1908, Walney has been linked to the mainland by what since 1935 has been called Jubilee Bridge, built to mark the diamond jubilee of Queen Victoria. Before then a chain ferry provided the only access other than by boat.

Back in the late 19th century, Barrow became a boom town, and needed workers' accommodation fast. Labelled the 'Chicago of the north' thousands of farm labourers poured into the town in search of jobs at the ironworks, shipyard or Furness Railway, which incidentally, ran a ferry service and had opposed the building of a bridge.

Walney was just a difficult to access rural outback sparsely populated by a farming and fishing community.

All that changed when Vickerstown was developed as a planned estate to house the workers at Vickers Shipbuilding and Engineering Ltd, one of the main employers in Barrow. Such was the shortage of places to live that some workers had been forced to live on board a liner moored in Barrow docks. Ordinary workers

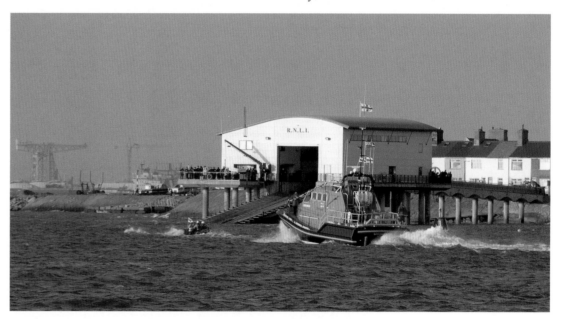

**The Roa lifeboat returns home.**
Barrow Evening Mail

were given terraced houses, while managers lived in bigger homes overlooking the channel. The terraced houses were well built and did not degenerate into slums as was the case in many other British urban areas. The place became immortalised as Vicarstown in the Reverend Wilbert Awdry's 'Thomas the Tank Engine' books.

Once Vickerstown was built, a bridge was needed to move the workforce quickly and efficiently to their places of employment. A bascule bridge was built with a rack-and-pinion system to swing it open for ships passing in the channel. At first, tolls were charged for pedestrians using the bridge, and there were stories about people ducking beneath the toll bar to avoid payment, or mothers racing across with babies in prams before they could be charged. The 'islandness' of Walney was suddenly turned upside down.

In 1935, with the construction costs paid off, the late Queen Mother came to officially lift the toll, since when use of the bridge has been free.

During World War 2, the bridge became part of the ring of defences around Barrow. The bridge was lifted at night so that enemy troops landing on the island would be unable to reach Barrow and harm the shipyards, where much work for the war effort was being undertaken.

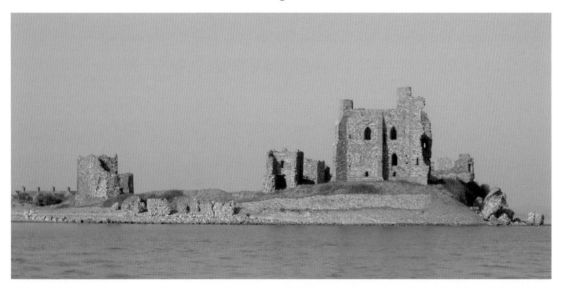

**Piel Island, as seen at high tide.**
Shiela Chattaway

In 1988, Vickerstown was declared a conservation area because of the estate.

The island has a small airfield, owned by BAE Systems, which also owns the shipyard. It began life as an airship station in World War 1 and from 1910–20 the site was home to one of Britain's most important airship-building plants.

The airfield itself was opened in World War 2 and sold off to Vickers in 1959. It was used for commercial flights in the 1980s and 1990s but now handles only private flights, with BAE running its corporate shuttle to Bristol, Warton in Lancashire and Farnborough.

Away from the industry and housing, Walney contains several Sites of Special Scientific Interest. The North Walney Nature Reserve, managed by Natural England, with its sand dunes, salt marsh and wetlands, known as slacks, provides the perfect habitat for natterjack toads and it is home to a quarter of the British population. The natterjack can live for up to 15 years and is so rare that you need a licence even to pick one up.

So far we have encountered several unique island plant species, and Walney is no exception, for it is the home of the Walney geranium.

The South Walney Nature Reserve is managed by the Cumbria Wildlife Trust and here visitors can experience a Steep-Holm type 'dive bomb alley' where gulls swoop at intruders who they think may be a threat during the summer nesting season. About a third of the UK population of lesser black-back gulls live on Walney, alongside the more common herring gulls. Large numbers of eider ducks make their way there too. Many rare plants including yellow horned poppies, seaside century, dune helleborine, coralroot orchid and variegated horsetail may also be seen.

Barrow Island, also known as Old Barrow, is the ninth most populated island in Britain, although it is now part of the mainland. The town's name is said to come from the Viking Barrae, the 'bare island', referring to the isle rather than the mainland. The filling in of the Devonshire Dock to provide a site for Devonshire Dock Hall ended its island status once and for all. The rest of the dividing channel is part of the Barrow docks system. It is home to the shipyard, which despite the long-term national decline in shipbuilding, remains one of the largest in Britain. Ramsey Island too has been similarly swallowed up by the mainland.

One island which the Furness Railway did not baulk at building a branch to serve was 30-acre Roa Island, which lies to the south of Barrow. Until 1847, Roa could be reached only by boat, or by walking across the huge expanse of sand at low tide. That all changed when London banker John Abel Smith built a causeway linking the island to the mainland, and the deep-water 810ft-long Piel Pier which served steamers sailing to Fleetwood. The railway seized the opportunity to lay at track down the causeway and launch a passenger service in 1846. Following several years of squabbling, the railway bought the entire Roa estate in 1852. The branch line ran until 1936, when it was replaced by a road from Rampside.

Tiny Roa today has a population of about 100 and boasts a yacht club, a café, a hotel and is home to a lifeboat station set up in 1864. It is also the gateway to one of the strangest of all islands around our shores, the absolute gem of English eccentricity that is Piel Island. Accessed by boat from Roa, the island has its own pub, the Ship Inn, and a king. The three-century-old inn has a tradition which decrees that every new landlord is crowned king. Wearing a helmet and holding a sword, he sits in an ancient chair, while alcohol is poured over his head.

There is also a similar order of Knights of Piel. Anyone who sits in the chair is made a knight, in a ceremony carried out by the King

of Piel or a fellow knight. The cost of the privilege is to buy a round of drinks for all those present – but in return, the knights are entitled to board and lodging off the innkeeper if they are ever shipwrecked on the island. The tradition is said to date back to the landing on Piel of Lambert Simnel, one of two pretenders to the throne of Henry VII, in 1487, and the ceremony has been held to be a pastiche of that rebellion.

Simnel claimed to be the missing Earl of Warwick who was the rightful heir to the throne, and with his army of mercenaries marched from Furness towards London to seize it. He was defeated by the King's forces at the Battle of Stoke, but still reached the capital – as a prisoner of the king, who gave him a job in the palace kitchens rather than inflict any harsher punishment. By the 19th century, responsibility for looking after the Piel helmet and chair was listed in the tenancy agreement. There has always been one overriding rule that 'the king and knights of Piel were always expected to be "a free drinker and smoker and lover of the female sex" '. In 1914, Piel boasted an entire 'cabinet' including a prime minister and Lord Mayor plus a whole royal family.

The inn is believed to have grown out of a former ships' chandlery and in Victorian times held a regular regatta. It seems it became too popular with yachtsmen, sometimes with fatal consequences. In one case, a coroner recommended, 'the landlord of the Ship Inn should not supply drink as to make incapable men who may have to take charge of a boat'.

In 1127, King Stephen gave Piel to monks who founded Furness Abbey and who used it as a safe harbour, becoming the 'Port of Furness'. It was one of the most powerful and wealthy Cistercian abbeys in England. As well as holdings in the Lake District, Lancashire and Yorkshire, it also owned land in Ireland and the Isle of Man. Sea trade was an important income stream for the monks. The abbot, wielded huge power and, being so far away from the monarch in London, talked directly to the royal houses of Ireland and Scotland.

A motte and bailey castle with its defence ditches was built early in the 14th century, possibly as a fortified warehouse to keep goods safe from pirates. In 1322 the Abbot tried to buy off an imminent raid by the Scottish King Robert the Bruce, who took the bribes and raided the island anyway. As a result, Piel Castle was rebuilt in stone. The monks were not averse to ducking and diving either side of the law themselves, and in 1423 were accused of wool smuggling and not paying taxes.

Following the dissolution of the monasteries by Henry VIII, the island and its castle became the property of the Crown. Its defences were upgraded during the time of the Spanish armada, and during the English Civil War a Parliamentarian fleet sought refuge here after Charles I captured Liverpool.

In the second half of the 17th century, a salt works existed on the island. At this time Piel also become important not for the avoidance of customs duties but for the paying of them, as it stood on the approach to Barrow, and smuggling was still rife.

In 1920, the Duke of Buccleuch gave the island to Barrow as a memorial to those who lost their lives during World War 1. The guardianship of the castle is now in the hands of English Heritage.

The non-identical twin of Roa is Foulney Island, a 40-acre low-lying grass and shingle patch to the south east, formerly known as Fowle Island because of its enormous bird population. A 19th-century mile-long rock causeway, built as a tidal protection measure, leaves the Roa Island causeway at the midway point along its length and can be walked by visitors.

A Site of Special Scientific Interest because of its Cumbria Wildlife Trust bird sanctuary, the island is patrolled by a resident warden during the summer nesting months, although nobody lives there permanently. Foulney is the only breeding location of the arctic tern, which fly vast distances just to access the shingle banks, in northwest England, but there are numerous other bird species and seals.

**Chapel Island, in the middle of the Leven estuary.** Matt Carr

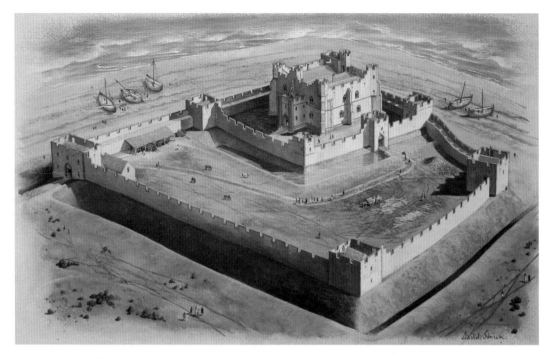

**A reconstruction of Piel Castle as it was in its heyday.** Barrow Borough Council

**The Walney geranium is unique to the island.** Martin Rhodes/Natural England

Island fever? Tiny Sheep Island sheltering in the lee of southern Walney may be just a shingle patch leading to a grassy plateau, but, reminiscent of Flat Holm, it once housed an isolation hospital for sailors returning to Barrow with exotic diseases.

Just off Barrow docks lies diminutive Headin Haw, which once served as a nicely isolated dynamite store when iron ore was mined at nearby Askham and Lindal.

Dovahaw is also known as Crab Island for obvious reasons.

On the southern Furness coast, a mile out into the vast low-tide desert that is the Leven Estuary, part of Ulverston Sands and Morecambe Bay, is the seven-and-and-a-half-acre Chapel Island. Previously known as Harlesyde Isle in 1593, it was renamed by the author Ann Radcliffe as Chapel Island in 1795. Gothic novels like Radcliffe's *The Mysteries of Udolpho* make much of old ruined buildings in rocky barely accessible places, and the ruins of an original chapel may still have existed at the time.

Lakeland's greatest writer, the Romantic poet William Wordsworth, described a stirring visit to Chapel Island in Book Ten of *The Prelude*: 'all that I saw or felt was gentleness and peace'. It was at this point that he recalls being told that Robespierre, the architect of the worst excesses of the French Revolution, was dead, filling his heart with gladness. The present-day structure is a mock ruin built in 1821 by Colonel Thomas Richard Gale Braddyll, to enhance the view from his similarly-new Conishead Priory. There was also a fisherman's cottage on the island, which is now all but overgrown.

Holme Island, further up the Leven estuary, is now attached to the bank at Grange-over-Sands because spartina grass has colonised the mud flats turning them into a thick belt of greensward so that it now lies next to a sea of green grass, not water.

The island, which is not open to the public, has a house built in the 1830s and hidden by trees, a lodge, cottage, and a mock Roman temple called the Temple of Vesta, based on the design of the temple near the Forum in Rome.

Legend has it that the man who killed the last wolf in England, on nearby Humphrey Head in the 14th century, was given the little island as a reward for his bravery.

A causeway linking Holme to the mainland was built in the mid nineteenth century by the Brogden family, who also helped build the adjacent Furness Railway line. Because the River Winster acted as the boundary between Westmorland and Lancashire, and occasionally carved a new channel through the sand and mud, the island 'leapfrogged' from county to county – giving the Brogdens an excuse not to pay rates to either.

Holme Island was taken over by the RAF in World War 2 and used as accommodation for female staff.

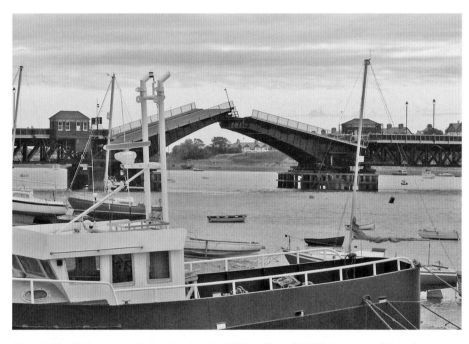

Above: **Jubilee Bridge opens to let craft pass through Walney Channel.** Bill Clark: www.southlakes-uk.co.uk

Top right: **View from the shipping beacon on Foulney Island towards Roa Island.** Stephen Middlemiss

Bottom right: **A natterjack toad.** Christian Fischer

Below: **Holme Island on the Kent estuary, now joined to the mainland by a sea of spartina grass.** Ray Knapman

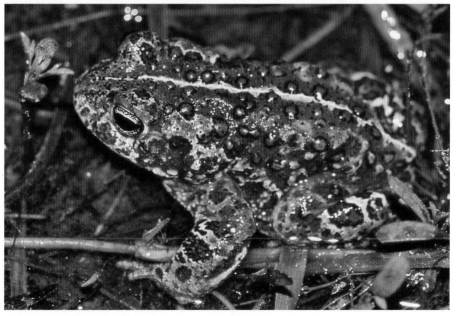

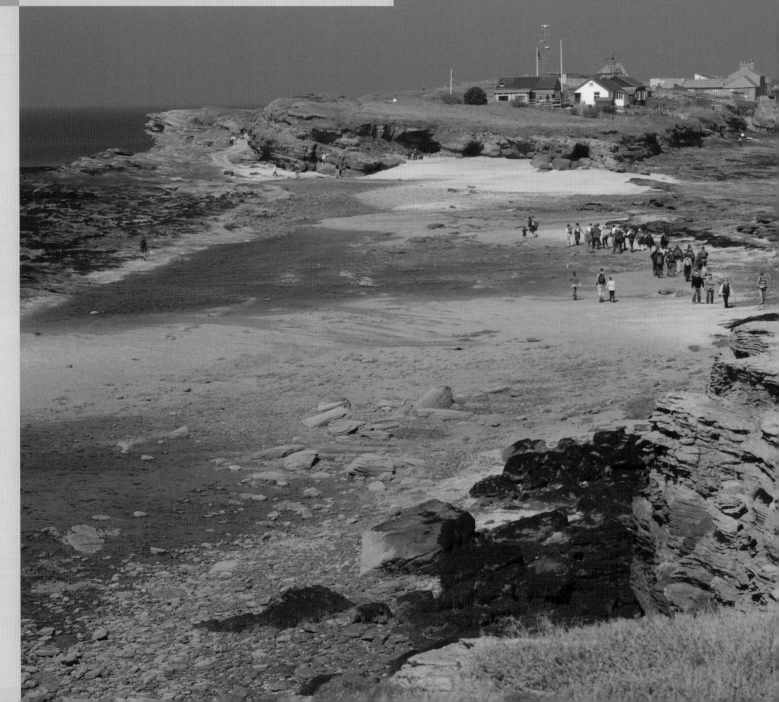

Hilbre Island as viewed from the top of uninhabited Middle Eye. Robin Jones

The River Dee's loss was the Mersey's gain. The wide Dee estuary was always prone to silting, while the narrow bottleneck of the Mersey estuary on the north side of the Wirral ensued that waters flowed fast, leaving a deepwater channel.

While Wirral's port of Parkgate silted up, Liverpool went from strength to strength.

When the tide retreats from the Wirral resort of West Kirby, a Saharan landscape appears, seemingly with a mirage on the horizon – a vision of a faraway fairytale land out in the Irish Sea with the windows of houses glinting in the sun. It is no mirage – it is Hilbre Island – and you do not need a boat to reach it, although after a four-mile round trip on foot, many wish they had hired a camel.

The two smaller islands in the chain are Middle Eye (or Middle Island, the 'eye' being the same as the 'ey' suffix on the names of former island settlements in the Cambridgeshire fens, like Thorney and Whittlesey), and Little Eye, both uninhabited and several hundred yards from each other.

The islands are composed of Bunter sandstone which forms the rocky ridge on the Wirral from West Kirby to Thurstaston. They were part of the mainland until the end of the last Ice Age when rising sea levels caused by melt waters gouged out a channel between them and West Kirby.

Hilbre Island has been occupied since the Stone Age, as the discovery of numerous neolithic arrowheads, scrapers and flakes testifies. As a gateway to the port of Chester (Deva), it is likely that it would have been settled in Roman times.

The name originated from a long-vanished medieval chapel dedicated to St Hildeburgh, an Anglo-Saxon saint, and became known as Hildeburgheye or Hildeburgh's island. The islands may have been mentioned in the Domesday Book which records that Chircheb (West Kirby) had two churches: one in the town and one on an island. A small group of monks settled on the islands about 1080, under the jurisdiction of the Benedictine abbey of St Werburgh in Chester.

Hilbre became a popular destination for pilgrims in the 13th and 14th centuries, when it took off as a busy trading port. The monastic settlement was dissolved by Henry VIII in 1538, but by then, commerce would have ruined the monks' treasured island solitude. About this time, a custom house on the island collected taxes on imports and exports.

A small rock salt refinery was established on the main island in 1602. The group were part of the port of Chester and received visitors from ships waiting to sail for Ireland as well as the crews of smaller local boats, and so a public house was set up on Hilbre by the late 18th century, and possibly before. It was rumoured that the landlord of the inn in the early 19th century had become wealthy through wrecking, the deliberate luring of ships onto rocks in order to steal their cargo. Smuggling was also said to be rife. However, as the Dee silted up, trade switched to the Mersey ports, and the beer house closed.

In 1828 the Trustees of Liverpool Docks obtained a lease on the islands and built a telegraph signalling station there in 1841. The Trustees, later the Mersey Docks and Harbour Board, purchased

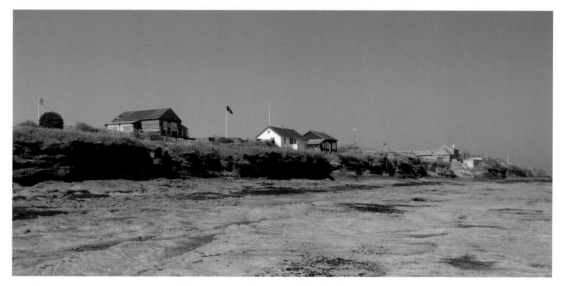

**Desert view at low tide: houses on the eastern side of Hilbre Island face Hoylake and West Kirby.**
Robin Jones

the islands outright in 1856. Hoylake Council bought them for a nominal £2,500 in 1945, and they are now owned by Wirral Borough Council.

Hilbre Island has a few houses, two of them privately owned, but the only permanent resident is the Dee Estuary Ranger, who lives in Telegraph House. The occupants can drive over firm sands to West Kirby at low tide, but, because of the danger of being cut off by the tides, walkers must take a recommended route from West Kirby via Little Eye, not the most direct way from Hoylake. The islands are cut off from the mainland for up to four hours out of every 12, and there are no public facilities, such as a toilet or shop, on them.

The lifeboat station is derelict but still houses an automatic tide gauge operated by the Port of Liverpool which has been in operation for more than 130 years. A 10ft-high solar-powered lighthouse established in 1927 by the Mersey Docks and

Opposite page: **An aerial view of Hilbre Island from the north.**
Trinity House

**Visitors scramble over Little Eye.**
Robin Jones

Harbour Board is now operated by Trinity House. The Mersey Canoe Club also has a base on Hilbre.

The islands are a designated Local Nature Reserve. The Dee Estuary is one of the 10 most important estuaries in Europe for wintering wildfowl and waders; the islands are used as roost sites when the tide covers the thousands of acres of mudflats which are exposed at low water.

They are also a key stopping-off point for the twice-yearly migration of birds along Britain's west coast, and accordingly in 1957, the Hilbre Island Bird Observatory was founded. Members record and ring birds on Hilbre Island before releasing them to continue their journeys.

The only mammal known to breed on Hilbre at present is the field vole, while large numbers of grey seals can be found at West Hoyle sandbank to the west, and whales and dolphins have also been spotted off the islands.

Sadly, camels are not available for a trek to the islands, but once you reach the mainland at West Kirby, traditional beach donkey rides are still available.

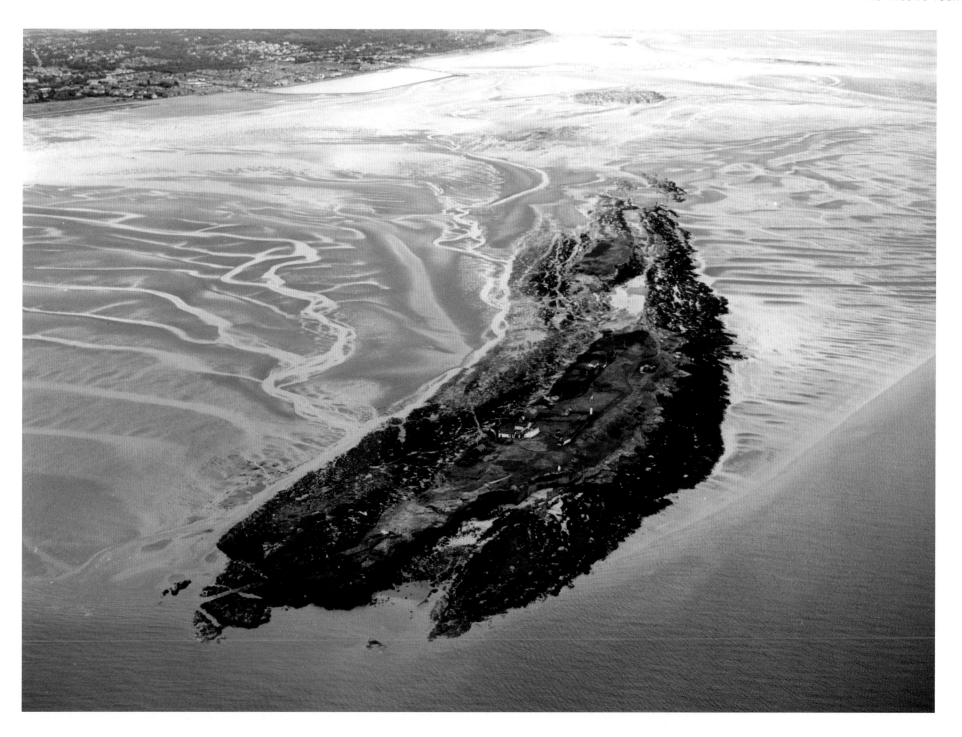

Telford's beautiful Menai Suspension Bridge provided the first dry crossing to Anglesey. Robin Jones

The Isle of Anglesey, the largest in Wales at 296 square miles, is traditionally linked with druids, the mysterious Celtic prophets and holy men who oversaw pagan rituals in sacred groves and whose word was law.

Not that druids were unique to the island but it was the place where they made their last stand against the Romans who, since invading Britain in AD 44, had been determined to break their power. Druidical practices were viewed as alien: Augustus Caesar banned his citizens from taking part in such rites, while Tiberius Caesar actively suppressed druids in Gaul. As Roman power expanded throughout Britain, they were pushed back and the Menai Strait, the great chasm that divides Anglesey from the mainland, became their final line of defence.

In AD 60, the Roman general Suetonius Paulinus, determined to crush them once and for all, invaded Anglesey, killing as many druids as his army could find, destroying their shrine and cutting down their groves. The Roman historian Tacitus, who from afar accused the druids of barbarity (a fine accusation coming from an empire which revelled in gladiatorial sports) said that the invading legionaries were at first unnerved by the sight of the druids on the Anglesey shore, their hands uplifted to the sky imploring the gods to intervene on their behalf. However, their military training soon overcame both their fears and the defences mounted by the islanders.

Before Paulinus could consolidate his victory, word came of Boudicca's revolt in East Anglia, and he was forced to withdraw his soldiers from the island. It was left to Roman governor Gnaeus Julius Agricola to finally bring Anglesey under Roman rule 18 years later, and by the end of the century, druids were but distant memories. The Romans built a fort at Holyhead, the largest settlement in the county of Anglesey, but which in topographical terms is on the physically-separate Holy Island.

The formidable natural barrier of the Menai Strait has served over the centuries to reinforce the isolation of Anglesey and slow down, if not prevent, the island succumbing to external influences. For instance, 70% of islanders speak Welsh as their first language, a figure bettered only by neighbouring Gwynedd, which is largely isolated by virtue of its mountainous terrain, whereas English has long been the first language throughout most of the principality.

The Isle of Anglesey is known in Welsh as Ynys Môn, a name first recorded in Roman times, and is similar to the Isle of Man. Comprising fertile flat land, in stark contrast to neighbouring Snowdonia, its agriculture supported the unproductive hilly wastes of Gwynedd and was called Môn Mam Cymru, or Mother of Wales by the 12th century chronicler Gerald of Wales. The name

Anglesey comes from Old Norse and means 'Ongull's Island'.

After the Romans left Britain, Anglesey was settled by Irish pirates, until Cunedda, a Celtic warlord from the north of Britain, drove them out. His grandson Cadwallon Lawhir finally defeated the Irish in 470.

The kings and princes of Gwynedd chose Aberffraw on Môn as the site for their court because the island could be easily defended. However, that did not stop invasions by Saxons, Vikings and Normans, the worst being a Danish raid in 853 when much of the island was sacked. Only improvements to the English navy finally allowed Môn to be conquered again, by Edward I in the 13th century.

Beautiful Beaumaris Castle was commissioned by Edward I in 1295 as one of a chain of forts around the North Wales coast. Beaumaris is the former county town of Anglesey, a position now held by Llangefni. Robin Jones

Technology, as opposed to military might, had to wait another six centuries to conquer the Strait. Until Thomas Telford's Menai Suspension Bridge was opened on 30 January 1826, as part of his London to Holyhead road (now the A5), the Strait could be crossed only by ferry, or by foot at low tide, with great difficulty. The bridge was designed to allow Royal Navy ships 100ft tall to pass at high tide. When finished, it cut nine hours off the London to Holyhead journey time. The bridge featured on the reverse of the 2005 pound coin.

It was subsequently supplemented by a second crossing, the Britannia Bridge, built to carry the Chester and Holyhead Railway. Elizabeth I had introduced a weekly post to Ireland in 1576 and this

railway was designed to take the mail, which had been carried from Dublin via Holyhead, on to London. The first steam packet boats entered service between Holyhead and Dublin in 1819, but with the advent of the railways, the Irish Mail contract was switched to the better-connected Liverpool in 1839.

Railway pioneer Robert Stephenson built the bridge with two main 460ft spans comprising rectangular iron tubes supported by masonry piers, the central one built on the Britannia Rock. The box sections were assembled on shore before being floated into position and lifted into place.

**Four Mile Bridge, so called because it is four miles from Holyhead, links Holy Island to Anglesey proper. Holy Island takes its name from its large number of standing stones, burial chambers and other religious sites, and is known in Wales as the island of Saints.** Robin Jones

Opposite page: **The restored harbour at Amlwch, which was developed inside a natural inlet, with a sailing ship berthed.** Robin Jones

Two additional 230ft spans made up the bridge, a 1,511ft continuous girder, with the railway running inside the tubes. It was a major landmark in civil engineering; until then, the longest wrought iron span had been 31ft 6in. The town of Menai Bridge expanded to house construction workers: before then, it was known as Porthaethwy and was one of the main ferry crossing points to the island.

It took four years to build the bridge which opened on 5 March 1850. As well as the main railway line to Holyhead, railway branches were built to Amlwch (currently mothballed) and Red Wharf Bay (lifted in 1953).

The bridge was severely damaged by fire on 23 May 1970, when two boys looking for birds dropped a burning torch inside it. The bridge was totally rebuilt and now has two levels, trains running below and the A55 on top.

Railways are historically credited with the development of industry in an area, but Anglesey was a world leader in copper mining in the 1780s, well before the first train crossed the Strait, thanks to ores from the labyrinthine network of mines on Parys Mountain. The ore was exported through the port of Amlwch, and shipped to South Wales and Lancashire for smelting. At the time, mining made Amlwch the second largest town in Wales after Merthyr Tydfil.

In those days, copper sheathing was used on the Royal Navy's wooden warships to prevent the growth of barnacles and weed which slowed ships down and, more importantly, to prevent attack by the teredo beetle, a boring marine mollusc capable of causing huge damage to wooden hulls.

By-products from the Parys copper mines led to local industries in sulphur, vitriol, alum and ochre pigments.

It is believed that copper may have been mined at the mountain 4,000 years ago. Today, it presents a unique lunar landscape of multi-coloured waste heaps, but mining is not dead. Anglesey Mining plc is still extracting minerals but on a much smaller scale, and has identified small deposits of gold and silver as well as zinc, lead and copper.

Heavy industry in recent times has been restricted to Holyhead, with its aluminium smelting works, which closed on 30 September 2009, powered by the Wylfa nuclear power station near Amlwch, the most northerly town in Wales. The power station operated by Magnox North Ltd was due to close in 2010 but an extension to its operating life was being considered by site owner the Nuclear Decommissioning Authority.

Almost the entire coastline of Anglesey is a designated Area of Outstanding Natural Beauty and tourism is a major industry which also attracts those who pass through on their way to Ireland. Especially in the north of the island, there is a definite air of yesteryear, a place that has, thanks to its isolation, largely escaped the worst excesses of modernisation and, sadly, many of its benefits too. Amlwch, for one, never really recovered from the decline in mining; it has the air of a place that has seen better days and is crying out for investment. A local group wants to revive its very overgrown railway connection: maybe that could be a way forward, both for the town and for other far-flung parts of the island.

Anglesey is home to two of Britain's few remaining colonies of red squirrels, which can be spotted at Newborough and Pentraeth – again, an island providing a refuge for this endangered species.

The Admiralty built the first harbour at Holyhead 1810–21, but by the 1840s it was inadequate for the volume of shipping that wanted to use it. With the coming of the railway to Holyhead, far bigger facilities were needed and work on building the Great Breakwater, running for 5,360ft from Soldier's Point, and a second breakwater, incorporating little Salt Island, both using vast quantities of stone quarried from Holyhead Mountain, began in 1848 and was completed in 1854. The Great Breakwater was further extended in 1873 and at 2.4 miles is the longest in Britain. STENA Line

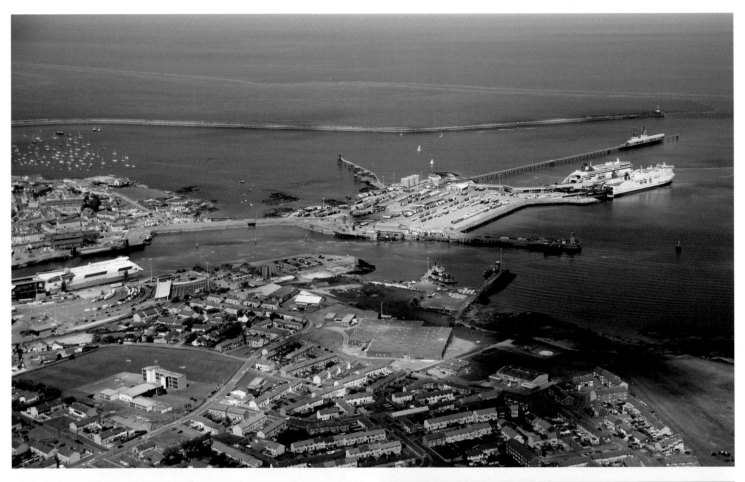

Cemaes, a delightful harbour village and sandy beach on the north coast.
Robin Jones

Overlooking the Menai Strait is Plas Newydd, which dates from the 14th century and is the country seat of the Marquess of Anglesey. It is now in the care of the National Trust. Visit Wales

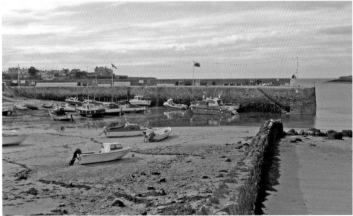

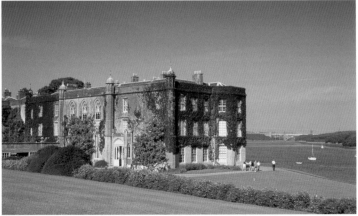

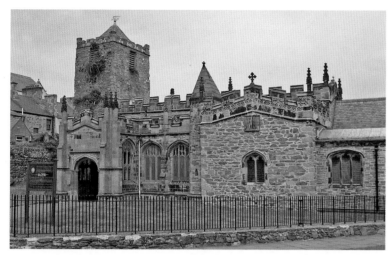

Top left: **People have been sailing between Holyhead and Ireland for at least 4,000 years. The Romans built a rare example of a three-walled fort (the fourth side being the sea) there, and a watchtower inside an earlier hill fort on top of Holyhead Mountain. St Cybi's church was built inside the ruined fort in the 13th century, the present structure dating from the 13th century.** Robin Jones

Bottom left: **Telford's post road from London, which ends at Holyhead's Admiralty Arch, reinforced Holyhead's position as the port for the Irish Mail. This toll house at Llanfair PG survives.** Robin Jones

Left: **Rhosneigr, a popular seaside destination, offers three main beaches, Cymyran, Pwll Cwch and Traeth Llydan.** Anglesey County Council

Whitebait Island and its fish weirs.
Robin Jones

As with Jupiter's place as the biggest planet in the solar system, Anglesey is the largest island in this book. The analogy is appropriate because just as Jupiter has an extensive series of moons, so Holy Island apart, Anglesey has a unique collection of small islands around its coast, which we will visit in anti-clockwise order.

Several lie in the Menai Strait. Ynys Gorad Goch, or Whitebait Island, lies to the east of Britannia Bridge and has a white-painted house and two fish weirs. When the tide receded, fish would be left trapped behind the brushwood weirs. The unusual combination of tides in the strait made it particularly suitable for this type of primitive fishing, very high tides can divide the island in two. It was once known as Bishops Island, because it was said they came there to meditate.

In the early 20th century visitors could walk through Coed Môr woods, ring a bell placed on the shore to summon a boat from the island, where they would be served whitebait teas for one shilling. It is now in private ownership.

To the west of Menai Bridge, and linked to the mainland by a short causeway, is 2.7-acre Church Island, occupied by the tiny 14th-century St Tysilio's church and its graveyard, with a war memorial.

Beyond Menai Bridge are several hilly islets linked to the mainland by causeways: Ynys y Bîg, which has a private house, Ynys Gaint, and a World War II RAF base, currently occupied by an army camp, and Ynys Castell, which also has a house.

Bearing a remarkable similarity in appearance to Steep Holm because of its inclined carboniferous limestone is Puffin Island of Priestholm, which lies off Anglesey's easternmost tip of Trwyn Penmon. Saint Seirol established a monastery there in the 6th century, and there are remains of a 12th-century church and a much later telegraph station. Nobody lives there today: the island is privately owned and landing requires a permit. It has been declared a Special Protection Area because it has one of Britain's largest colonies of great cormorants. Sadly, brown rats were accidentally introduced in the late 19th century and decimated the puffins – showing how fragile some of our islands' ecological systems are.

A mile and a half offshore in Dulas Bay is rocky Dulas Island, which expands to 18 acres at low tide. A ruined cylindrical building with a conical roof was built in 1824 by Lady Dorina Neave of Llysdulas Manor to store food and provide shelter for shipwrecked seamen. Seals live on and around the island.

The northernmost point of Wales is uninhabited Middle Mouse island, which stands about half a mile off the coast near Cemaes. The Welsh name is Ynys Badrig, Patrick's island, because St Patrick was said to have been shipwrecked there before swimming ashore and founding the nearby church of Llanbadrig about 440.

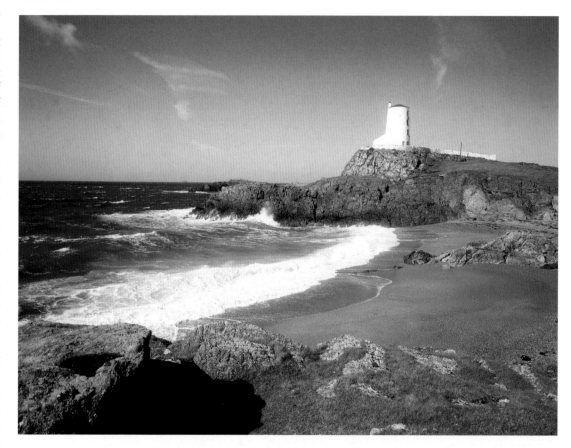

**Llanddwyn Island and its lighthouse.**
Anglesey Tourist Board

Also off the north coast lie the Skerries, a skerry being Old Norse for rocky island. Notorious for shipwrecks on the Holyhead-Liverpool route, a 75ft tall lighthouse was built on the largest island in 1717 and automated in 1987. The Skerries, another Special Protection Area, are an important seabird reserve and a breeding ground for arctic terns. The islets can be visited by charter boat from Holyhead, and little bridges link some of them. Their Welsh name, Ynysoedd y Moelrhoniaid, means 'the island of bald-headed grey seals'.

South Stack Island, on the far side of Holyhead Mountain from the port, is a big tourist magnet because of its spectacular lighthouse which dates from 1809 and is reached by more than 400

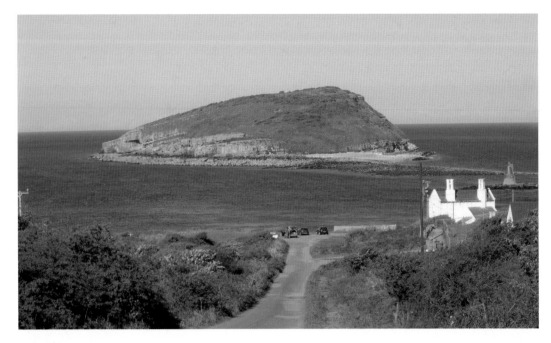

steps. When an iron suspension bridge linked it to the mainland in 1828, it replaced a basket which carried people over the deep channel below on a hemp cable. It's another major bird reserve.

Attached to the mainland at all but the highest tides is romantic Llanddwyn Island, at the northern end of beautiful Blue Flag Newborough beach and part of the National Nature Reserve of Newborough Warren. The name Llanddwyn means 'the church of St Dwynwen', the Welsh patron saint of lovers, a St Valentine equivalent. Her saint's day of 25 January is often celebrated with cards and flowers. A lighthouse was built on the island in 1873 and deactivated in 1975.

Left: **Puffin Island as seen from Penmon.** Robin Jones

Below left: **St Tysilio's church.** Robin Jones

Below: **South Stack Island and its lighthouse.** Trinity House

Opposite page: **Ynys Castell near Menai Bridge.** Robin Jones

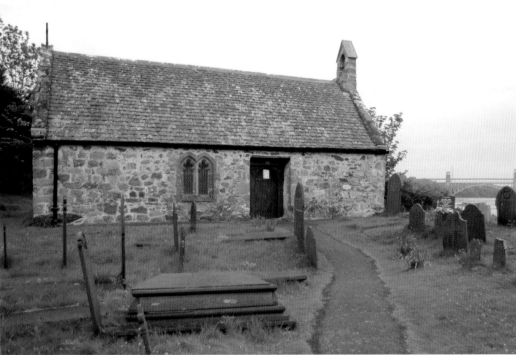

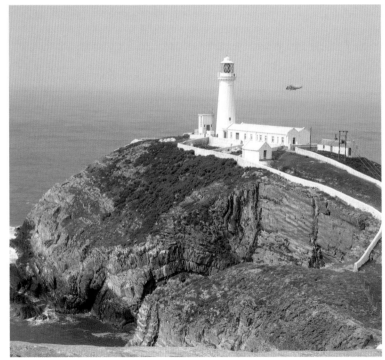

The main road on the island. Bardsey's mountain, Mynydd Enlli, rises to a height of 548ft. Ben Porter

So far in our journey around the coast of England and Wales, we have encountered several islands with 'monarchs' – Lundy, Sealand, Piel. Bardsey can boast a complete dynasty – and a crown to go with it. Measuring roughly one-and-a-half miles by one mile and lying in treacherous seas nearly three miles off the southwest tip of the Lleyn Peninsula, Bardsey was once home to a community of about 90 residents.

The name Bardsey is Norse, its meaning lost in obscurity, but the Welsh version, Ynys Enlli, means 'island of the great current' or 'the island in the tides'.

It was the established tradition for the oldest male to be crowned Brenin Enlli (King of Bardsey) by the island's owner, Lord Newborough of Glynllifon near Caernarfon, or his representative. The role of the king was to settle any disputes.

The entire congregation at the coronation comprised siblings or close relatives of the monarch and the Queen of Bardsey was also heir to the throne. The last king was Love Pritchard, who died in 1927. When he visited Pwllheli on the mainland two years earlier he was welcomed as an 'overseas king' by no less than former Prime Minister David Lloyd George.

In 1926 King Love led most of the inhabitants off the island, having decided to evacuate it because of the harshness of farming and fishing, a place where stone walls had to be built around the cottages to protect them from the ferocity of the elements.

His brass and tin crown was later sold and is now displayed in the National Maritime Museum in Liverpool, having been part of the city's collections since 1986. Requests have been made to return it to Wales, even though only 10 people now live on Bardsey, and the royal family might well be greater in number than the subjects.

It could well be that the island was the final resting place of the greatest king of mystery and romance – Arthur. It has been conjectured that he was brought to Bardsey after being wounded in the Battle of Camelot, which some local traditions place on the Llyn Peninsula. Bardsey has been identified with the Isle of Avalon, which according to some manuscripts, was not Glastonbury in Somerset, but located between Borth in Cardiganshire and Arklow in Ireland. Furthermore, it is also held that Merlin the magician is buried in a cave on Bardsey.

Those who support the theory point to the legend which states that Avalon was an 'isle of apples'. In recent years, an ancient apple tree on the island was identified as the only survivor of an orchard that was tended by the monks who lived on the island a millennium ago. The tree is only a short distance from the cave in the legends. The apple, long ignored because of the island's location, has been identified as a strain unique to Bardsey, and was

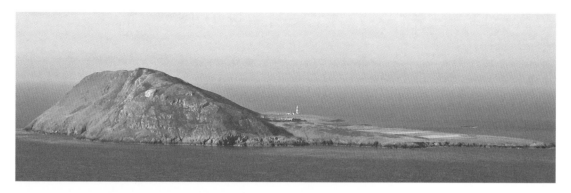

**Bardsey as viewed from the Lleyn Peninsula.** Robin Jones

**The ruined tower of the 13th-century St Mary's abbey, dissolved by Henry VIII, is the most prominent ancient monument on Bardsey.**
Ben Porter

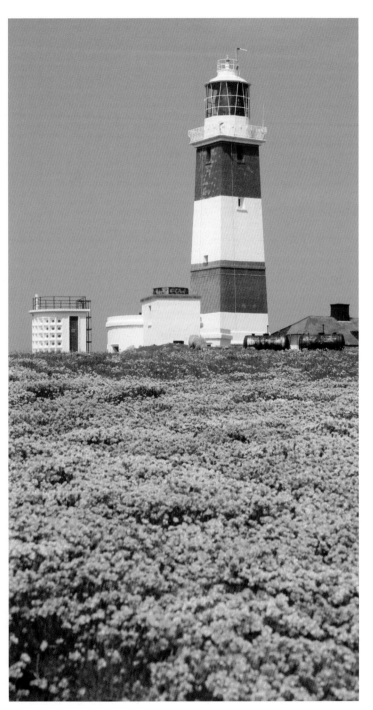

**The tallest square lighthouse in Britain at 99ft was built at Bardsey in 1821. It has been automatic since 1987.** Ben Porter

eagerly described by the media as the world's rarest. It was finally identified and classified when a sample was sent to the National Fruit Collection in Brogdale, Kent in 1998. Saplings of what is now named the Bardsey apple, or Afal Enlli in Welsh, are sold to raise money for the charitable trust that now runs the island.

It is said that Arthur was taken to Bardsey during the 6th century when St Cadfan was abbot of a monastery that he built there, although the island was inhabited long before history was written. The establishment, like others we have seen on islands like Lindisfarne, became a focal point for the early Christian church.

Cadfan, a Breton nobleman, led a large band of missionaries to western Wales with his cousin, St Tydecho, and friend, St Cynllo. Cadfan founded a monastery at Tywyn, but later sought the seclusion of Bardsey.

Thanks to Cadfan, Bardsey became an important place of pilgrimage, and it was held that three pilgrimages to the island were equal to one made to Rome. His followers and many pilgrims were buried there, and Bardsey has been called the burial place of 20,000 saints. Welsh poets hailed the island as 'the land of indulgences, absolution and pardon, the road to Heaven, and the gate to Paradise'.

The tiny population is augmented in the summer months by visitors renting cottages. Just one of the original 'crogloft' buildings, Carreg Bach, survives, the rest dating from the 1870s. All the buildings are listed by Cadw, the Welsh Historic and Ancient Monuments organisation; with no electricity, they are lit by candles or gas lamps. A telephone link to the mainland was finally set up in 2001, but all the permanent residents are on the same party line.

Like many of our islands, it is a vital breeding ground for birds. Bardsey Bird and Field Observatory which opened in 1953 charts the seasonal passages of choughs, oystercatchers, herons, peregrine falcons, wheatears, gannets, razorbills and shags, and the island is renowned for its 16,000 breeding Manx shearwaters, nesting in burrows and flying at night. Since 1979, the island, designated both as a Site of Special Scientific Interest and a National Nature Reserve, has been owned and managed by the Bardsey Island Trust.

The island can be readily visited by the ferry which mainly runs from Porth Meudwy, but sometimes from Pwllheli. The day trips give three-and-a-half-hours on Bardsey.

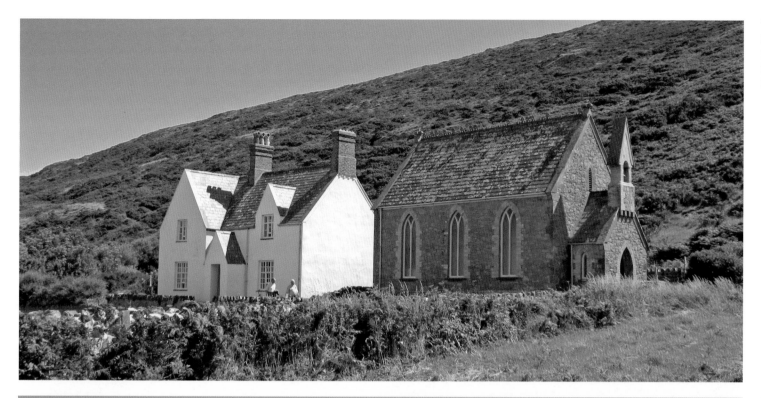

The chapel dates from 1875 and is Bardsey's newest building. When asked by landowner, Lord Newborough, the inhabitants chose to have a chapel rather than a new harbour. David Metcalf

The former schoolhouse, where the last teacher left in 1953. David Metcalf

**Beyond the waves: lonely Cardigan Island.** Chris Shipton

What do you do if you become the youngest-ever Briton to reach the summit of Mount Everest? One answer is to buy a deserted island of your own. That is exactly what adventurer, writer and TV presenter Edward 'Bear' Grylls and his wife Shara did.

Three years after Bear conquered Everest at the age of 23, the couple bought a 70-year lease on St Tudwals Island West off the coast of the Lleyn Peninsula in Cardigan Bay, along with a derelict 125-year-old cottage. The house originally comprised two lighthouse keepers' cottages sold off in 1935 and later made into one dwelling. The couple have restored it as a holiday cottage.

With jagged cliffs rising to 80ft, a summit about 200ft above sea level, an unmanned lighthouse dating from 1877 and nothing but countless flocks of seabirds for company, the 20-acre island was the perfect place for someone who had been to the roof of the world and back.

There again, if you're a celebrity, it is perhaps only right that you should have a famous neighbour. For the twin island of St Tudwals Island East is owned by playwright and animal rights campaigner Carla Lane OBE, creator of *The Liver Birds*, *Butterflies*, *Bread* and *Bless This House*.

The pair of granite islands together with the Carreg y Trai rocks form a small archipelago to the south of Abersoch, and which is renowned for its seal population.

The remains of a priory, referred to in the 1291 tax rolls, can be found on the eastern island. It is believed to be the hermitage of St Tudwal, a Breton monk who died about 564, and is one of the seven founder-saints of Brittany. Tudwal is said to have journeyed to Ireland to learn about the gospels before becoming a hermit on the island. He later returned to Brittany with 72 followers, founding a monastery and being made bishop of Tréguier by Childebert I, King of the Franks. His feast day is celebrated on 1 December.

In late Victorian times, Roman Catholic missionary Father Henry Bailey Mary Hughes attempted to restart the monastic settlement, with the aid to two benefactors, but his building was wrecked by storms in 1887, and the project came to an end.

The original priory was excavated at the start of the 20th century when pieces of Roman pottery were found.

On the far side of Cardigan Bay from the Tudwals is the tenth biggest offshore island in Wales, the 40-acre Cardigan Island. Situated next to the northern shore of the estuary of the River Teifi and consisting of cliff, grassy slope and plateau, Cardigan was inhabited in the past. Like St Tudwals Island East, it once had an early Christian community. Nowadays it is home only to Soay sheep, introduced in 1944 from the Duke of Bedford's flock at Woburn Abbey; grey seals breed in the caves along its shorelines, and bottlenose dolphins are frequent visitors to its waters.

Now in the care of the South West Wales Wildlife Trust the island is a Site of Special Scientific Interest and part of the Cardigan Bay Special Area for Conservation. Cardigan Island is home to an important colony of lesser black-backed gulls, while seabirds like guillemots, razorbills, cormorants and fulmars nest in the cliffs. While there is no access to the island other than by boat, for which a permit is required, you can watch the seabirds through binoculars in early summer from Cardigan

Island Farm Park on the mainland. Much of the flora of this delicate eco habitat was drastically changed in 1934, when the steamer *Herefordshire* was wrecked on the rocks. Brown rats jumped ship and bred on the island, eating the natural flora and causing great soil erosion. They were eradicated in the late sixties by pest control officers, but not before they demonstrated one important principle: introducing a new species to a small island can have devastating consequences.

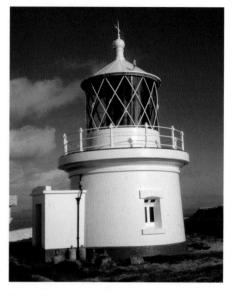

**Seals on the rocks of Carreg y Trai.** David Medcalf

Trinity House built a lighthouse on St Tudwals West in 1877, along with two cottages for the keepers. In 1922 the light was converted to acetylene operation and was run by means of a sun valve,

invented by the Swedish lighthouse engineer, Gustaf Dalen. It was modernised and converted to solar power in 1995.

**Cardigan Island as viewed from the top of the mainland.** Chris Shipton

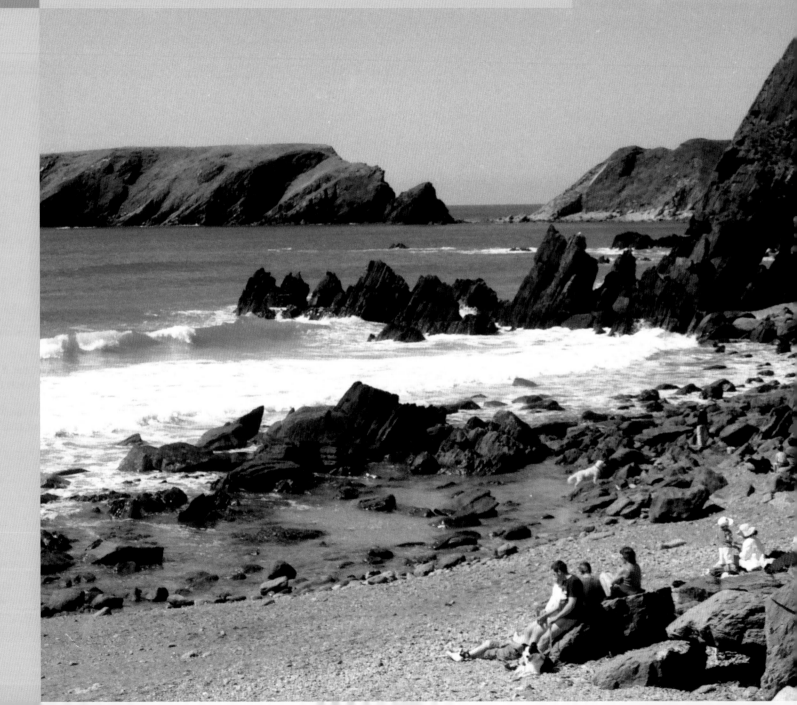

Gateholm at high tide. Robin Jones

Cornwall has the Isles of Scilly; Pembrokeshire, the corresponding southwestern tip of Wales, has its own collection of islands stretching out into the Atlantic. Unlike Scilly, they are not part of an archipelago and are quite different in character.

While Scilly is now a thriving community, the west Pembrokeshire islands, thanks to their comparatively difficult access, are all but uninhabited and given over completely to nature.

St Mary's, St Martins and Tresco have long swathes of sandy beaches; the islands of west Pembrokeshire are characterised by soaring jagged cliffs, home to thousands of seabird colonies for which they are world famous.

Some of the islands are close to the mainland: others are distant dots on the horizon, conjuring up images of the mythical Celtic land of Tir na Nog.

Many consider Ramsey Island to be the most beautiful of those in west Pembrokeshire. Lying about two-thirds of a mile off the St David's peninsula, its Welsh name is Dewi Sant (St David), and the nearest town, or rather, city, is St David's. It was home to David's confessor, St Justinian, a 6th-century hermit who, legend has it, was beheaded by his servant or monks because of his strict regime. Undeterred, he picked up his head and crossed Ramsey Sound walking on the water; his body was buried in the ruined chapel which can still be seen on the mainland at St Justinian's.

At two miles long, covering 600 acres and rising to 446ft above sea level, Ramsey is the fourth largest island in the principality after Anglesey, Holy Island and Skomer. Owned by the Royal Society for the Protection of Birds, Ramsey has the largest breeding colony of lapwings in Wales and is an important nesting ground for choughs.

The 400ft western cliffs, among the highest in Wales, are also home to ravens, peregrine falcons, razorbills, fulmars, kittiwakes and shags, while the island's southern heathlands, comprising heather and gorse, are frequented by skylarks, linnets, stonechats and meadow pipits. Ramsey's beaches and caves house the most important breeding colony of Atlantic grey seals in southern Britain, with about 400 pups born each year. The island has a resident population of just two, the RSPB warden and his wife who live in the farmhouse.

On clear days Ireland can be seen from the island's summits of Carn Ysgubor and Carn Llundain.

Ramsey is accessed by boat from the lifeboat station at St Justinian's; it runs from Easter to the end of October. To the eastern side of the Island are the treacherous waters of Ramsey Sound,

which has one of the strongest tides in Britain, the cause of many shipwrecks. It includes The Bitches, a popular destination and for extreme sports enthusiasts such as surfers and whitewater kayakers.

Ramsey is surrounded by several smaller islands, islets and rocks, notably the Bishops and Clerks whichie up to two miles to the west. They include South Bishop Island or Emsger, on which a

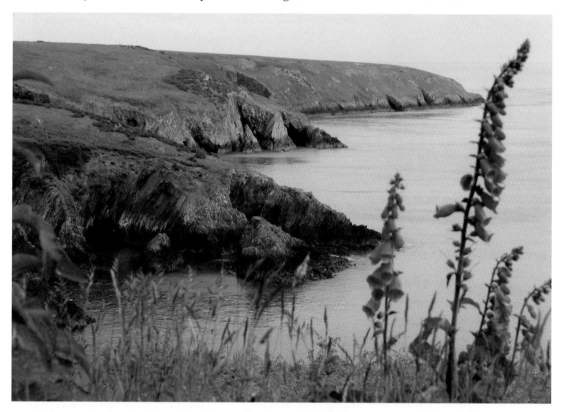

A typical stretch of Ramsey Island coastline. Jo Dickson

lighthouse was built in 1839. The lighthouse was converted to electricity in 1839, a helipad was added in 1971, and it was automated in 1983.

On the opposite side of St Bride's Bay lies Skomer, the most popular of the west Pembrokeshire islands for visitors. The name comes from the Viking Skalmey, meaning a short sword or cleft and 'ey', meaning island.

Measuring 1.13 square miles, the plateau-like Skomer is cut off from the mainland by Jack Sound, through which runs a tidal current forming a natural barrier to mammalian predators, a factor which allows burrow nesting seabirds to thrive. Skomer is a haven

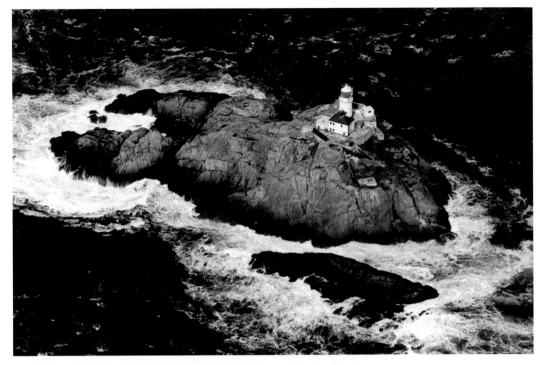

for Atlantic puffins, Eurasian oystercatchers, European storm-petrels, guillemots, razorbills, black-legged kittiwakes, great cormorants, short-eared owls, kestrels and peregrine falcons. Skomer and sister island Skokholm, are the world's most important breeding ground for Manx shearwaters, comprising over half the global population. Rabbits were introduced about 1400 as a source of meat and fur, and shearwaters have adapted their burrows for use as nests.

Along with its 500,000 nesting seabirds, Skomer has one of Britain's biggest seal colonies and the island is home to slow worms. And Skomer has one species which is found nowhere else, the Skomer vole, a variation of the mainland bank vole. Thanks to the lack of predators such as cats or foxes, it thrives in the bracken and, although a food source for owls, has a thriving population of about 20,000.

Managed by the Wildlife Trust of South and West Wales, Skomer is inhabited nine months of the year by a warden, while there is a limited amount of self-catering accommodation for overnight visitors.

The island has been inhabited from the Iron Age, when up to 200 people lived there. A farmhouse was built in the centre of the island in the early 19th century. The advent of refrigerated steam ships made farming much less profitable in such isolated locations, although it supported a farm until the 1950s, when the last farmer, Reuben Codd, moved to the mainland and looked after the island from there.

Skomer, which covers 730 acres and rises to a height of 260ft, is a designated National Nature Reserve and Site of Special Scientific Interest. Much of it is also an Ancient Monument, because of the presence of a stone circle, a standing stone and and the remains of prehistoric houses. It is surrounded by Wales' only statutory Marine Nature Reserve, the haunt of dolphins and harbour porpoises and in which coral and 70 species of sponge grow, fed by the warm waters of the Gulf Stream.

Skomer, which is leased by the Countryside Commission for Wales to the Wildlife Trust of South and West Wales, is accessed by boat from the tiny harbour of Martin's Haven from April to October. Spring is a favourite time for visitors, when the island erupts into a blaze of colour comprising bluebells, sea and red campion and pink thrift.

Between Skomer and the mainland lies tiny Middleholm, also known as Midland Island.

Skokholm, which lies to the south, was given its name by the Norsemen. It means 'wooded island', although there are no trees there now, and is similar to Stockholm, the Swedish capital. The island, which is one-and-a-quarter miles long and half-a-mile wide, was settled as far back as the Bronze Age. Classed as a Special Area of Conservation, Skokholm is the site of the third largest colony of Manx shearwaters, and also has a huge population of storm-petrels, puffins, guillemots and razorbills.

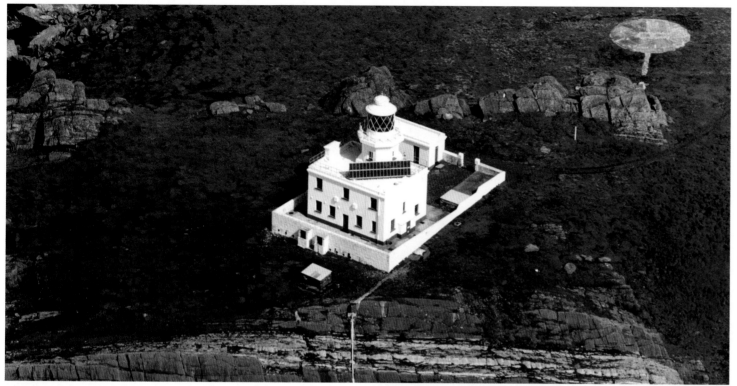

Opposite page top: **South Bishop Island and lighthouse.** Trinity House

Opposite page bottom: **The trip boat to Skomer as seen from the top of the island.** Gareth Morris

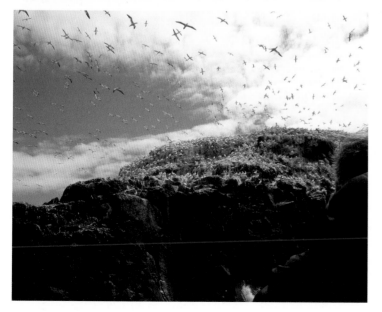

Above left: **The Skokholm lighthouse.** Trinity House

Above: **The unique Skomer vole.** Jonny Page

Far left: **Gannet heaven - the skies above Grassholm.** David Challender

Left: **Taking supplies to The Smalls.** Trinity House

The island was bought for £300 in 1646 by barrister William Philipps, and it remained in the family for the next 360 years, until his descendant Mrs Osra Lloyd-Philipps of Dale Castle died in 2005. It was then bought by the Wildlife Trust of South and West Wales which had managed it for the previous half century.

Ornithologist Ronald Lockley, who died in 2000 aged 96, not only lived on the island for decades and wrote many books about it, but in 1933 set up Britain's first bird observatory there. Thanks to him, Skokolm is said to have been the most intensely studied of all the small islands around Britain's coast.

Lockley and his wife Doris took out a 21-year lease on Skokholm in 1927, at first attempting to farm chinchilla rabbits before he began studying migratory birds.

**Thorne Island as seen from the air.**
Thorne Island Hotel

When World War 2 broke out, Skokholm was taken over by the military, and he returned to farming on the mainland. In 1952 Lockley helped set up the Pembrokeshire Coast National Park, of which all the islands in this chapter are part.

Visiting the island – boats run from Martin's Haven – has to be done by prior booking with the trust. In the centre lies a Grade II Listed cottage and converted farm buildings, which provide accommodation for staff and up to 15 visitors.

Skokholm has a lighthouse built, like South Bishop and The Smalls, to guide ships through the treacherous waters into Milford Haven or the Bristol Channel. Dating from 1916, a jetty was built to offload construction materials, and later for landing supplies which were carried the mile to the lighthouse on two trucks hauled by a donkey on a narrow gauge railway. The lighthouse was automated in 1983.

Eight miles from the mainland and looking like a blob on the horizon is the little circular island of Grassholm. It was given the name Grass Island by the Vikings, but those who sail past it will notice it is bright white rather than green, the result of gannet droppings or guano. It is the third most important site for the species in the world, containing about 12% of the global population, up to 34,000 breeding pairs. Grassholm has been described as the most impressive wildlife sight in Pembrokeshire: when you see the birds diving for fish from 100ft, you would not beg to differ. In 1890, there were about 500,000 puffins on the island, but they have almost disappeared.

In 1947, Grassholm became the first reserve to be bought by the RSPB, and is now a designated National Nature Reserve. Landing is prohibited, but boats from Martin's Haven get close enough for the bird colonies to be viewed, although the stench from the guano can be overpowering and the 'arrah arrah' chorus from the birds is utterly deafening.

The westernmost extremity of both Pembrokeshire and Wales is marked by The Smalls lighthouse, which occupies a rock 20 miles west of St David's peninsula. The first lighthouse on the rocks was built between 1755/6.Unusually, but successfully, it stood on nine oak pillars which allowed the raging sea to pass below and reduced stress on the tower.

The first message in a bottle was successfully sent from the small island when repair workers, including the designer Henry Whiteside himself, became stranded.

A chilling episode in 1801 was to change the way in which lighthouses were administered everywhere.

The Smalls was manned by two keepers, Thomas Griffith and Thomas Howell, who, it was known, did not get on. One day Griffith died in a freak accident. Howell was terrified that he might be blamed for murder if he disposed of the body in the only way possible, into the sea. So he built a makeshift coffin for the corpse and fastened it outside. Howell had to live and work with the coffin on his doorstep until he was relieved, and during a gale, the box was shattered and an arm fell out in full view of a window, as if beckoning him. Howell suffered so much psychological damage that from that time lighthouse teams across Britain were changed to a minimum of three.

Trinity House bought out the leaseholders of the lighthouse in 1836, and in 1859 began the construction of a new tower which was completed two years later. The lighthouse had a helipad added in 1978, and was automated in 1987. Not only was it Britain's first wind and solar-powered lighthouse but it was the first to have a flushing toilet.

Beyond The Smalls lie 3,000 miles of ocean before you reach land, in the form of North America.

Not all of west Pembrokeshire's islands have to be accessed by boat. At the northern end of magnificent Marloes Sands, one of the finest beaches in Wales, and within sight of Skomer and Skokholm, stands Gateholm, a long thin tidal island. Now part of the local coastline owned by the National Trust, it is renowned for its early British remains, including a round barrow and hut circles. Indeed, it is claimed that there is evidence of more than 100 structures there.

There are two more islands in west Pembrokeshire, one a natural rocky outcrop, and the other manmade. Both comprise Palmerston forts, part of a ring built to protect the approach to Milford Haven.

Two-acre Thorn Island lies off the village of Angle from which it is reached by boat. The Angle lifeboat rescued the crew of the whisky-carrying ship the *Loch Shield* from nearby rocks in 1878. The tale gave rise to a Welsh version of the Scottish tale *Whisky Galore* in which locals were not too eager to return cases of flotsam from the wreck. Full beer bottles recovered in recent times from the wreck have sold for £1000 at auction.

The fort was converted into a hotel in 1947. In 2001, the new owner announced plans to link the island to the mainland by a cable car system, which, had it gone ahead, would have been a first for the islands covered in this book.

Lying off South Hook Point on the approach to the Milford Haven liquefied natural gas terminal is Stack Rock Fort, a massive four-storey circular stone structure with its own jetty, and which covers the entire third-of-an-acre island. Complete with barracks for five officers and 175 men, the fort became redundant in 1929 and sold at auction for £60 in 1932. In 2005 it was again offered for sale. Unlike the Thorn Island Hotel, however, there is no running water or electricity, and grass grows on the roof.

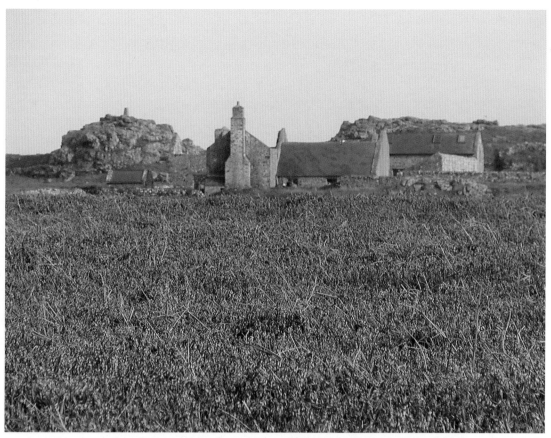

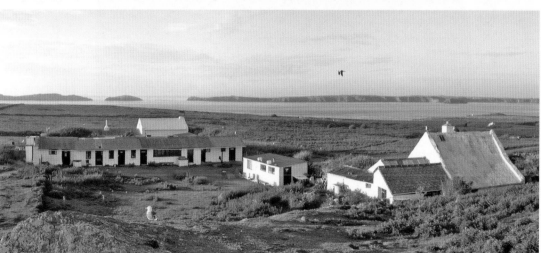

**The farmhouse surrounded by a spring carpet of bluebells.** Mike Penny

**The cluster of buildings at the heart of Skokholm, with Skomer on the horizon to the left.**
Sarah Dalrymple

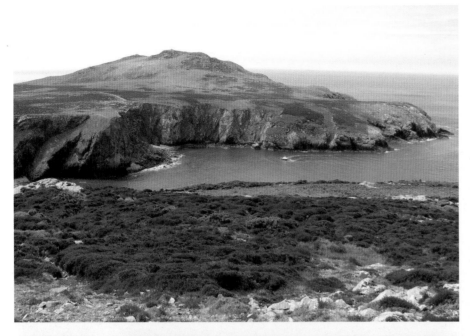

Top: **Ramsey Island, as viewed from the shore near St Justinian.** Jo Dickson

Above: **St David's-based Voyages of Discovery runs guided boat trips manned by scientists and oceanographers around many of the west Pembrokeshire islands, navigating into deep sea caves, as pictured on Ramsey Island, through** gorges and around spectacular cliffs, where colonies of birds, seals and porpoises can be observed at close hand. Janet Baxter

Top right: **The interior of the Palmerston fort on South Stack.** Mark Davis

Right: **The sheer cliffs of Ramsey.** Chris Gunns

Above: **Skomer puffin in its burrow.** Paul Williams

Right: **The kings of Ramsey Island: red deer roam freely.** Martin Hitchen

Below: **South Stack fort guarding the approach to Milford Haven.** Robin Lucas

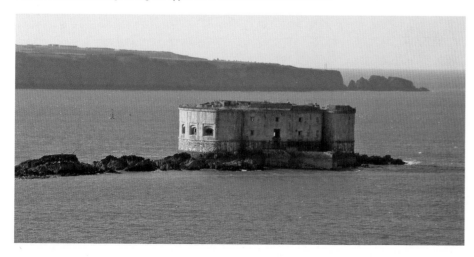

**38**    *Caldey and St Catherine's islands*

One of several glorious golden sand
beaches on Caldey Island. Brian Candy

War and peace: diametric opposites form the defining characteristics of the two islands off the coast of Tenby on the eastern coast of Pembrokeshire.

St Catherine's Island, which is joined to South Beach at low tide, but not open to the public, is dominated by another of the great Palmerston forts that we first encountered on Flat Holm. The rectangular fortress was designed to prevent a landing at Tenby, which could have served as a bridgehead to attack Pembroke Dock and Milford Haven. However, the forces of Napoleon III never came, and a shot was never fired in anger. While the foundations were being dug, the ruins of a medieval chapel were found, along with an Egyptian effigy, a skeleton and some Roman coins.

In 1907 the island was sold for £500 to the Windsor-Richards family, who had made their fortune from iron and steel, and became a private residence. It has four main bedrooms and 16 turret rooms. The banqueting hall, which holds a life-size statue of Queen Victoria, has been used by the family for many celebrations including the annual Tenby Hunt Ball. The barracks accommodated 150 soldiers and the basement housed an armoury which held 444 barrels of gunpowder. The family left Tenby in 1920, and sold off most of the lavish fixtures and fittings.

The Army reoccupied the fort in 1914-18 and again in 1940. Troops from the Belgian Army and the Home Guard were among those based there. After World War 2, it was converted into a private residence called Gun Fort House and in 1959 it was advertised for sale for £10,000. At one stage it was even used as a small zoo.

Although Grade II listed, the island's buildings are now derelict, its grim fortifications exuding an air of menace above the golden beach packed with holiday-makers.

From nearby Tenby harbour, boat trips take visitors to Caldey Island, internationally renowned as a spiritual haven of peace and tranquility. Caldey Island is divided from the mainland by Caldey Sound, about one-and-a-half miles across at its widest point. The island's name comes from the Viking 'keld-eye' meaning 'cold island'.

We have visited many islands that were once the home of early Christian saints and hermits, whose religious establishments have long since vanished. Caldey is different, for here, the island is occupied by a modern-day monastic order.

A Celtic monastery was founded on the island in the 6th century, and a Roman Catholic Benedictine institution existed from 1136 until it was dissolved by Henry VIII in 1536. Nearly four centuries later, however, monks would return. In 1906, an Anglican Benedictine community led by the Right Reverend Dom Aelred

Carlyle built the current abbey. It was the first Anglican Benedictine community to be established since the Reformation. Following a dispute with the Bishop of Oxford, the monks were accepted into the Roman Catholic Church in 1913, but left the island in 1925 owing to financial difficulties and moved to Prinknash Abbey in Gloucestershire. In 1929, a community of Reformed Cistercians arrived from Scourmont Abbey in Belgium, and are still there today.

The monks follow a simple life farming the land alongside the island's small village, which has its own school, gift shop, post office, tea gardens and a small museum.

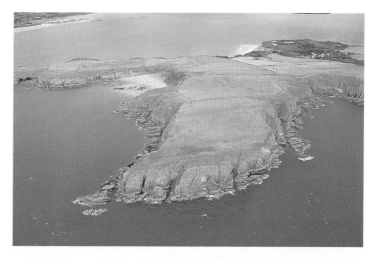

**Caldey Island as seen from the air.**
Pembrokeshire Tourism

There is a private guesthouse on the island as well as a fire engine, ambulance and coastguard. The island also provides a spiritual retreat throughout the year.

The monks observe a strict no-speaking rule between 7pm and 7am, during the day; they work alone and speak only when necessary. They also take vows of poverty, chastity and obedience on joining the monastery. While visitors are admitted to parts of the monastery, women are banned from certain areas, and cannot join the guided tours.

By and large, the monks shun the modern world. A rare occasion on which they were allowed to watch TV was the funeral of Pope John Paul II, when a satellite dish was flown in by helicopter, and taken back after the service. The dish was needed because the height of the monastery's walls made the signal difficult to pick up.

The brethren are internationally renowned for their produce including chocolate, ice cream, clotted cream, shortbread and

yoghurt, plus perfumes and hand lotions derived from wild flowers that grow on the island. Excelling in commercial activities, the monastery opened an internet store in 2001.

The quiet religious atmosphere generated by the monastic buildings and lifestyle of the brothers matches the beautiful and peaceful wooded surroundings, which include a Norman chapel, a 12th-century church, the 6th-century Ogham cross and a lighthouse built by Trinity House in 1829. On either side of the lighthouse are two keepers' houses which became redundant when the light was converted to automatic unmanned operation in 1927. The last Trinity House lighthouse powered by acetylene gas, in 1997 it was modernised and converted to mains electricity.

The island was inhabited long before the arrival of the monks. The discovery of early flint tools indicate that man lived there 12,000 years ago, when sea levels were much lower and Caldey would have been a hill on the flat plain now covered by the Bristol Channel.

Limestone was quarried on Caldey in the 19th century and taken to kilns, where it was burned to make fertiliser. Some of the stone was exported to north Devon for this purpose and there was a small tramway serving the quarry.

From mid-May until mid-September, boats run between Caldey and Tenby every 15 minutes from 9.30am until 5.00pm Monday to Saturdays. Short as it is, the crossing can be dangerous and Caldey is often cut off in winter.

To the immediate west of Caldy is St Margaret's Island, a nature reserve, with the biggest colony of cormorants in Wales. Once extensively mined for limestone, it is not open to the public.

Right: **The lighthouse.** Humphry Bolton

Far right: **The 20th-century monastic buildings.** Janice Lane

Below right: **The village green forms the heart of Caldey, overseen by the 20th-century monastery.** Brian Candy

Below far right: **The Norman parish church of St David's. Simple wooden crosses mark the graves of monks and islanders.** Janice Lane

Opposite page: **St Catherine's Island, as seen from Tenby.** Robin Jones

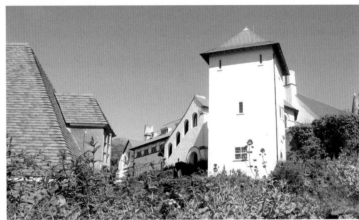

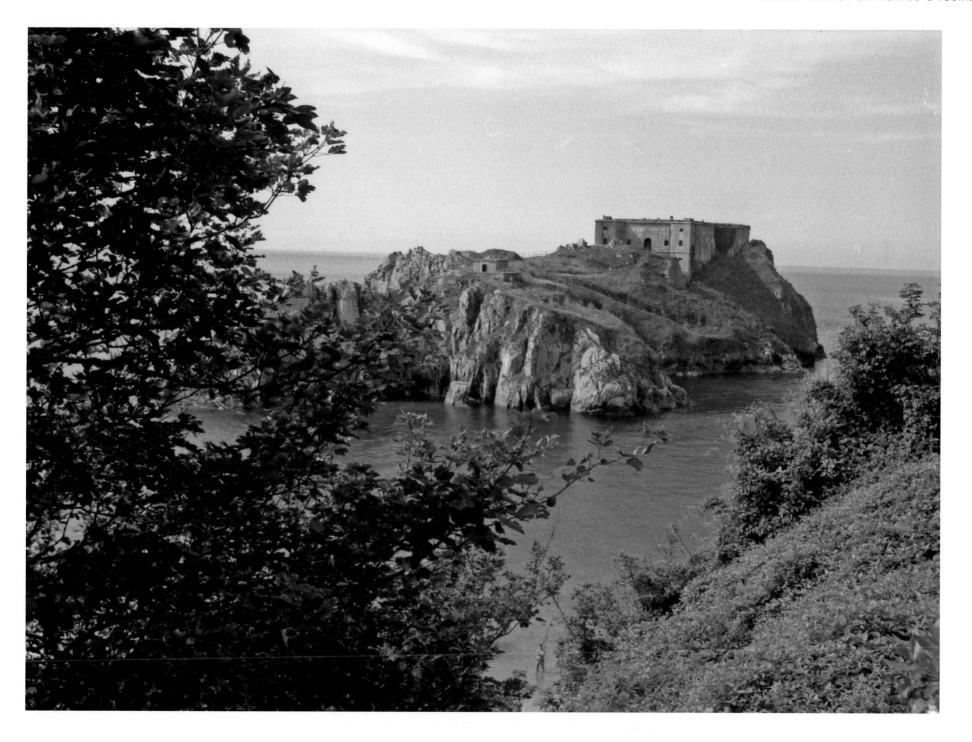

The splendid golden sand beach at Barry Island in 1987, with the Butlin's camp chalets dominating the far cliff.
Robin Jones

There is much to say about Barry. It was named after the sixth-century Welsh saint Baruc, a disciple of St Cadoc, who was a hermit on the tidal island which lay a short distance from the mainland, and who we first encountered in Chapter 1. One day Baruc forgot to bring Cadoc's reading matter with him from Flat Holm. He was sent back to get it but drowned on the return crossing of the Bristol Channel, to be buried on Barry. The remains of a chapel dedicated to him lie in Friars Road.

The island's history goes back way before Baruc with evidence of activity as long ago as the Middle Stone age, with the Silures, a Celtic tribe, settling on the island, where they left Bronze Age burial mounds.

The Romans apparently bothered little about the island, but the 12/13th-century Norman Welsh chronicler Gerallt Cymro gave a detailed description of the island's well in his *Journey through Wales*.

However, all of this pales into insignificance when compared to a single word – 'railway'.

It was the railway which 'made' Barry. By 1913 it was the world's biggest coal-exporting port and the island was a major holiday resort. In the late 20th century coal exports ended and the resort took a major downturn but Barry played a key part in developing a major part of the tourism economy of the whole of Britain through the magic of steam railways.

The Barry Railway Company was set up by coal pit owners to provide an alternative means of exporting coal from the South Wales valleys, on which the Taff Vale Railway and Cardiff Docks had a monopoly. The 18½-mile Barry Railway main line from Treharod to Barry opened in 1889. More modern and efficient, it had overtaken Cardiff by 1901. Those years saw the population of Barry rise from about 100, when it was an agricultural backwater, to 13,000. Eventually the railway had 68 route miles, including the short branch from Barry across a causeway to Barry Island, which was completed in 1896, and on to Barry Pier station, serving steamships in the Bristol Channel. There were also 100 miles of sidings around Barry Docks, which had been created in the partially-infilled channel between Barry and its island.

The Barry Railway was by far the most successful of the South Wales companies. Trade grew from one million tons in the first year, to over nine million tons by 1903. Barry Docks were crowded with ships and offered ship repair yards, cold stores, flour mills and an ice factory. By 1913 it handled more than 4,000 ships and 11 million tons of coal a year.

The opening of Barry Island Station on 3 August 1896 along with the short causeway meant that visitors no longer had to cross on foot through low-tide wet sand and mud, or wait for a Yellow Funnel Line paddle steamer at high tide. The railway opened the island up for residential and leisure development, but building the causeway and docks, had turned it into a peninsula.

With one of the best sandy beaches in the Bristol Channel (unlike those on the English shore, there was little low-tide mud),

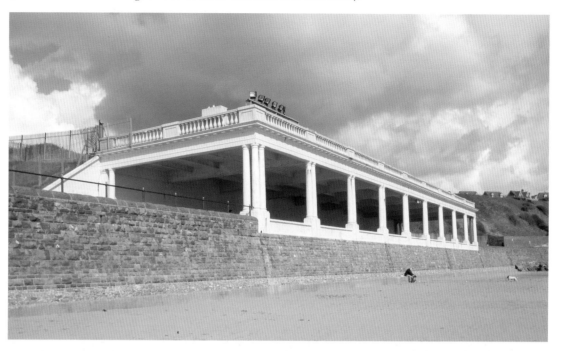

*The columnated pavilion shelter behind the main beach.* Anne Ward

it took off as a day-trip destination for the families of Welsh miners, who could easily reach it by train. Over 150,000 visitors were recorded arriving one August Bank Holiday weekend, mostly by rail, and in 1934, more than 400,000 people visited the island's fairground during the August Bank Holiday week.

Often on high days, weekends and holidays, the beach was packed to standing room only, and a plethora of guest houses, hotels, fish and chip shops, ice cream stalls and souvenir shops sprang up. In 1930, the Great Western Railway enlarged the island station's platforms to handle large excursion trains from much further afield, and the Pier terminus offered an interchange with pleasure steamers plying the channel.

The great holiday camp magnate Billy Butlin drew the inspiration for his business empire from an unhappy holiday on Barry Island, when he had been locked out of his bed-and-breakfast accommodation all day by his landlady, a standard practice in British seaside resorts until recent decades.

He opened his first camp in 1936 in Skegness, and the last and smallest Butlins on the headland at Nell's Point, Barry Island, in 1966. Offering all the standard Butlins fare – Redcoats, the funfair, the early morning wake up call, indoor and outdoor swimming pools, a dining hall, a ballroom, a boating lake, tennis courts, a sports field, snooker tables, amusement arcades and shops, plus 1,400ft chairlift system - it was an overnight success; 800 basic 1960s chalets were built on the headland. It remained popular during the 1970s, but with the advent of cheap overseas package holidays and a widening expectation of more modern accommodation, Butlins closed the camp at the end of 1986.

Sold to Majestic Holidays, it reopened on 23 May 1987 as Majestic Barry Island, later renamed Barry Island Resort, and still

**Rows of rusting steam engines in Dai Woodham's scrapyard next to Barry Island.** Paul Chancellor Collection

included Redcoats. It was the filming location for a 1987 Dr Who adventure, *Delta and The Bannerman*, set in a holiday camp in 1959.

Following growing criticism of the standard of accommodation and maintenance at the camp, it finally closed on 7 November 1996. A year later, the site was bought by Vale of Glamorgan Council, which demolished the camp and sold the land for a housing development now known as Bryn Llongwr.

Incidentally, two other Dr Who episodes were filmed on the island in 2004, when it was the setting for a London bombsite. From a bombsite, however, there must come regeneration, and that is what has happened at Barry, in more ways than one.

Family holidays at traditional resorts like Barry Island declined with the growth in mass car-ownership, as people could choose where they wanted to go, and often took cheap package holidays by air.

Barry was the site of legendary Woodham Brothers scrapyard, owned by Dai Woodham, and it was a veritable Valhalla of the glories of the steam age. Such scrapyards existed across Britain, taking in redundant steam engines and cutting them up within days. Barry's scrapyard, however, was different. Dai Woodham discovered that it was far more profitable to cut up redundant wagons, which would otherwise take up miles of siding space. The more difficult locomotives were left in rows for a 'rainy day.'

The last British Railway steam locomotives ran on the main line in 1968, and by then, several enthusiast groups had begun taking over short lengths of disused line and reopening them as heritage railways. Sadly, this initiative came too late to save many classes of British locomotive from the cutter's torch, but at Barry many were left intact.

Eventually, the preservation movement gathered pace, and enthusiasts found themselves able to buy locomotives from Dai Woodham for a reasonable sum, and return them to running order. The first one to leave was Midland Railway Class 4F 0-6-0 No 43924 in September 1968, being taken to Yorkshire's newly-reopened Keighley & Worth Valley Railway. Largely thanks to the support of Dai Woodham, a total of 213 engines were bought from him for the preservation movement, and many of them went on to be restored to work on Britain's heritage lines, or haul modern-day specials on the main line.

With more than 100 operational heritage railways in Britain, and about 60 steam centres, offering more than 400 miles of track, they now form a significant slice of the British tourist market, satisfying the public's seemingly-endless thirst for the steam era. Much of it would not have been possible but for the huge supply of steam engines from Barry. Steam has also returned to Barry Island. As part of a council regeneration scheme for the town and its resort, the lifted second track on the island causeway was relaid, so heritage trains as well as regular commuter services could run between the two. The Barry Island Railway runs for about two-and-a-half miles and offers rides behind steam and heritage diesel locomotives.

Where thousands of ships once came to collect coal, luxury apartment buildings have appeared on the waterfront, as Barry

aims to move up market. While it may no longer be a first choice for main summer holidays, the resort is still a popular day-trip destination.

Hate to spoil your fun, but one happy holidaymaker at Barry Island in the fifties was mass-murderer Fred West, whose ashes were scattered here after his suicide in prison in 2004 while awaiting trial.

If you want to see a smaller version of what Barry would have looked like before its harbour was built, four miles along the coast lies Sully Island, publicly accessed by a 400-yard low-tide sand and stone causeway from a pebble beach that contains warnings to swimmers of dangerous currents. The tide comes in very fast and many people have been swept away while trying to leave the island.

Norman pirate Alfredo de Marisco, otherwise known as the Nighthawk, and one of the notorious Lundy family, established a base on Sully, and in later centuries it was used for smuggling.

Swanbridge and its waterfront protected by Sully Island were a commercial port for several centuries, although there is no sign of this today. The harbour was used in 1658 as a landing place for illegal immigrants, described as 'undesirables'.

The famous Antarctic survey ship, the SY *Scotia*, was wrecked on Sully on January 18 1916.

The British biologist Brian J. Ford, who lived at Swanbridge, carried out extensive ecological studies on Sully, and found many plants unusual for the area, including the bee orchid, marine spleenwort and the adders tongue fern.

In May 2009, the 14½-acre island was offered for sale by its owner with an asking price of £1.25 million. While it is unlikely that planning permission would ever be granted for a house, the local council has indicated that an appropriate tourist attraction might be considered.

**Sully Island and the low-tide causeway.** Alan Bowring

**Clowning around by the camp swimming pool.** Butlins Memories

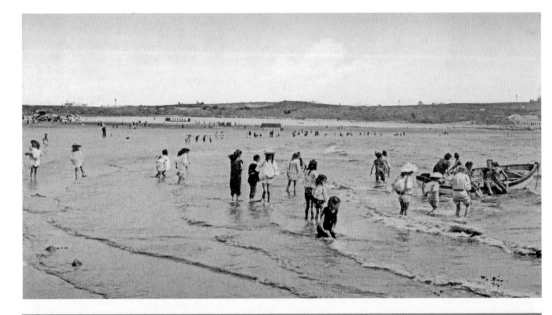

Above left: **Barry Island was popular as a resort a century ago.** Robin Jones Collection

Left: **Steam in action on the modern-day Barry Island Railway, a two-mile heritage line which runs from the island to the mainland at Barry alongside the Network Rail branch linking the two. The locomotive is GWR saddle tank No 813, the sole surviving locomotive from the Port Talbot Railway, and which is now based at the Severn Valley Railway.** Robin Jones

Opposite page: **A view from the cliffs at Sully out to Steep Holm (right) and Flat Holm (left).** Alan Bowring

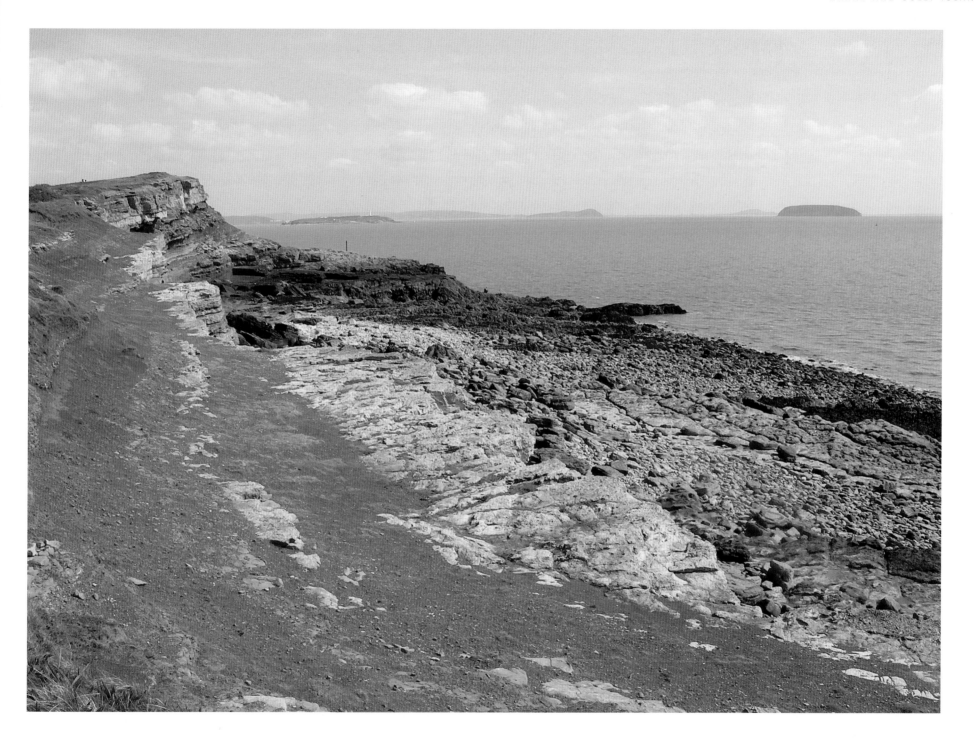

We are now almost at the end of our tour of islands, but there is just about one final place to visit. Way up the Severn estuary from the Holms is a lump of rock known as Denny Island, which lies in the shadow of the second Severn motorway crossing.

Not much is known about Denny, probably because there is not much to know. Although its top is covered in scrub and grass, with violets and mallow adding a touch of colour, its diminutive size, just two-thirds of an acre, probably made it too small for even the most determined early Christian hermit to live there, although seagulls, cormorants and other birds do not mind one bit, and it is a significant roosting site.

Three miles off Portishead, it marks the boundary between England and Wales; it is surrounded by the sandbanks of the Welsh Grounds, and the portion above the high water mark is part of Monmouthshire.

The islet was first recorded as Dunye, in the charter of the creation of the county of Bristol in 1373. The name in Old English means 'island shaped like a down'.

That charter established the city's limits not only on land but on water. The boundary extends across to Denny, before running down to Flat Holm, across to Steep Holm – without including any of the three islands – and then to the shore at Clevedon. It has been said that as 47 square miles of Bristol are at sea and 45 on land, it is a city that is mostly underwater.

One visitor in recent times has been a Lord Mayor of Bristol, Councillor Royston Griffey. On 29 September 2007, he decided to revive the old tradition of beating the city bounds, last carried out in 1901. To do this, he had to visit Denny Island and both holms, braving the enormous tidal range.

He sailed from Avonmouth Docks on board HMS *Ledbury*, leading a flotilla of boats, including the Portishead lifeboat, with Denny as the first port of call. He landed in a dinghy and symbolically placed a marker stone, as he did on the other two islands.

In 2004, the private estate that owns Denny Island unsuccessfully appealed against it appearing on a map of registered common land under the Countryside and Rights of Way Act 2000, although any visitors would surely be few and very far between.

While we have visited some magnificent and uniquely fascinating places in this book, little Denny Island cannot really rub shoulders with many, if any, of them. Looking little more than a black blob on the horizon, that is just right for the end of our journey. Appearing from one angle like a giant full stop, I'm appropriately placing it here, on the final page.

Seen from Portishead, tiny Denny Island is thrown into silhouette by the setting sun. Robin Jones